ST. LOUIS
THEN & NOW

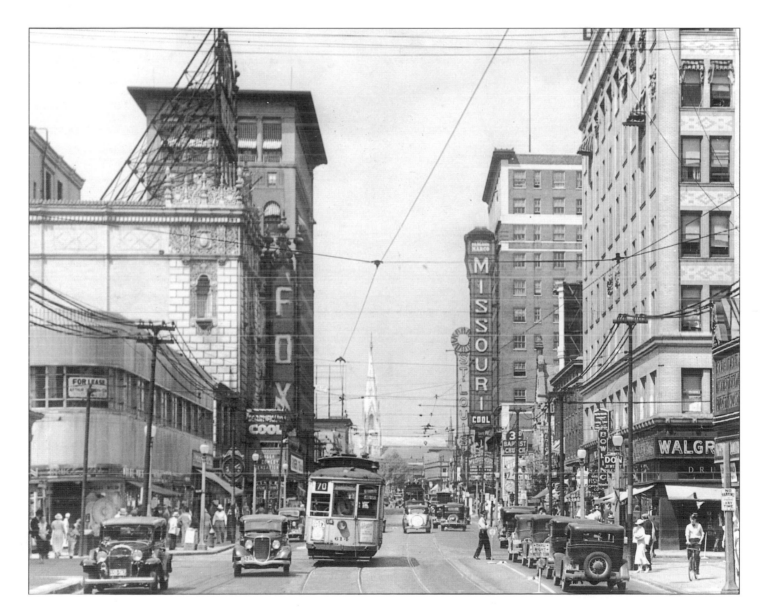

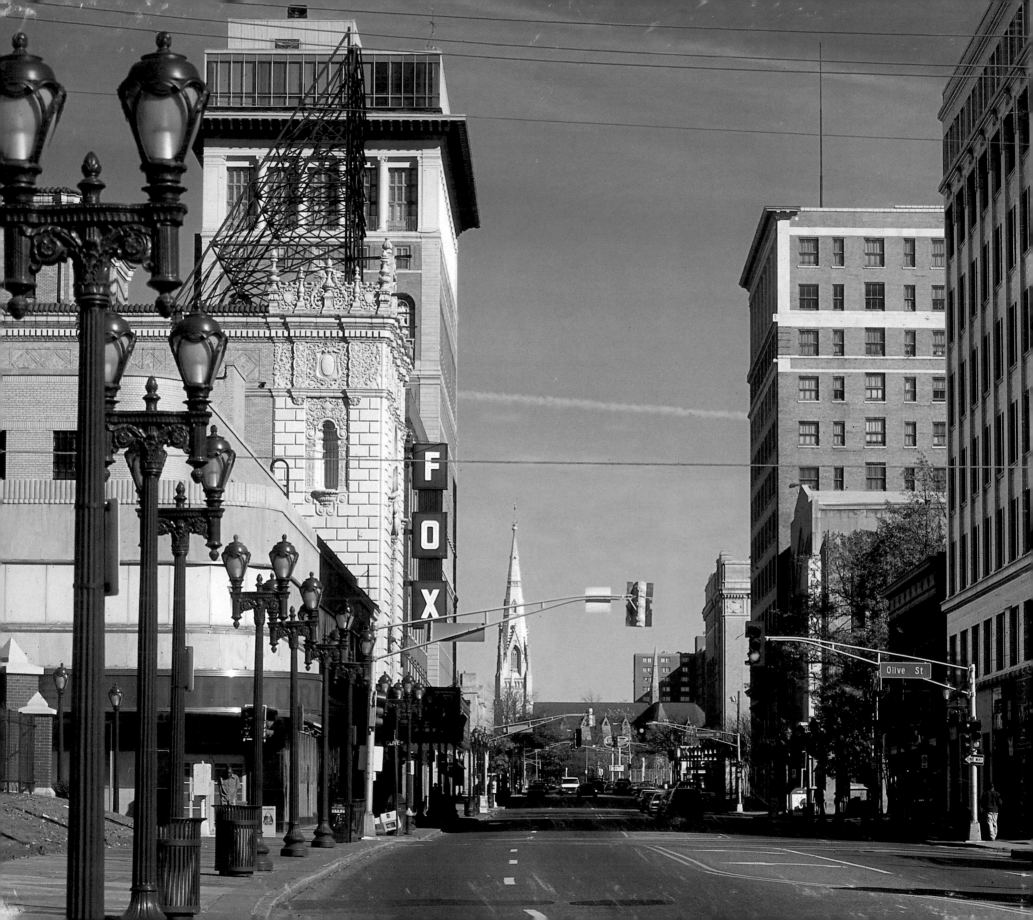

ST. LOUIS
THEN & NOW

ELIZABETH McNULTY

THUNDER BAY
P · R · E · S · S

Published in the United States in 2000 by
Thunder Bay Press
An imprint of the Advantage Publishers Group
5880 Oberlin Drive, San Diego, CA 92121-4794
www.advantagebooksonline.com

Produced by
PRC Publishing Ltd,
Kiln House, 210 New Kings Road,
London SW6 4NZ

Printed and bound in China.

3 4 5 01 02 03 04

McNulty, Elizabeth, 1971-
 St. Louis then and now / Elizabeth McNulty.
 p. cm. -- (Then and now ; 5)
 ISBN 1-57145-243-5
 1. Saint Louis (Mo.) Pictorial works. 2. Saint
Louis (Mo.)--History Pictorial works. I.
Title. II. Title: St. Louis then and now. III.
Series: Then and now (San
Diego, Calif.) ; 2.

Acknowledgments:
Thanks first and foremost to Ellen Thomasson and Samantha
Cooper of the Missouri Historical Society Photograph and
Print Department. Without their expert and enthusiastic help,
this book would never have happened. (Thanks also to Duane
Sneddeker, who turned a blind eye as I took up Ellen and
Sam's time.) Thanks to Jennifer Crets at the Mercantile Library
and to Sister Dionysia Brockland at the School Sisters of Notre
Dame. To JoAnn Padgett for an excellent edit, to Sue
McDonald for great proofing and indexing, to my parents for
racing all over the city with me, and to David for putting up
with "book mode."

Dedication:
For my mother, Patricia Rombauer McNulty, whose St. Louis
ancestors fought to keep Missouri in the Union, and for my
father, James McNulty, who continues at Spicer's the proud St.
Louis mercantile tradition.

Picture credits:

The publisher wishes to thank the following for their kind
permission to reproduce the photography for this book:

Front cover image courtesy of ©Bettmann/CORBIS.
Front flap image (bottom), pages 2, 7, 9, 11, 13, 15, 17, 19, 21,
23, 25, 29, 31, 33, 35, 37, 39, 41, 43, 45, 47, 49, 51, 53, 55, 57,
59, 61, 63, 65, 67, 69, 71, 73, 75, 77 (both), 79, 81, 83, 85, 87,
89, 91, 93, 95, 97 (both), 99, 101, 103, 105 (both), 107, 109,
111 (both), 113, 115, 117, 119, 121, 123, 125, 127, 129, 131,
133, 135, 137, 139, 141, 143, the back cover image, and the
back flap image (bottom) courtesy of Simon Clay.
Front flap image (top), pages 1, 4 (both), 6, 8, 10, 12, 16, 18
(main), 20, 22, 26, 28, 30, 32, 34, 36, 38, 40, 42, 44, 46, 48, 50
(both), 52, 54, 56, 58, 60, 62, 64, 66, 68, 70, 74, 76, 78, 80, 82,
84, 88, 94, 96 (main), 98, 100, 102, 104 (both), 106, 108, 110,
112, 116, 118 (both), 120, 122, 126, 128 (both), 130, 132, 134,
136, 138, 140 (both), 142, and the back flap image (top) cour-
tesy of the Missouri Historical Society.
Images on pages 14, 18 (inset), 24, 114, 124 courtesy of the St.
Louis Mercantile Library.
Images on pages 90 (both), 92, and 96 (inset) courtesy of the
Swekosky Collection at the School Sisters of Notre Dame.
Image on page 72 courtesy of the Campbell House Museum.
Image on page 86 courtesy of Ralston Purina.

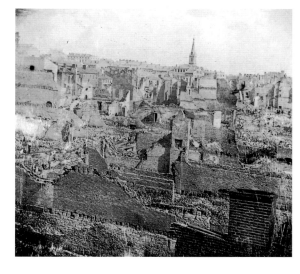

Above: Aftermath of the Great Fire of 1849 viewed from the levee. On May
17th, a fire ignited aboard the steamboat *White Cloud*, moored at the St.
Louis waterfront, and quickly spread. In such an event, boatmen pushed the
burning vessel out into the stream to float away. However, on this particular
night, a strong northeasterly wind blew the castaway back into the pileup of
boats. The fire quickly spread to twenty-two steamboats, then to huge piles
of freight on the levee, then to the city itself. Four hundred buildings and
fifteen city blocks were destroyed; property losses were then estimated at
$6.1 million dollars. The Old Cathedral, one of the few stone buildings,
escaped intact. Daguerreotype by T. Easterley.

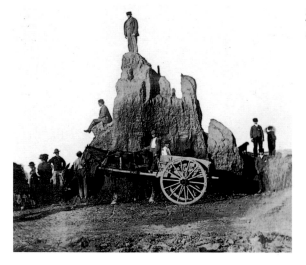

Pages 1 and 2:
The theater district of St. Louis.
See pages 124 and 125.

Above: Fifth (Broadway) and Mound streets, final stages of demolition of
St. Louis' largest mound, named *La Grange de Terre* (the earthen barn) by
the French settlers. St. Louis earned her nickname "Mound City" from the
twenty-seven ritual and burial mounds that once dotted the landscape.
Riverboaters used the largest as landmarks for over fifty years, but in the
1860s, Big Mound, as the Americans called it, was already crisscrossed by
streets. In 1869, despite some public sentiment in opposition, Big Mound
was torn down completely. Daguerreotype by Thomas Easterley. Today,
excellent examples of the Mississippian Mound Builder's prehistoric art
remain across the river in mostly rural Cahokia, Illinois.

INTRODUCTION

There is something in having passed one's childhood beside the big river, which is incommunicable to those who have not," wrote famed modernist poet T.S. Eliot, born and raised in St. Louis. "The strong brown god" of the mighty, muddy Mississippi races past the city with fierce current, yet calm demeanor, drawing thoughts ever with the lure of dreamy adventure and the promise of easy reward. Huck and Jim floated along this river whose dangers their creator, riverboat pilot Mark Twain, knew only too well. The "Old Man River" Mississippi, with all its travails, is St. Louis' defining feature.

It was up this river that New Orleans–based French fur-trader Pierre Laclede sent his stepson, Auguste Chouteau, in 1764 with a crew of men to begin construction on an outpost for his ventures. Upriver 1,200 miles from New Orleans, the men stepped off the *bateau* onto the Mississippi's western bank. The spot possessed a natural sand levee, sheltering limestone bluffs, and a convenient location less than twenty miles downriver from the confluence with the Missouri. In April 1764, Laclede arrived and named the town Saint Louis in honor of Louis IX, patron saint of France; he told his men that "by its locality and central position," St. Louis was to become "one of the finest of cities."

Of course, the French were not the first to find the area amenable. Centuries before, an advanced culture of Mound Builders inhabited the upper Mississippi Valley, farming the fertile land and creating the most populous city in North America. For some reason, after A.D. 1400, they drifted away from the site. When the French arrived, the land that would become St. Louis was dotted with ritual and burial mounds, the largest of which were used as navigational landmarks by riverboaters, earning St. Louis the nickname "Mound City."

After dramatic growth as a French-settled fur-trading center, in 1804, St. Louis entered the American era, when United States President Thomas Jefferson purchased the Louisiana Territory from France. He sent Lewis and Clark to St. Louis to head up an expedition to explore the new lands, seeking a northwest passage to the Pacific. As the western edge of American civilization, but also the second largest inland port, St. Louis thereafter became chief provisioner for westward-bound explorers and adventurers like Fremont, Parkman, and countless other pioneers and gold-rush fortune-seekers. All westward journeys began in St. Louis, establishing the city's reputation as "Gateway to the West."

While journey's beginning for some, St. Louis was journey's end for others. Travelers' accounts of the bustling "Queen of the West" or "Lion of the Valley" drew swarms of easterners seeking opportunity. Famine in Ireland and a failed revolution in Germany created a flood of mid-nineteenth-century immigrants. St. Louis was the original American boom town, her population doubling, sometimes quadrupling, decade by decade.

The arrival in St. Louis of the *Zebulon Pike* in 1817 announced the steamboat era on the Mississippi. By the 1850s, steamboats were stacked three deep for a full mile along the St. Louis levee. River trade in both passengers and freight was booming when the Civil War broke out in 1861. Soon after, trade with the South along the lower Mississippi was completely blockaded. Although a slave state, Missouri did not secede, but St. Louis was too far south to be an effective trade hub for the Union. St. Louis' archrival, Chicago, was left to capitalize on these northern routes.

After the war, as the South recovered slowly and steamboats were steadily losing business to railroads, St. Louis turned instead to the booming American Southwest, developing an extensive railway trade. The later nineteenth century presented a continuing reign of prosperity for St. Louis, as transportation connections made the city a natural center for warehousing and wholesaling, and civic boosters touted St. Louis as "The Future Great City of the World." By the turn of the century, St. Louis was the fourth largest city in the nation and could boast of being among the nation's largest producers of apparel, cotton, bricks, tobacco, and beer. "First in shoes, first in booze, and last in the American league," went the saying (the last, a dig at the old St. Louis Browns baseball team). It seemed like a good time to celebrate.

For seven months in 1904, St. Louis hosted the Louisiana Purchase Exposition, the World's Fair commemorating the centennial of Jefferson's historic purchase. The city created in Forest Park a wonderland of fanciful plaster palaces, complete with perfumed fountains and an artificial canal system for gondola rides. The whole nation sang "Meet me in St. Louis, Louis," and visitors came from around the world. Several quintessential American foods had their debut here: hot dogs, ice-cream cones, and iced tea. To the strains of marching bands and Scott Joplin's ragtime, the Fair marked the end of the American Gilded Age.

The twentieth century was one of ups and downs for St. Louis, true to her boom town roots. Today, St. Louis is an amazing blend of cultures, ethnicities, and history; where quaint historic neighborhoods of nineteenth century red-brick town homes sit a few minutes from soaring late twentieth-century skyscrapers; where a neoclassical 1850s courthouse is beautifully framed by a strikingly modern, stainless steel monument. The Gateway to the West is still a major transportation hub—now for trucks and planes, as well as for barges and rail—and a headquarters for major corporations in the biotech, healthcare, aerospace, and, of course, brewing industries.

The "strong brown god," as Eliot called the Mississippi, has raced alongside St. Louis for over 230 years; photography has existed for only the most recent 150 of those years. *St. Louis Then and Now* pairs images from the late 1800s and early 1900s with contemporary photos to show the evolution of a city, from a frontier trading post on the edge of "civilization" to the twenty-first-century city of St. Louis.

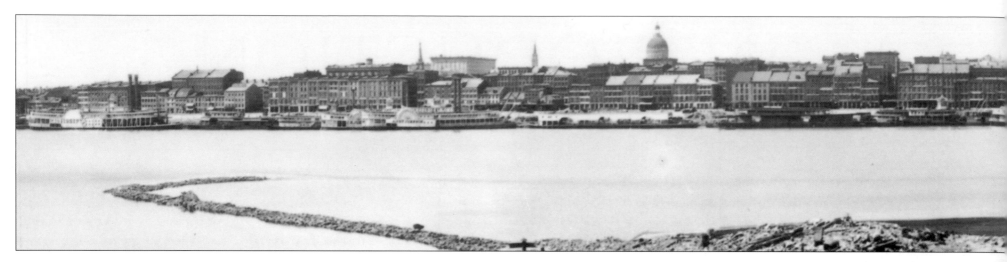

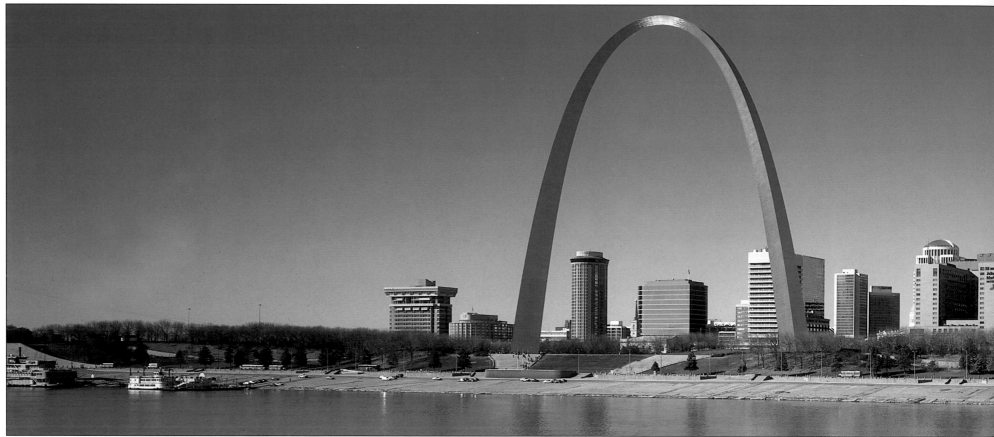

Top: Panorama of St. Louis taken from Illinois, 1867. In this era of four- and five-story buildings, the Old Courthouse dominates the skyline. The steeple of the Old Cathedral is also a marked presence at left. At the end of the Civil War, St. Louis' historic downriver trading partners lay in ruins. Note the absence of steamboats. In the years following, the city focused on an expansion of rail trade with the booming American Southwest. By the turn of the century, St. Louis had undergone a nearly complete conversion from a river-based commercial city to a railway-based industrial center.

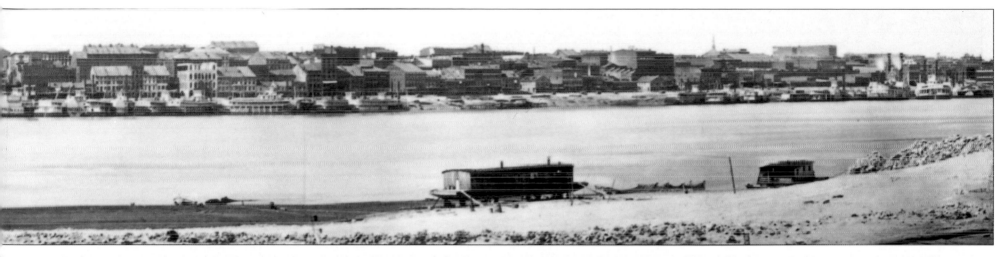

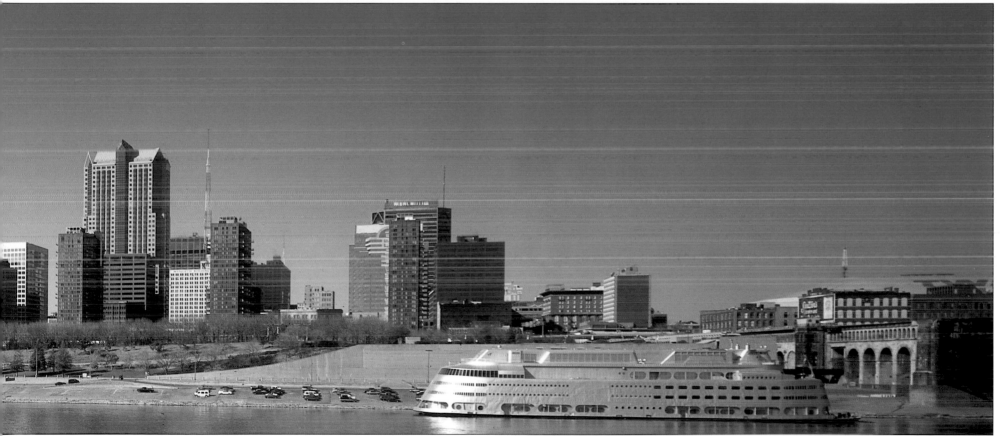

Above: Today, the Gateway Arch, monument to St. Louis' historic role in westward expansion, dominates the skyline. The Old Courthouse and Old Cathedral are respectively blocked and dwarfed by surrounding skyscrapers. The formerly commercial waterfront is now a park at the foot of the Arch. In the centuries-old tradition of gambling on the river, the restored 1930s Art Deco pleasure cruiser, the *Admiral*, is home to a casino. At right the Metropolitan Square building with the gabled roof soars to forty-two stories; at six hundred feet (just thirty below the Arch), it is St. Louis' tallest building.

Below: Looking north, 1890. The landing of the *Zebulon Pike* on St. Louis' shores in 1817 had initiated the steamboat era. By Mark Twain's time on the Mississippi in the 1850s, such steamers were stacked three deep and a mile long on the levee, and antebellum St. Louis was the nation's third-largest port. By 1890, railroads had surged to the fore, and although triple-decker steamboats still ran on the river, low-slung barges were the frontrunners in freight hauling as they allowed easier loading to and from rail cars. Note the railroad tracks running the length of the waterfront and the Eads, a railroad bridge, in the distance.

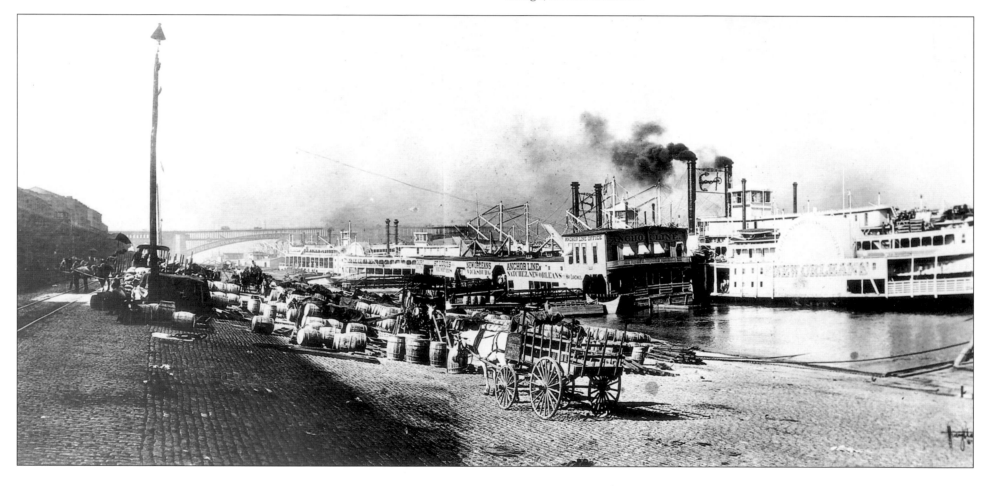

Right: Today, the waterfront is recreational. In the 1930s, the city razed much of the warehouse district, which had become badly rundown. The railroad tracks were moved underground, and plans were made for a Jefferson National Expansion Memorial, commemorating the Louisiana Purchase and westward settlement. Today, the levee is lined by a floodwall. In the water is the *Admiral*, an Art Deco showboat from the 1930s, now converted into a casino. The pinky-gray cobblestone wharf slopes into the Muddy Mississippi, a vestige of the riverfront's commercial past.

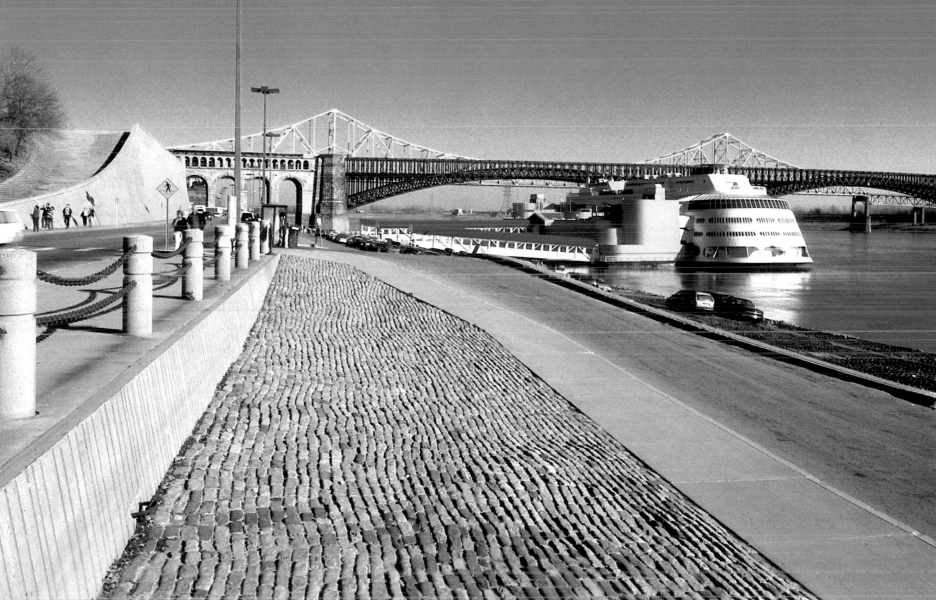

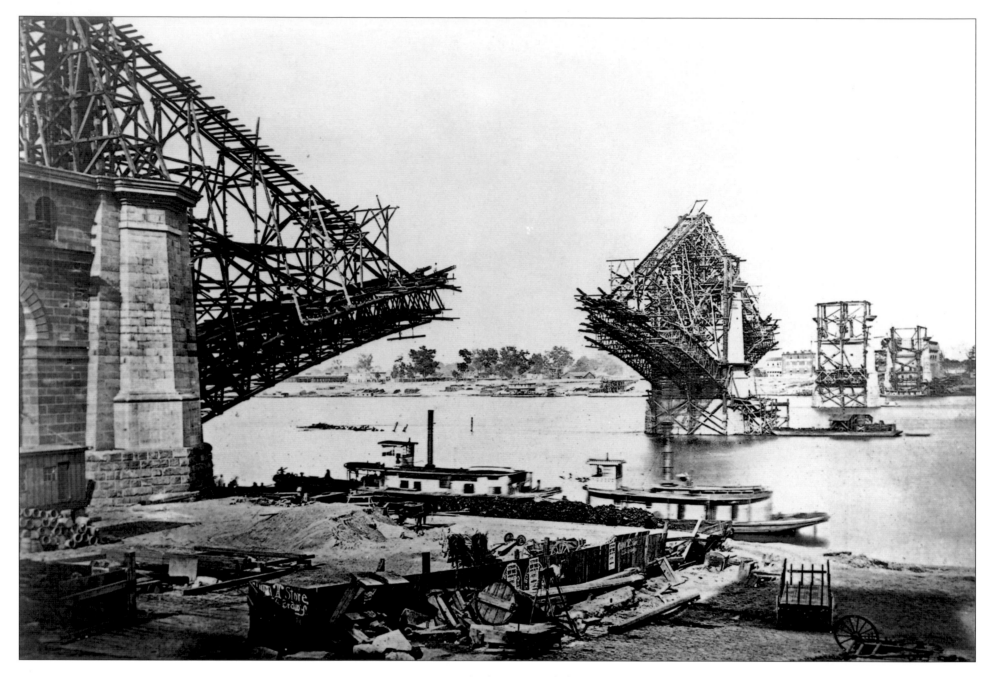

St. Louis had recognized the need for a bridge as early as 1839, but plans for spanning the Mississippi River were cost prohibitive, and steamboatmen opposed anything that might block up the already crowded waterway. Eventually the Civil War intervened, and thus for the better half of the nineteenth century, the only way across the Mississippi at St. Louis was by expensive and delay-ridden ferry. The city finally agreed on a bridge design by river salvage expert and battleship engineer James B. Eads, and construction began in late 1867. The bridge was to be a pioneering feat of engineering in several respects.

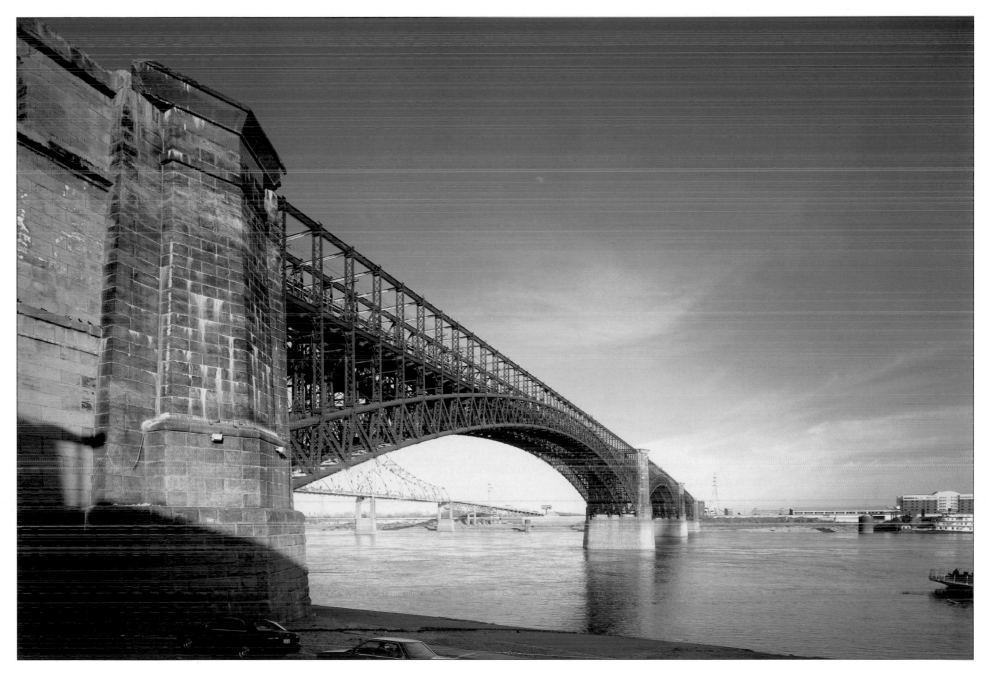

Today, the Eads Bridge is still a marvel of engineering. Eads designed the world's first steel trusses (steel was then an experimental metal), allowing him to cross the river in just three spans. He further accommodated boat traffic by foregoing construction scaffolding with a novel plan: spans were built out from central piers simultaneously in both directions. Thus balanced, there was no need for scaffold. Pneumatic caissons, the first used in the United States, allowed sound mooring of piers on the bedrock beneath the river's shifting sands. On May 24, 1874, a Sunday, the bridge opened to the public, and 25,000 people crowded the upper deck in celebration.

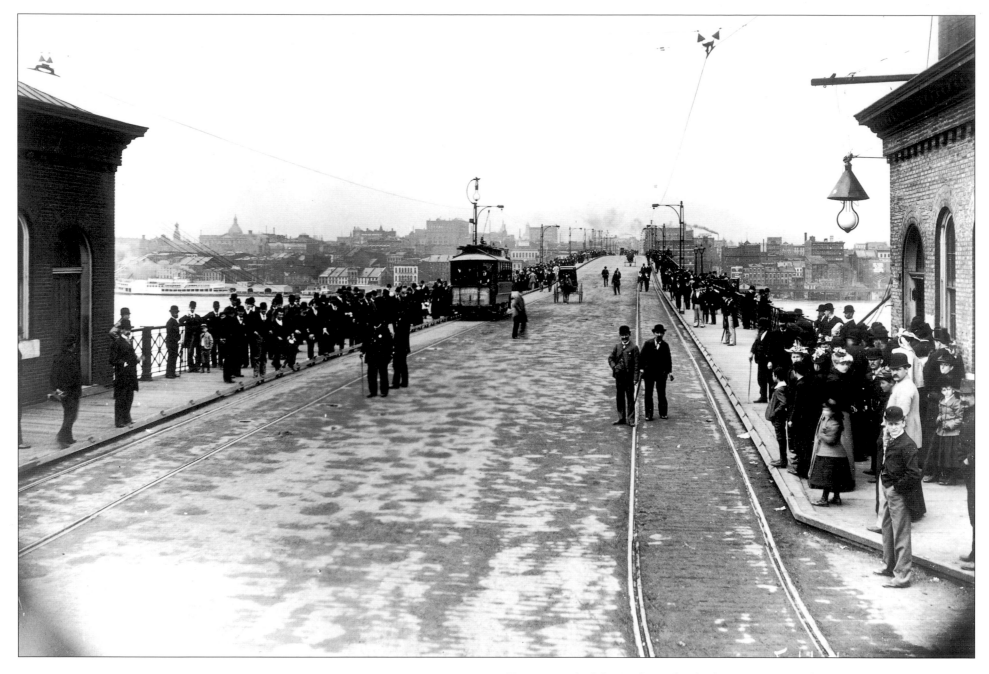

Eastern end of the Eads Bridge looking west toward St. Louis, circa 1903. Almost thirty years after its construction, the Eads Bridge was busier than ever. Beneath this pedestrian/streetcar level, the bridge supported a double railroad track that ran from the east through a tunnel under Washington Avenue out to the industrial Mill Creek Valley area. The waterfront was lined with commercial warehouses, with the Old Courthouse dominating.

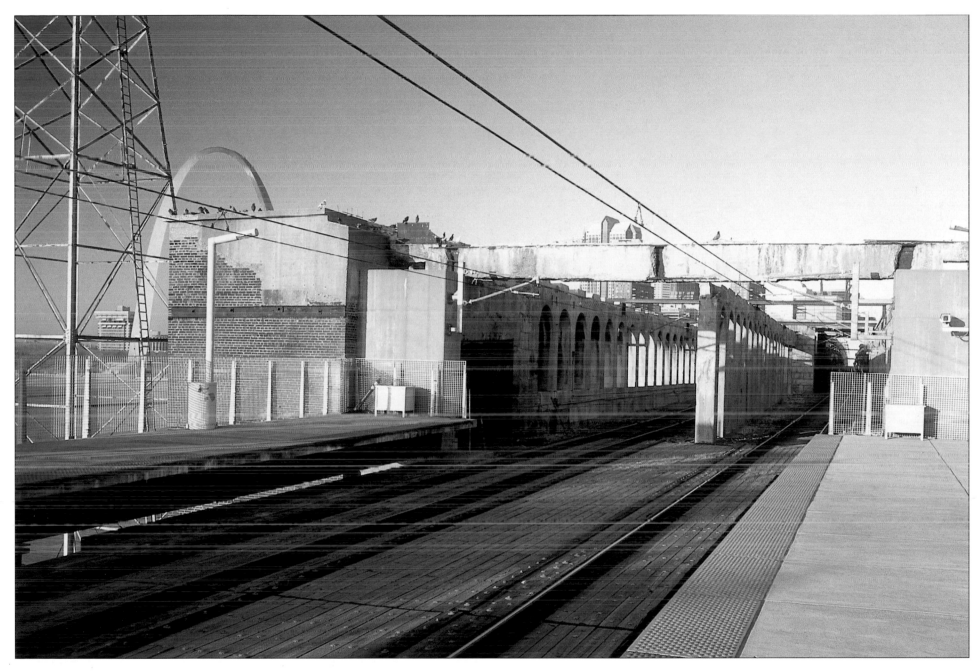

Eads Bridge was St. Louis' first rail bridge, but several others followed it, competing for traffic. Eventually, trains became too heavy for the aging bridge and too wide to fit through the Mill Creek Valley tunnel. Eads was closed to train traffic in 1974, exactly one hundred years after its opening. Today, the pedestrian level is gone, but the tracks and tunnel have been put to good use by the St. Louis public transit light-rail, the MetroLink.

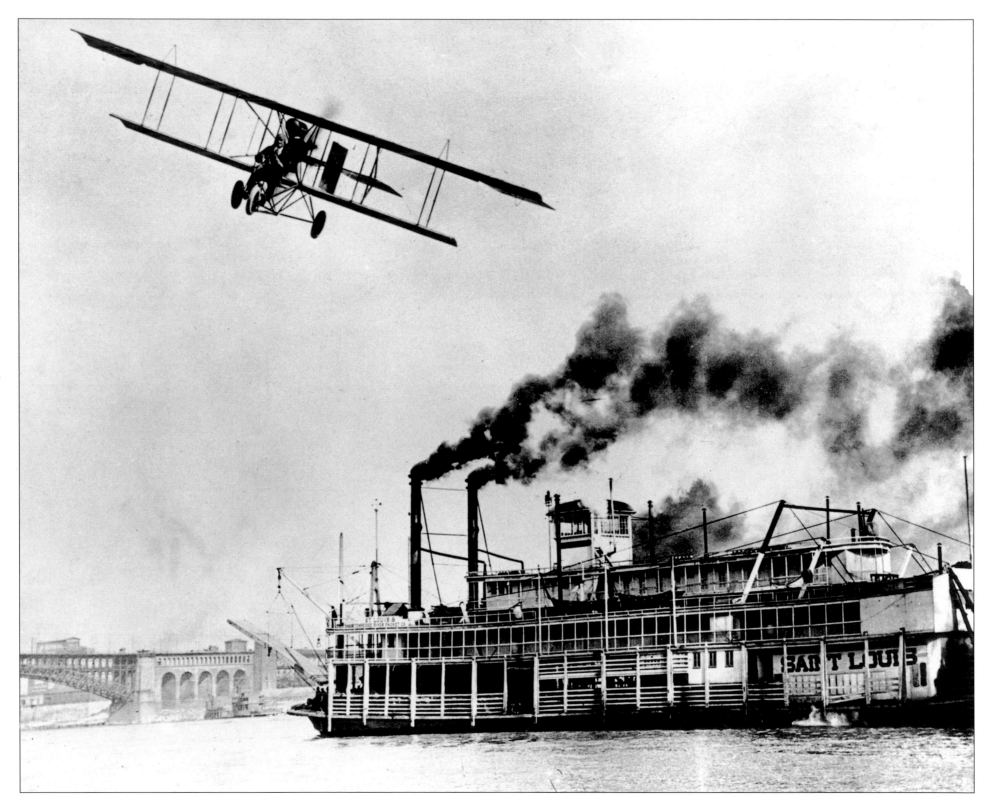

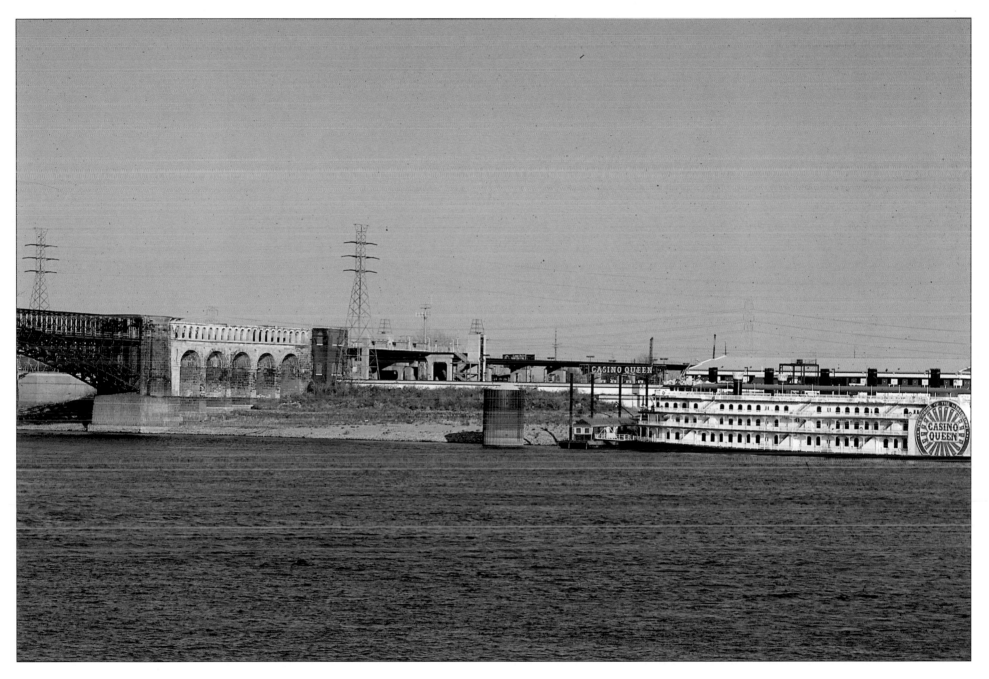

Left: The first airplane flight over the Mississippi River occurred in St. Louis in 1910, when Thomas Scott Baldwin flew his plane the *Red Devil* over and under the Eads and McKinley bridges. The history of aviation was again linked to St. Louis when a consortium of St. Louis businessmen, headed by A.B. Lambert, raised the money for a transatlantic flight attempt by an unassuming airmail pilot.

Above: Charles Lindbergh, then flying the route between St. Louis and Chicago, flew the *Spirit of St. Louis* all the way to Paris, becoming on May 21, 1927, the first aviator to cross the Atlantic. Today, the jets of Trans World Airlines, headquartered in St. Louis, streak past above the clouds and land at Lambert International airport. The only steamboats today are pleasure cruisers and gamblers, like the *Casino Queen* pictured here.

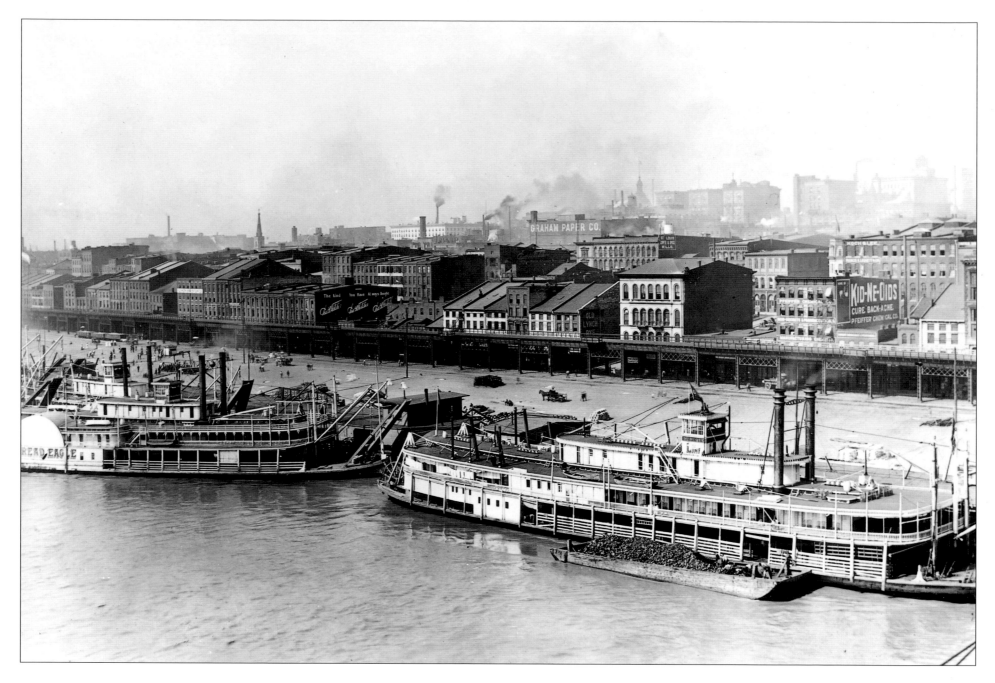

From the Eads Bridge, 1904. Freight-bearing steamboats and barges are positioned for the transfer of goods to and from rail cars. The flag-flying cupola of the Old Courthouse is barely visible in the midday smoke. By the turn of the century, soft black Illinois coal (note the off-loaded pile on the foreground barge) took its toll on the city's air quality. Those who could, moved west away from the smog. Finally on Tuesday, November 28, 1939, the city witnessed "midnight at noon," and local papers reported that no one knew what time the sun had risen, if it had at all.

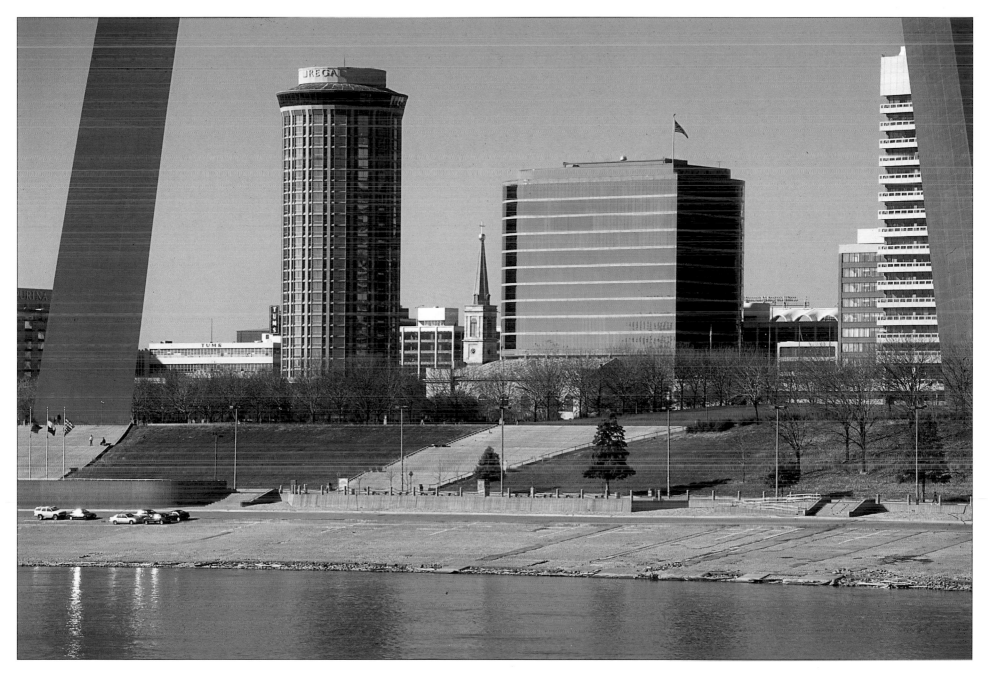

Black Tuesday, as it was called, goaded the politicians into action, and air quality measures were finally enacted. Today, St. Louis ranks substantially below the national average for air pollution. The once bustling industrial waterfront was transformed in the 1960s into lush green parklands, protected by floodgates, and crowned by the Gateway Arch, whose stainless steel legs bracket this scene. The cobblestone wharf, punctuated by huge links of old chain for anchoring, is a vestige of the riverfront's commercial past. Skyscrapers now hide the Old Courthouse, but beside the blue-green MCI Building, the Old Cathedral is visible.

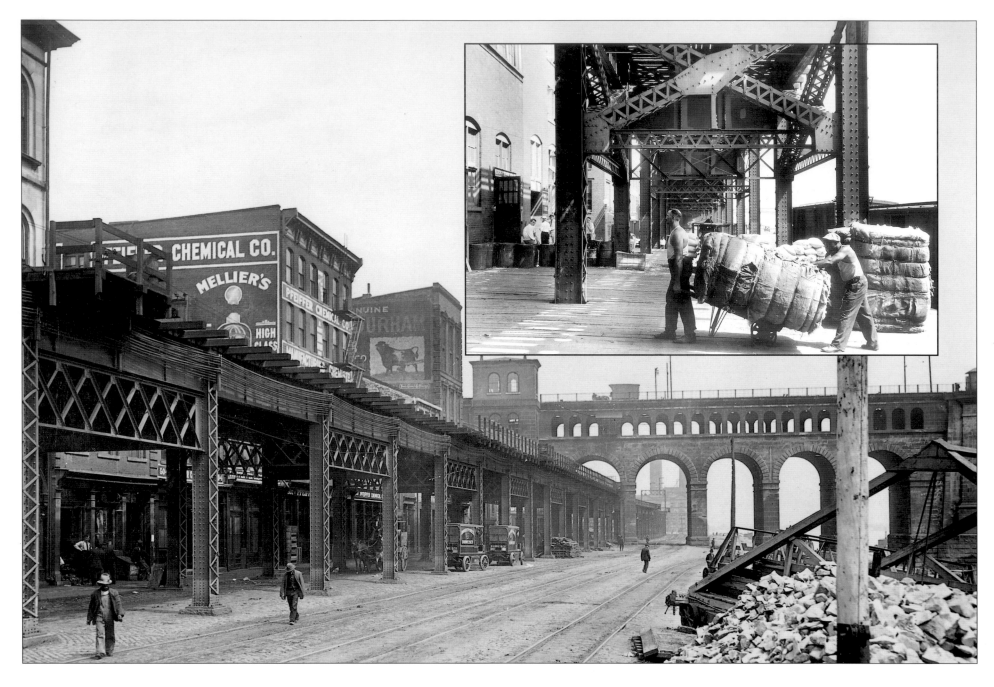

Circa 1904. Despite a terrible tornado and growing pains as the city's economy shifted from raw materials to light manufacturing, business was booming on the turn-of-the-century waterfront. Big piles of rubble everywhere were signs of construction and paving, as the city cleaned up for the 1904 World's Fair.

Inset: Even in 1935, cotton bales were still transported manually from freight cars to the point of processing. Thanks to local cotton compression facilities that allowed bales to be flattened for rail shipment, St. Louis had become the largest interior cotton market in the world.

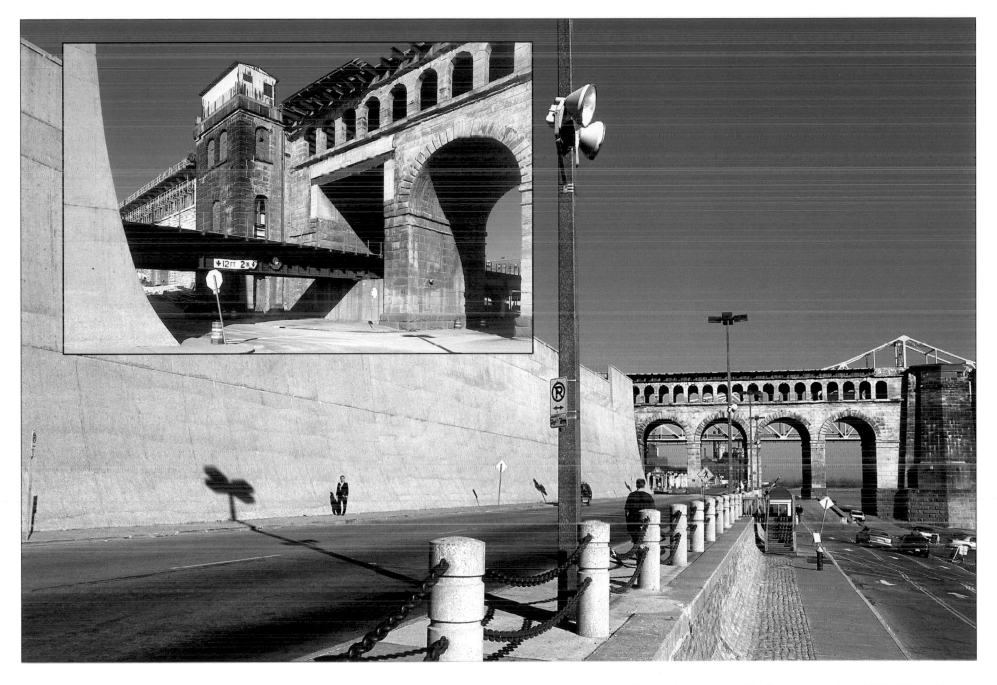

The elevated tracks of the Terminal Railroad Association that paralleled the waterfront were moved underground in 1949 as part of the waterfront redevelopment project. Today, a giant floodwall stands in their place. The classic curves of the Eads Bridge still grace the wharf, although the bridge today hosts the city's light-rail transit system. Beyond it stands the Martin Luther King Bridge (formerly Veterans' Bridge), opened in 1950. Wharf Street has been renamed in honor of U.S. congresswoman Leonor K. Sullivan, but the lengthy new name is rarely used. *Inset:* St. Louis' gritty industrial history is glimpsed in this closeup of the Eads with a piece of the underground rail visible.

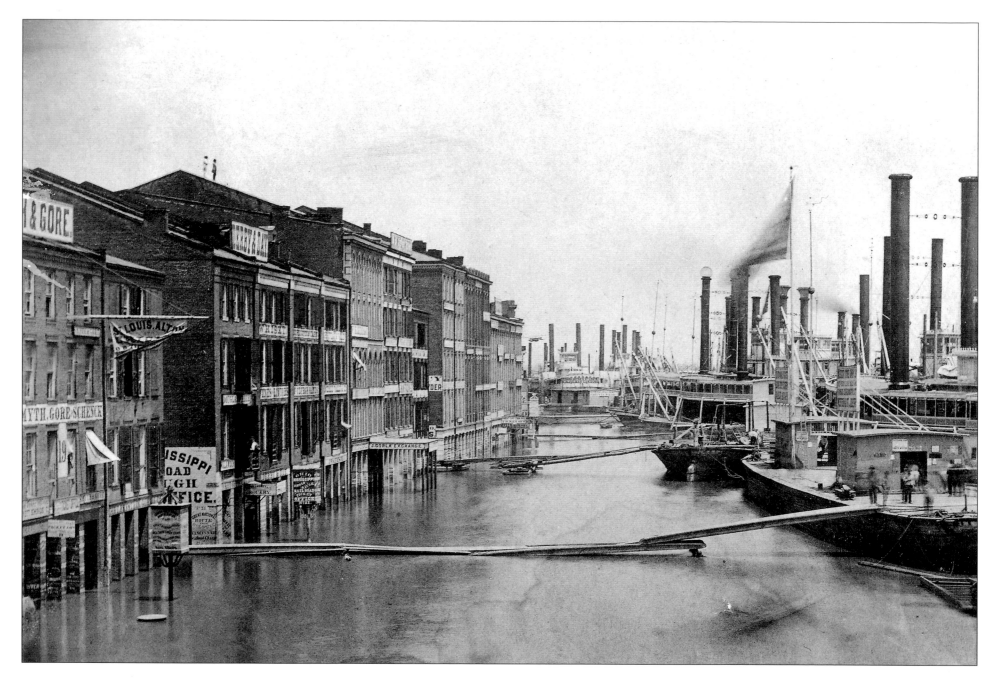

High water at St. Louis, June 15, 1858. The capricious river that gave
St. Louis her fortune as a trading center, frequently threatened to overflow
the city as well. The city's limestone bluffs initially afforded some measure of
protection; however, by the mid-1800s, the soft stone had been cut almost
entirely away for construction. Here, the steamers are practically tying up to
the buildings on First Street as two men on the rooftop look on. Fourteen
years earlier, during the Great Flood of 1844, the river created something of a
freshwater sea, stretching twelve miles wide and rising even beyond Second
Street.

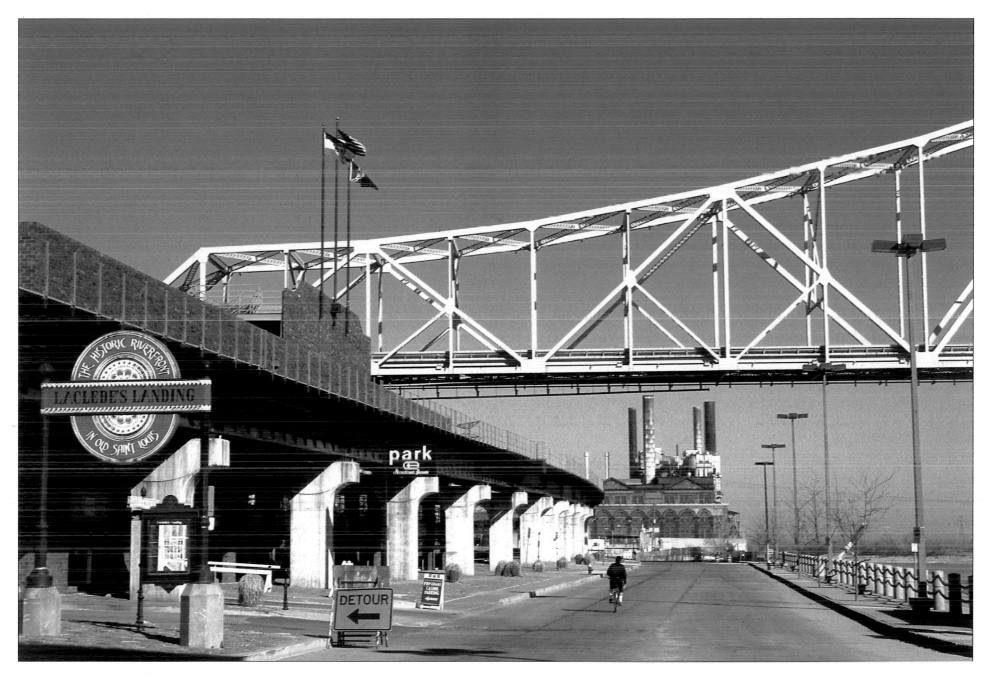

Before the advent of modern engineering, St. Louis was completely at the mercy of the "Mighty Mississippi," but even the floodwall installed during the Arch construction may not always contain the river. During the Flood of 1993, the waters crested that August at forty-nine feet, seven inches, just a few inches below the floodgate's edge. Eleven times the volume of Niagara Falls was flowing under Eads Bridge; enough to fill Busch stadium every 65 seconds. Today, this area north of Eads Bridge is home to Laclede's Landing, a three-by-three block stretch that preserves the waterfront's original Creole street layout and nineteenth-century warehouse district buildings.

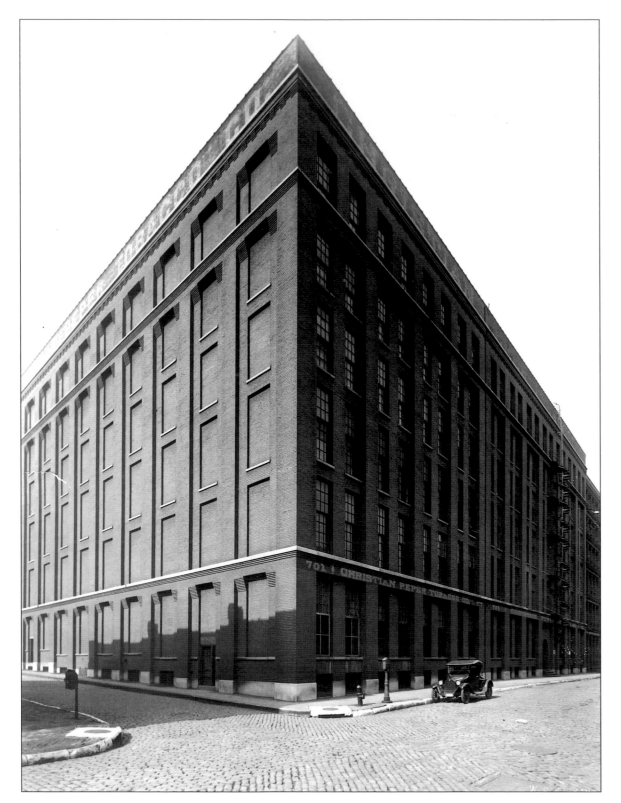

Main and Morgan streets, circa 1925. Tobacco was grown in Missouri with slave labor, and antebellum St. Louis was the nation's leading producer of pipe and chewing tobacco. After the end of slavery, the tobacco industry still flourished in St. Louis until the twentieth century. In 1878, a fifty-year veteran in the St. Louis tobacco industry gained a partner, and Liggett & Myers became the largest manufacturer of plug tobacco in the world. Shown here is an 1898 brick warehouse, one of the four Christian Peper Tobacco Company buildings. Today, this building houses the Bi-State Development Agency.

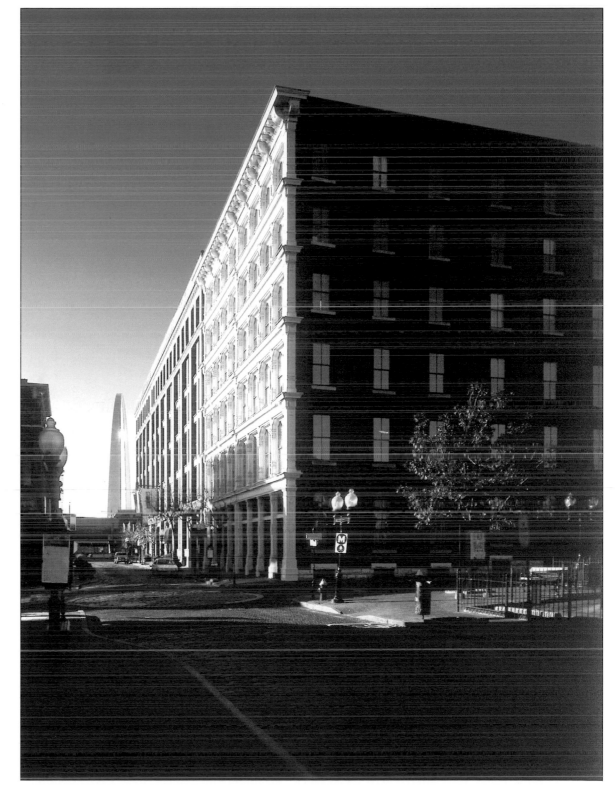

This view south down First (Main) Street shows the 1898 Christian Peper in the distance, and, at right, another famous Peper building. Designed by Frederick Rader, and built in 1873–4, Rader Place with its six-story, cast-iron facade, is recognized as one of St. Louis' architectural treasures. The surrounding area, Laclede's Landing, named after city founding father Pierre Laclede, retains its nineteenth-century commercial and warehouse buildings and its eighteenth-century street layout north of Eads Bridge. All other waterfront industrial structures were razed for the Archgrounds. With its original cobblestone streets, brick walks, and quaint gaslamps, Laclede's Landing is now home to upscale office space, shops, restaurants, and bars.

Left: Flood, June 10, 1903. More easily unloaded onto rail cars (note the elevated tracks), barges were increasingly taking over the riverfront. By the1930s, all the old warehouses seen here had become (or at least were deemed) derelict and razed. The railroad was moved underground, a change in grade that allowed for the construction of a much-needed floodwall. On the formerly industrial waterfront was planned the Jefferson National Expansion Memorial to the city's historic role as "Gateway to the West." In 1948, Finnish architect Eero Saarinen won a design competition with his modified catenary arch, roughly the shape made by a chain dangling from two points.

Right: Today, this view is taken from atop the fifty-foot floodwall, completed with the Archgrounds. In the background is the Poplar Street Bridge, built in 1967, and behind it the MacArthur. Due to funding troubles, the Gateway Arch was not begun until 1963, when the necessary $13 million was raised. At its completion in 1965, it instantly became a national tourist attraction. Trams run inside the stainless steel legs up to the viewing deck, 630 feet in the air. Below ground lies the Museum of Westward Expansion, opened in 1976, housing artifacts from Thomas Jefferson's historic purchase of the Louisiana Territory and the difficult exploratory voyage of Lewis and Clark.

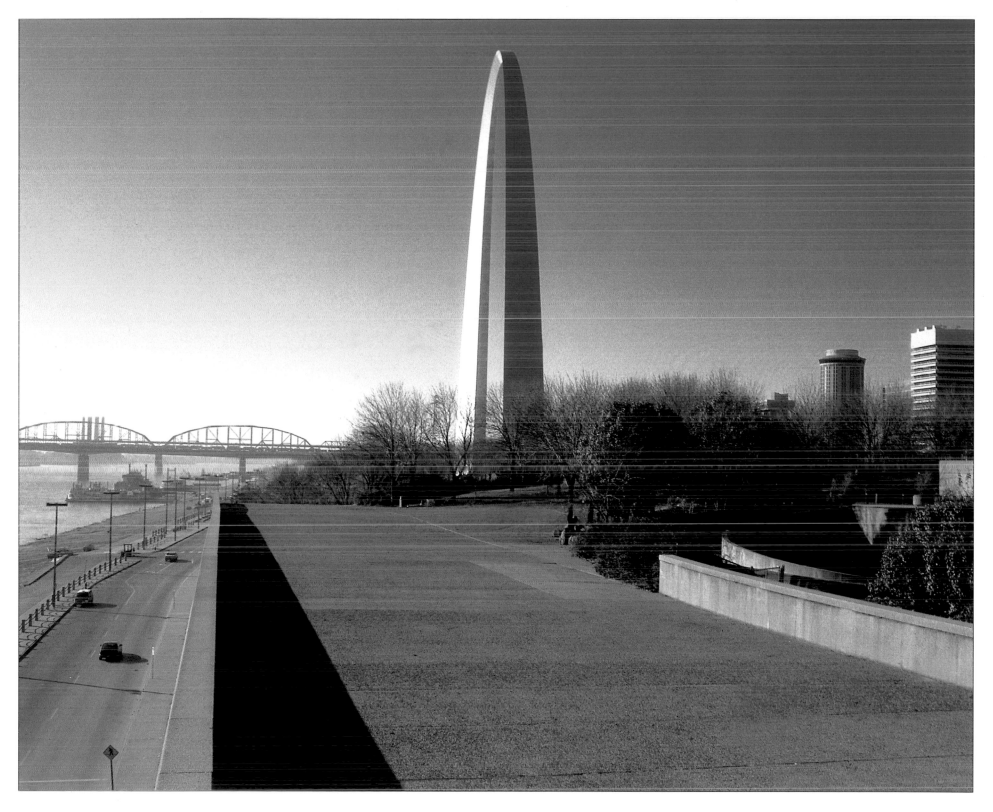

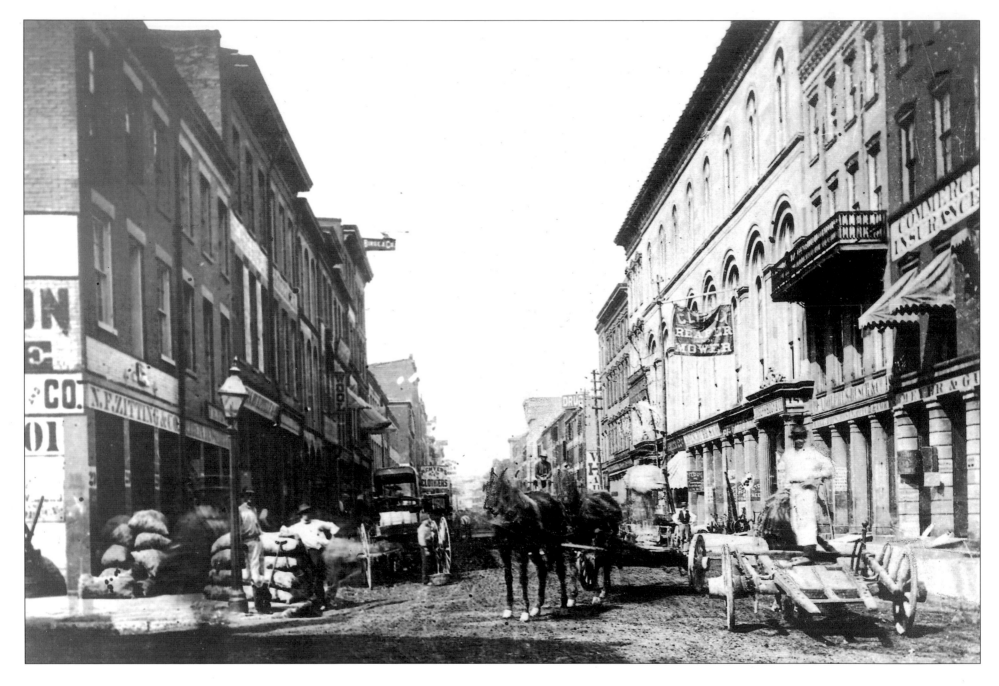

Main (First) Street from Walnut, 1874. The waterfront was a gritty, bustling commercial hub. After the Great Fire of 1849, wholesale and commission houses relocated a block back from Front (Wharf) Street to Main and were rebuilt almost exclusively in fireproof brick. The 1850s witnessed huge leaps in population and construction. Curbs and sidewalks were added to downtown streets, but cobblestone paving was often coated in mud from flooding and damaged by the load-bearing mule-wagons and horse-drawn passenger omnibuses. The 1870 census declared that after New York, Philadelphia, and Brooklyn (then a separate town), St. Louis was the fourth largest city in America.

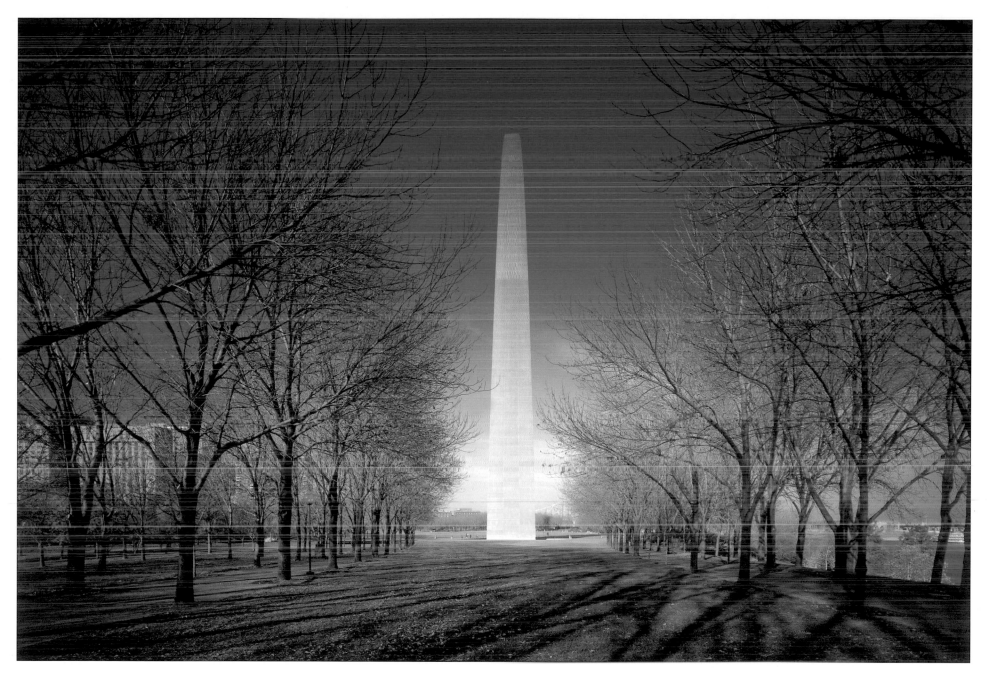

Today, this spot falls just below the southern leg of the Arch and affords an unusual view of the monument, here appearing almost like an obelisk. As the population moved westward away from the dirt and noise of downtown, the old commercial center gradually fell into disrepair. In those days before historical preservation was a popular concept, throughout the 1930s, the city tore down the "seedy tenements and warehouses," forty blocks in all to make way for the grassy parkland of the Jefferson Westward Expansion Memorial. Only the Old Cathedral was spared. The city had demolished part of her past, but had constructed in the Arch a new symbol for the city.

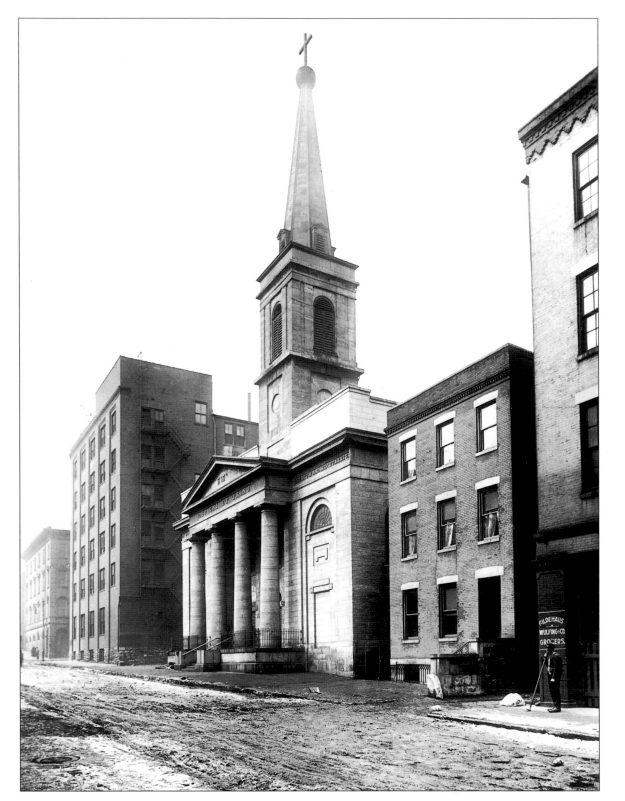

Cathedral of St. Louis, Walnut Street at Third (Memorial), circa 1900. This early example of Greek Revival architecture, the oldest cathedral west of the Mississippi, was built in 1834. Pierre Laclede himself reserved the land for this purpose at the city's founding in 1764. The first church was a small wooden structure built in 1770; it was soon rebuilt in larger form. When Bishop Louis Dubourg arrived in 1818, the second wooden church was replaced with brick. Finally, in 1831, construction began on the stone church, built of native Missouri limestone. It was one of the few buildings left standing after the Great Fire of 1849 (see page 4).

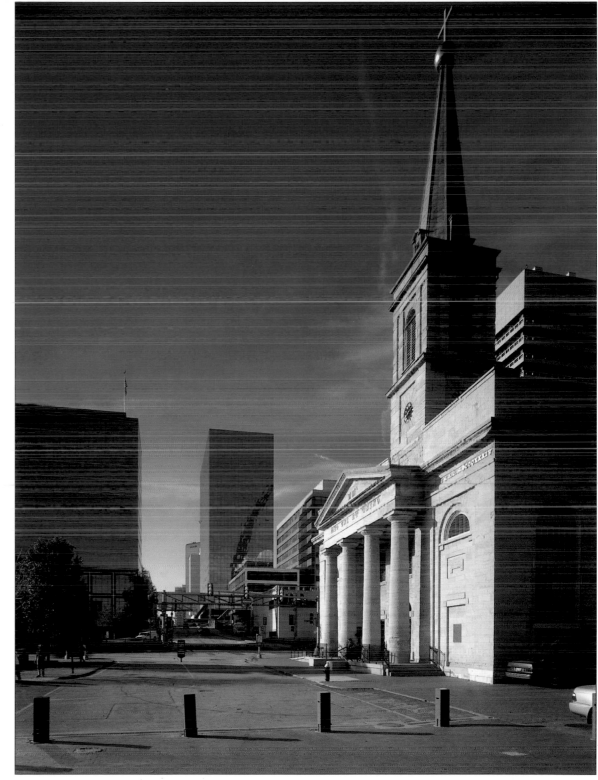

Today, the Old Cathedral is the only historic building that remains on the Jefferson Memorial grounds. While commercial brick buildings crowd it in the 1900 photograph, today the church's verdigris steeple, gold ornaments, and geometric proportions are stunning against the backdrop of contemporary skyscrapers. From the church interior, the classically arched windows afford lovely views of the Arch. In 1914, the title "cathedral" ceased when the new St. Louis Cathedral was consecrated on the western edge of the city. However, in 1961, Pope John XXIII designated this historic church the Basilica of St. Louis, but locals still call it simply the "Old Cathedral."

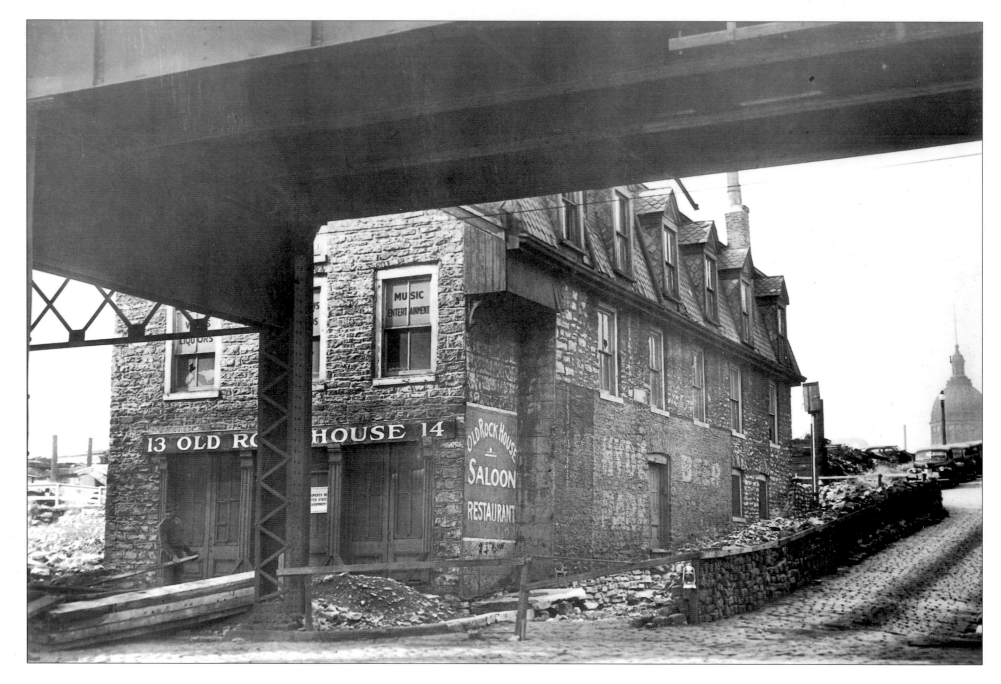

Chestnut and Main (First) streets, seen here in 1940 during waterfront clearing. Spanish fur-trader Manuel Lisa built the house sometime before 1816 as a warehouse for his badger, buffalo, and beaver pelts. The simple structure served that purpose until the 1880s, when the incongruous mansard roof was added, and the building became a saloon where notable blues musicians, like St. Louisan W.C. Handy, frequently performed. The Old Rock House, as it came to be called, was slated for dismantling when this photo was taken.

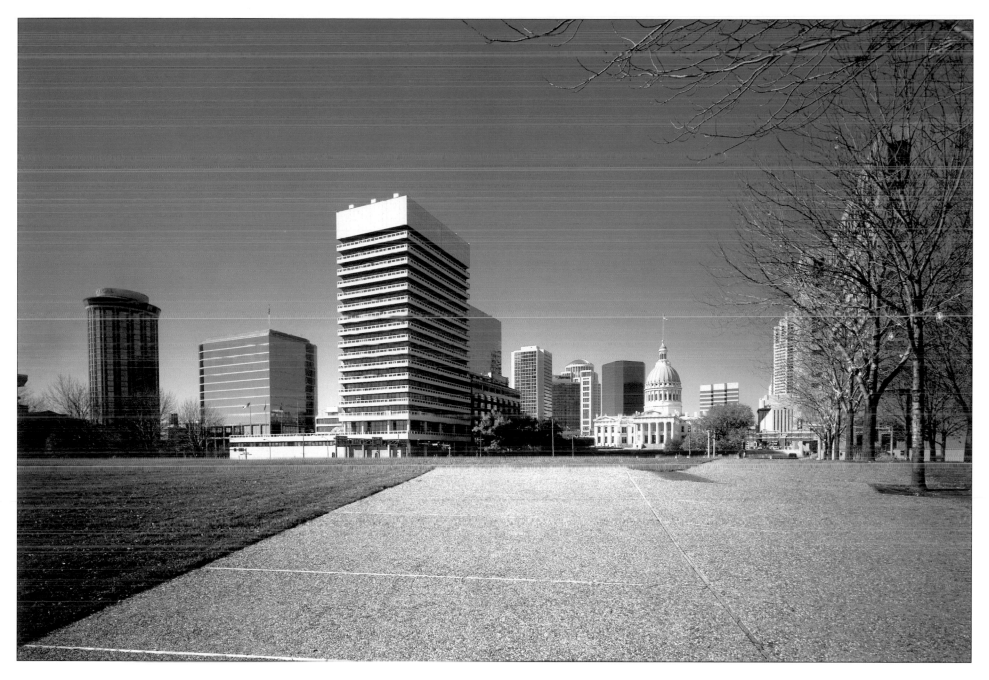

The National Park Service promised to reconstruct the house, but when the Jefferson Expansion Memorial was completed, the Old Rock House location was part of the Archgrounds. In any event, the house had been built of highly porous native limestone, and one historian estimates that only ten to twenty percent of the original stone remained after dismantling. Those original stones were incorporated into an exhibit, giving an idea of the building's construction, on display in the Old Courthouse seen here (*center right*).

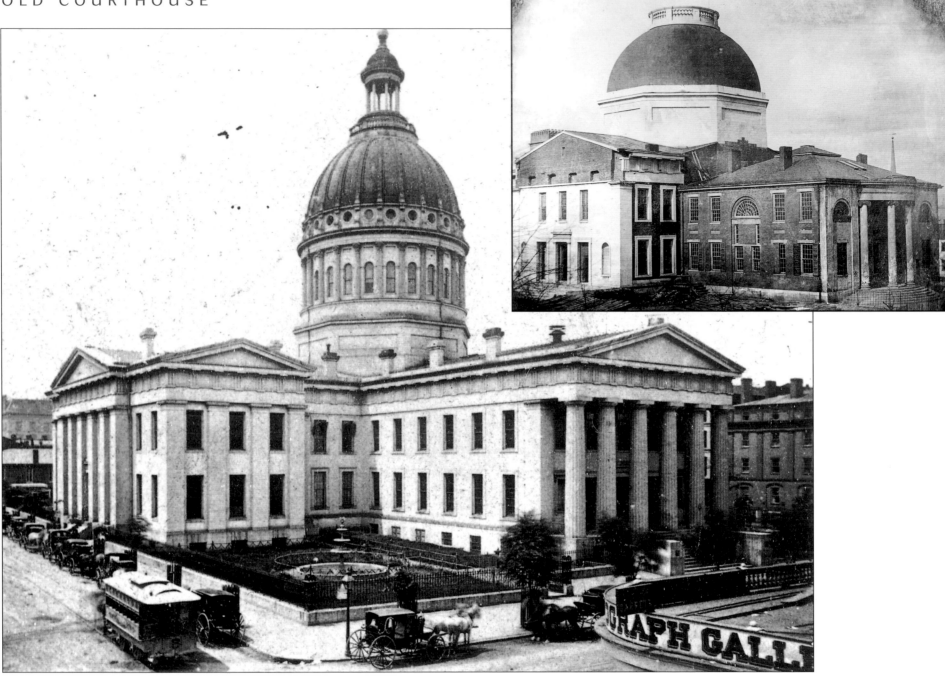

Stereograph circa 1865. The courthouse had been through several overhauls before it reached its eventual neoclassical "look." Around 1840, architect Henry Singleton retained the original 1820s courthouse on the site as the east wing of his new cruciform Greek Revival style building, which featured rounded portico and low cupola (*see inset*). Wings were demolished and annexes added throughout the 1850s, then in 1860, William Rumbold designed the taller, sturdier Italian Renaissance dome. Considered an engineering marvel in its day for its pioneering use of an iron shell, the St. Louis dome was the precursor of the cast-iron dome placed on the U.S. Capitol in 1865. Although many St. Louisans were opposed to slavery, slaves were auctioned from the very steps of the courthouse until 1861.

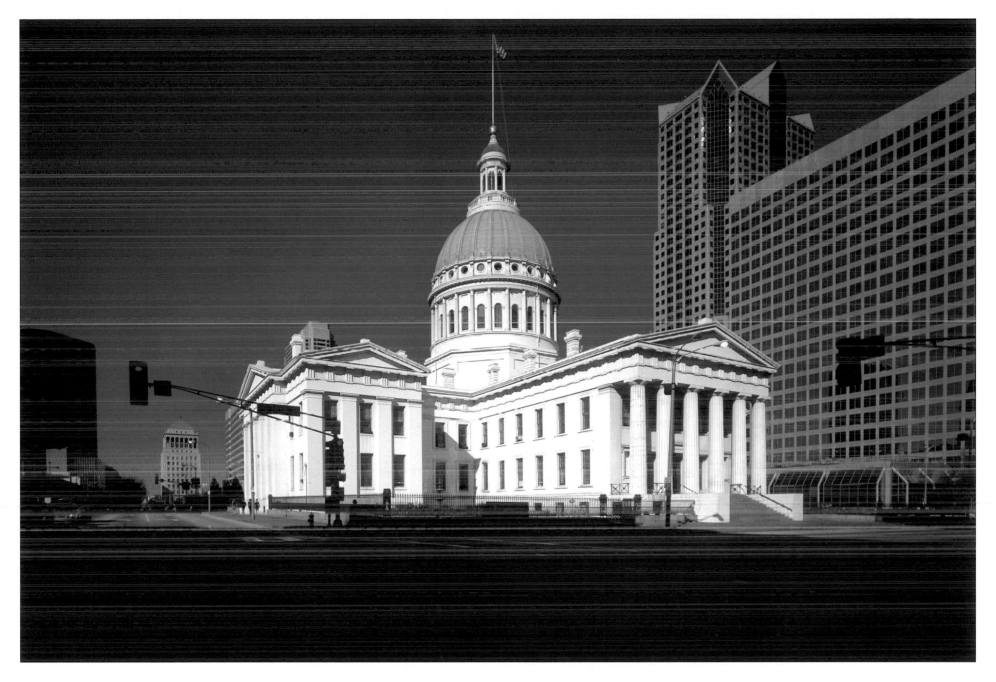

Today, the Old Courthouse is a St. Louis history museum and national heritage site. It was here that the two trials of Dred Scott were heard in 1847 and 1850. Scott, a slave, sued for his freedom on the grounds that he had once lived in a free territory. The case was appealed all the way to the U.S. Supreme Court, where it was decided in 1857 that Scott had never been free, despite living in a free territory, and thus had no right to sue in a U.S. court.

The decision, which opened the door to slavery in the west, outraged anti-slavery Americans and directly hastened the Civil War. Another civil rights trial of a national scale took place here in 1872, the Virginia Minor case for women's suffrage. It, too, went to the U.S. Supreme Court where it was struck down. It would be almost another fifty years before women attained the right to vote.

Left: Fourth Street south from Olive, Thomas Easterley daguerreotype, 1866. The newly installed Italian Renaissance-style dome on the Old Courthouse dominates the city's skyline. St. Louis in the 1860s was a city of predominantly four- and five-story brick buildings, the maximum then possible with contemporary building materials. Space was at a premium, the population was doubling, and the 1870 census would place St. Louis fourth largest in the nation with 310,000 inhabitants. By 1859, the horse-drawn omnibuses were toting 14,000 passengers daily, and streetcar tracks had just been installed.

Right: Today, space is still at a premium along Fourth Street, but buildings here are now considerably taller. The twenty-one story Equitable Building, built in 1971, reflects the Old Courthouse in its mirrored glass. Five years later, the same architects, Hellmuth, Obata, & Kassabaum, designed the Boatmen's Bank Tower (now NationsBank) to the north of the Old Courthouse (appears pinkish in the photo). The two reflective surfaces nicely frame their nineteenth-century neighbor. The street in the foreground now accommodates automobiles.

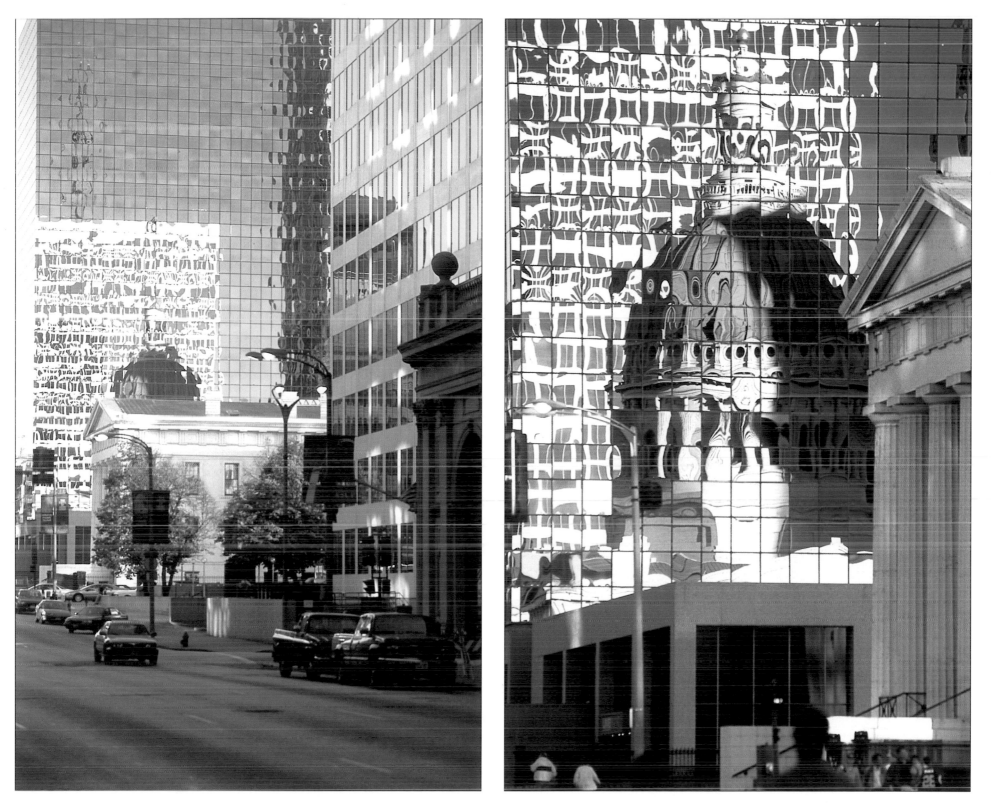

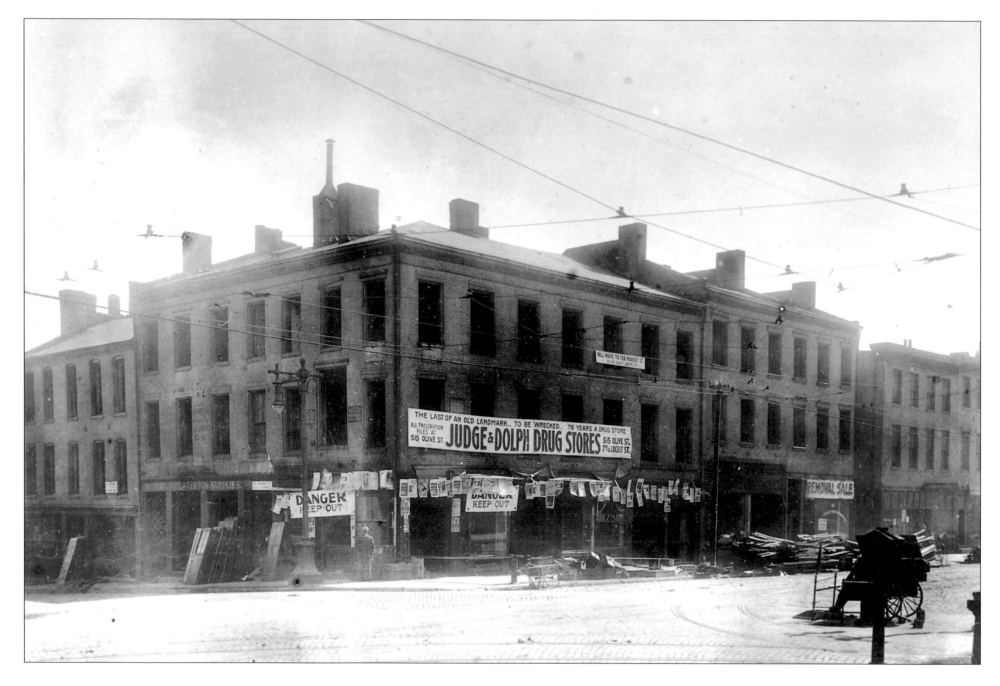

Fourth and Market, opposite the Old Courthouse, October 1911. St. Louis was founded in 1764 as a commercial center for the lucrative western fur trade. The fur trade foundered in the nineteenth century after beaver stocks were depleted and fashions changed. However, at the turn of the century, St. Louis was still the nation's primary fur market. Since the 1830s, this corner had been home to a drug store, but following a resurgence in fur fashion, it was purchased by the newly formed International Fur Exchange.

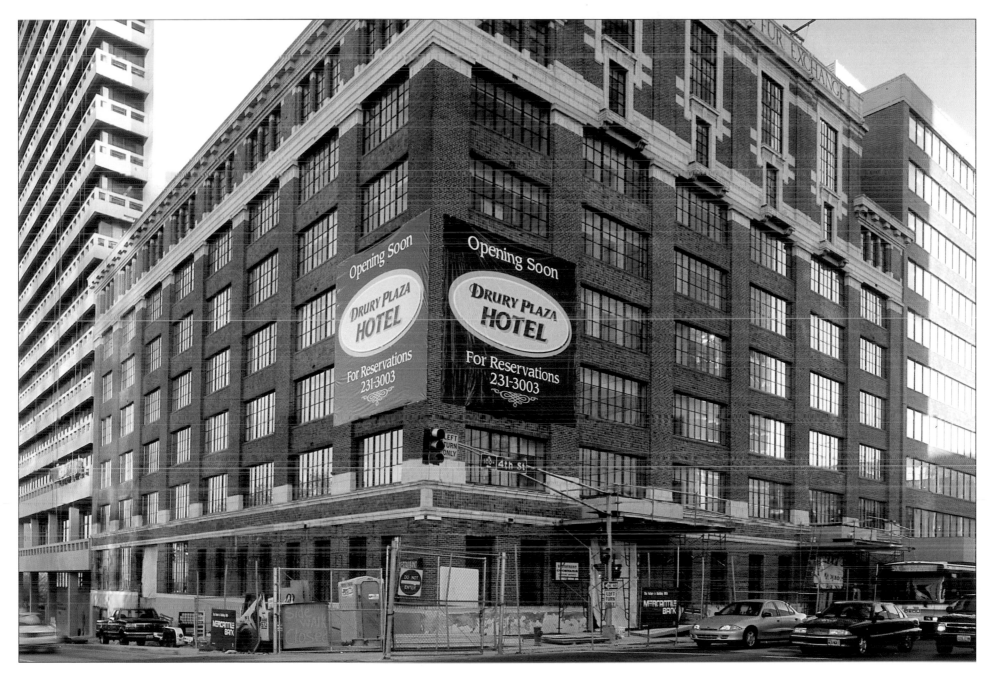

In 1919, fur-trader, and Exchange founder, Philip Fouke commissioned George Hellmuth
to design the seven-story International Fur Exchange Building seen here, complete with a
two-story auction room at the top and "unexcelled lighting facilities" for buyers to examine
goods. Today, the Fur Exchange Building and her neighbors, the Thomas Jefferson and the
American Zinc buildings (*right*), have been converted into the new Drury Plaza Hotel,
listed on the National Register of Historic Places.

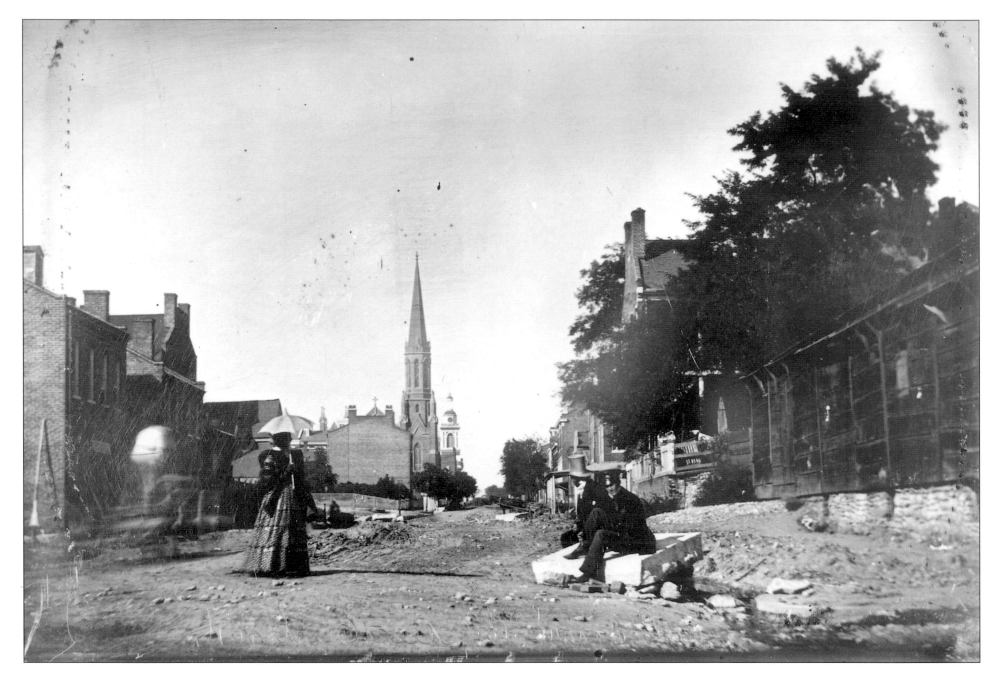

Daguerreotype of Ninth Street looking north from Chestnut, 1852. Antebellum St. Louis was a rapidly expanding boom town. Despite heavy losses from a terrible cholera epidemic and the departure of hundreds of young men for the California gold fields, from 1840 to 1850, St. Louis had increased in population by over 370 percent to almost 78,000. In the early 1850s, more than 13,000 buildings were under construction at any one time, and street-side construction rubble was so ordinary that pedestrians were accustomed to using chunks of granite slabs as public benches.

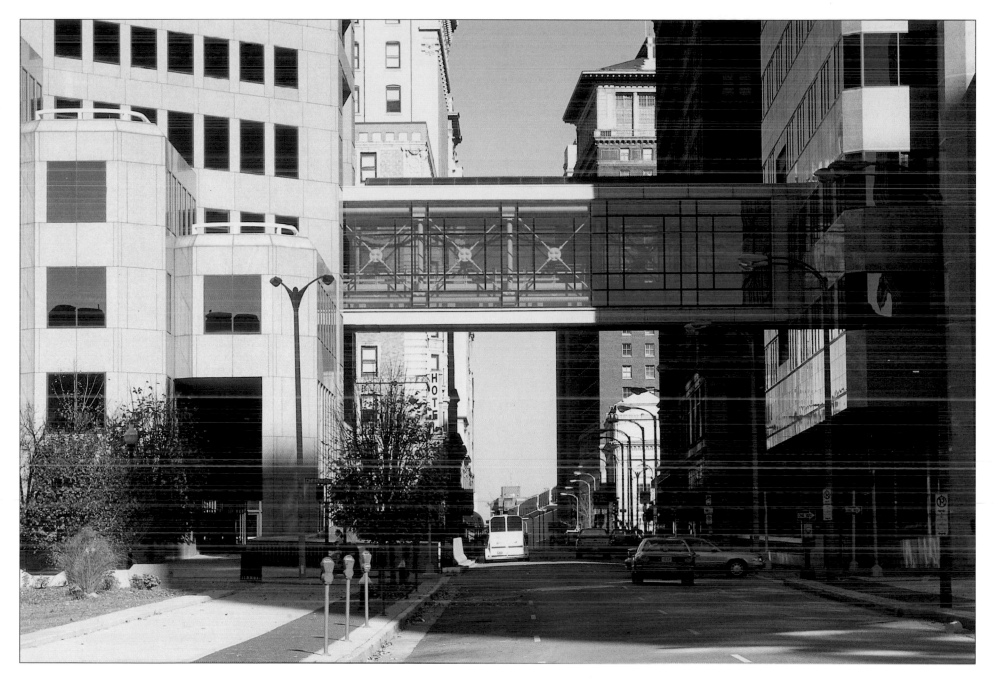

Today, the only recognizable feature is the street itself. In the 1850s, Ninth Street was mostly residential, a street where gentlemen in top hats rested along the walk and calico-clad ladies strolled toward church with parasols to protect the pallor of their skin. Today, Ninth Street is the heart of the business district. A glass-enclosed pedestrian overpass connects the One Bell (*left*) and Bell Data (*right*) centers of Southwestern Bell, headquartered in St. Louis until a few years ago, and still maintaining large offices. At center right stands the Arcade Building.

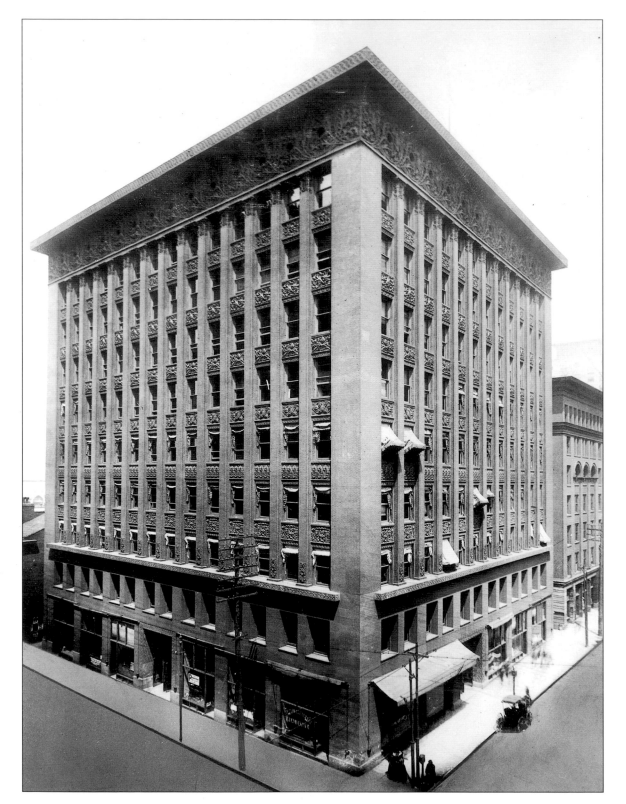

Northwest corner of Seventh and Chestnut streets, circa 1907. St. Louis businessman Elias Wainwright commissioned Chicago architect Louis Sullivan to design an office building in 1890. Until that time, commercial buildings had been constructed with masonry support or, even if framed in metal, preserved the look of masonry buildings. When completed in 1893, the Wainwright Building, with its all-steel internal frame and vertical upthrust, first captured the soaring spirit of the skyscraper. The facade is constructed of red sandstone and red Missouri granite, and is notable for its signature terra-cotta ornamenation.

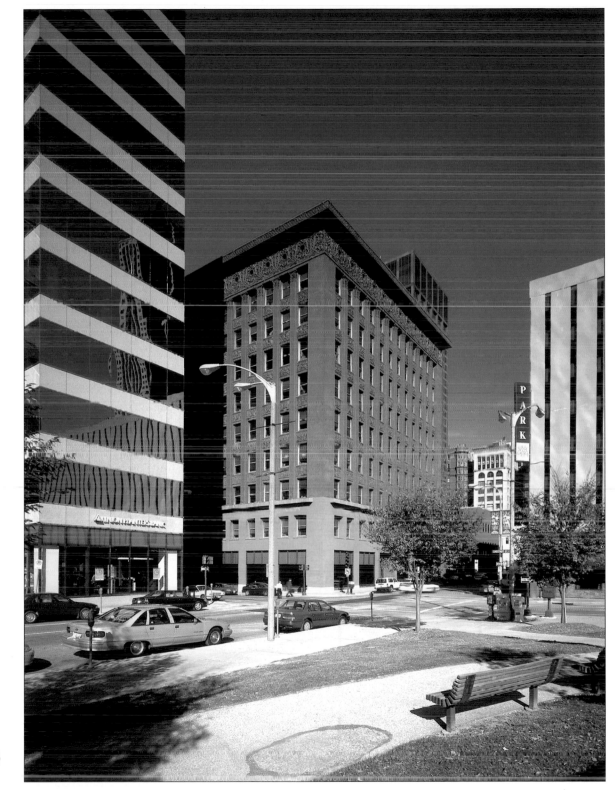

Frank Lloyd Wright, Louis Sullivan's student, called the Wainwright Building and Union Station, St. Louis' finest structures. In the Wainwright, despite brandishing a few old-fashioned touches like the cornice, Sullivan managed to create, in the words of Wright, "the tall building as a harmonious unit." The Wainwright was purchased by the state of Missouri in 1974; it now houses government offices. In the distance, we see one of the last cast-iron ornamented buildings in St. Louis, the Chemical Building (1896) with its oriel windows, and beside it another Sullivan creation, the former Union Trust Building (1893) with its Romanesque arches.

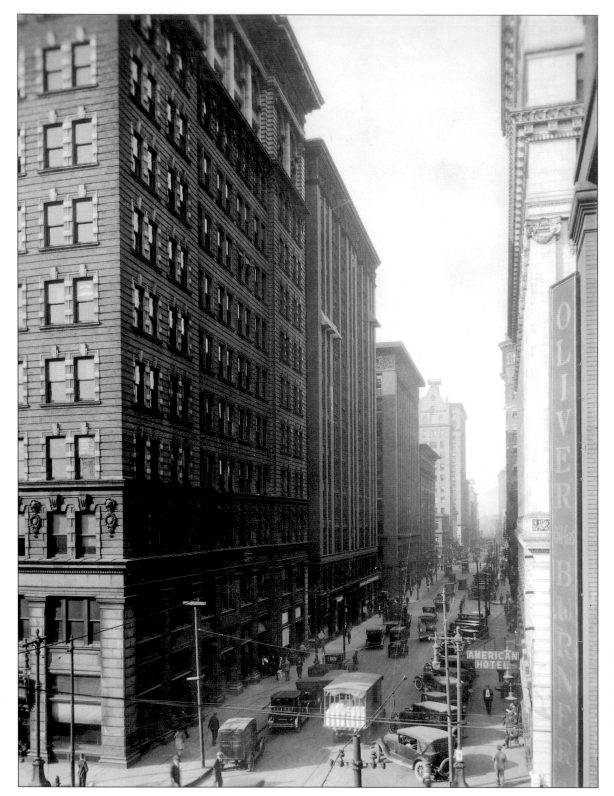

A view of Seventh Street looking north from Market, 1923. "Real Estate Row" featured the best of St. Louis' turn-of-the-century commercial architecture. Most buildings here stood around the twelve-story maximum then allowed by city ordinance and featured fugue-like themes in terra cotta. The massive, harmonious row, built within a decade, reflected the optimism of St. Louis in the Gilded Age. On the left corner stands the Buder Building, designed by W. Swasey and completed in 1902 as a headquarters for the Missouri Pacific Railroad. Next in is the Title Guaranty Building, completed 1899, designed by Eames & Young for the Lincoln Trust. The Wainwright (1892), Demenil (1894), and Union Trust (1893) round out the row.

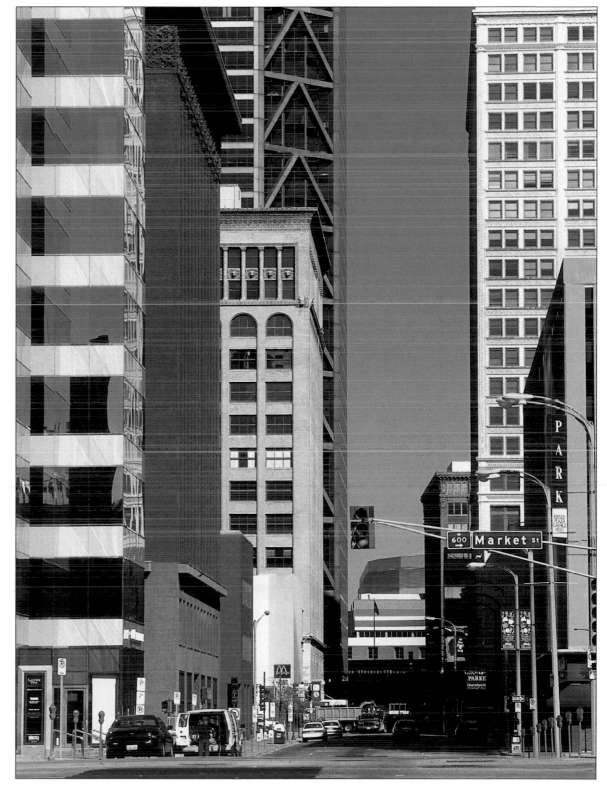

Today, only the Wainwright and Union Trust (now 705 Olive) buildings remain. Contemporary Yale architectural historian Vincent Scully called the row "the major architectural achievement of St. Louis in present, no less in historical terms… an overwhelming and irreplaceable work of civic art." Nevertheless, by the 1970s, the buildings were deemed "down-at-the-heel" and would require significant rehabbing. In a highly controversial planning decision, the city opted to tear down the unified "wall" of tall buildings that was Real Estate Row in the early 1980s. There now stands: Gateway One (1986) with its pink exterior and mirrored windows at left, the Wainwright State Office Building (1981, hidden beside the Wainwright), and the Laclede Gas Tower.

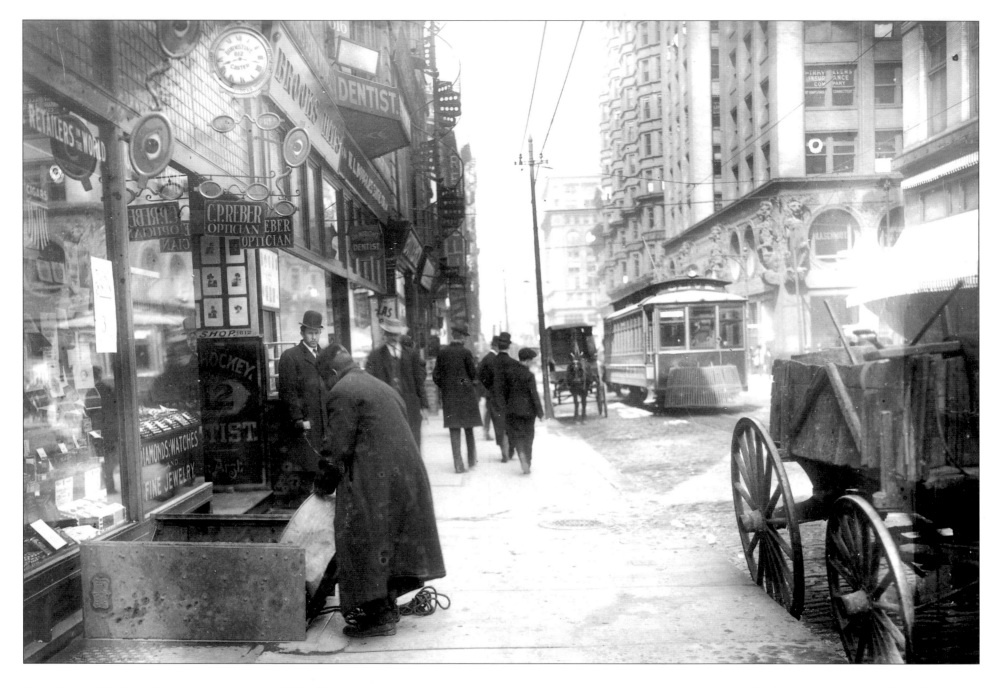

View from 612 Olive Street looking west, 1910s. This busy street scene really captures the feeling of early twentieth-century St. Louis—cobbled streets where electric streetcars overtake horse carts, graphic signage and public clocks on almost every corner, and "walls" of tall new buildings. At far right, we see a corner of the newly completed Railway Exchange, St. Louis' then tallest building at twenty-one stories. Beside it is the Union Trust Building, designed by Louis Sullivan in 1893, and further down the street the Chemical Building (1896) with its stiffly undulating facade.

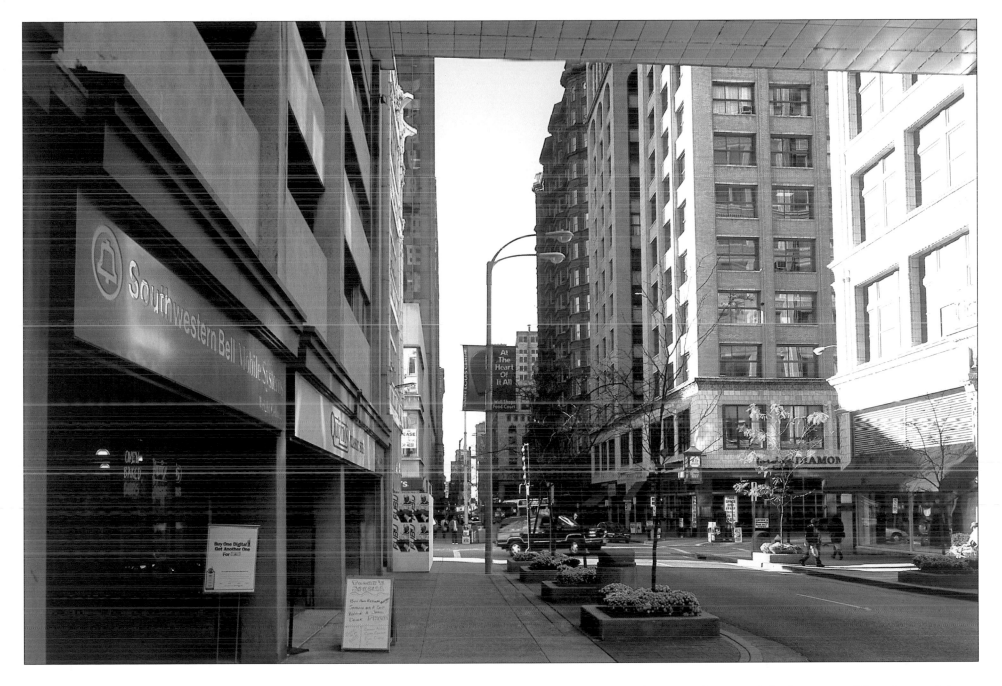

Today, the Railway Exchange and Chemical buildings are virtually unchanged. The Union Trust, now the 705 Olive Building, still stands, though somewhat altered. A 1924 remodeling removed the second-floor round windows, the corner lions' heads, and a Roman-arched entrance. This stretch of Olive preserves several of its turn-of-the-century buildings, but the street-level character has gone the way of the horse cart. The advent of the automobile altered the American cityscape in far-reaching ways. Where once were pedestrians hurrying to their neighborhood dentist or optician, now there are cars and parking garages.

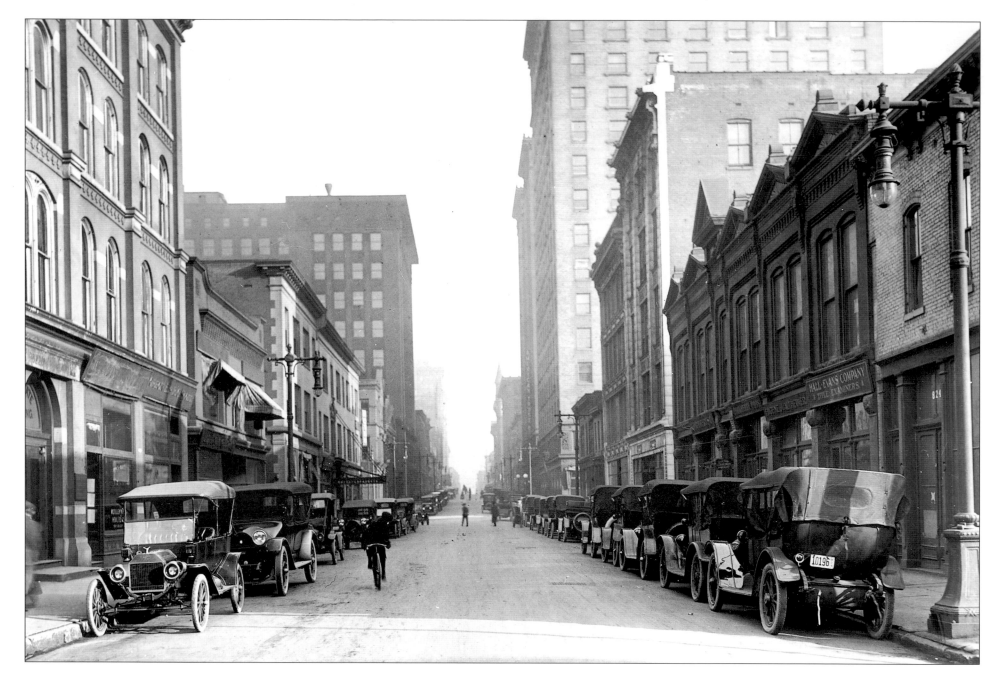

Chestnut Street looking east from Ninth, circa 1914. In 1826, the city voted to rename city streets based on the Philadelphia system, replacing all old French street names with numbers north-south and tree varieties east-west. Shortly thereafter, lower Chestnut was one of the first streets paved in the city; the blocks nearest the river were home to "Quality Row," a row of brick two-story town homes among the otherwise wooden structures. The "quality" kept creeping west, however, as industry infiltrated more and more neighborhoods.

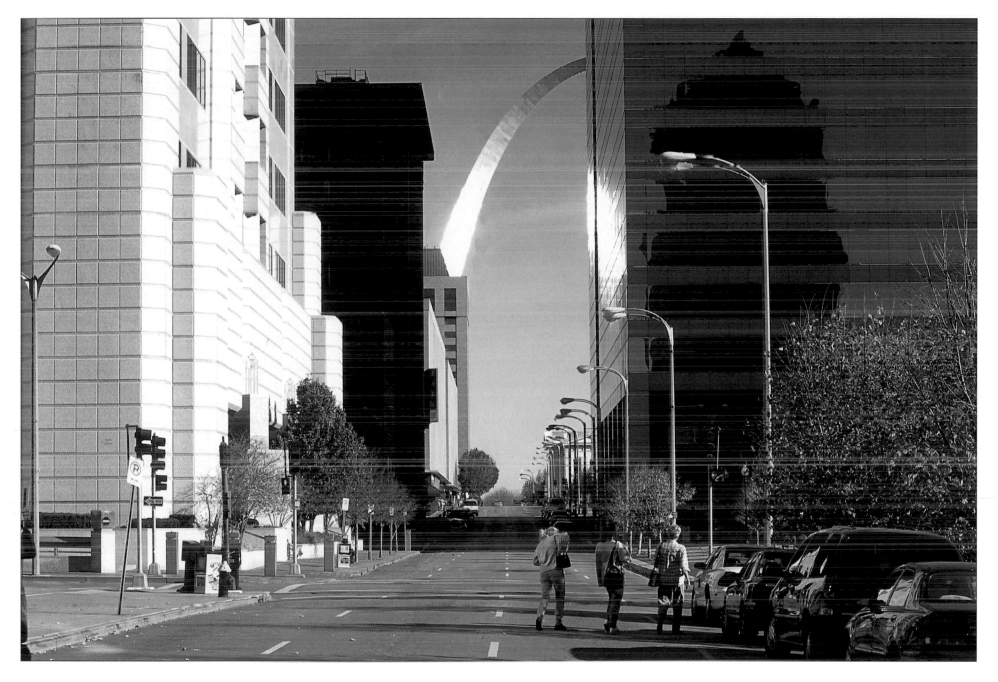

In 1918, St. Louis became the second city in the nation after New York to adopt city-wide, industrial-residential zoning. However, as we see in the 1914 photo, by that point business clearly dominated most of downtown. In a plan to reintroduce open space in the form of a grassy mall, almost all buildings lining the south side of Chestnut were torn down. Today, this stretch of Chestnut affords a glimpse of the Arch reflecting against the Gateway One Building (*right*). At left is the Bell Data Center and the Wainwright beyond it in shadow.

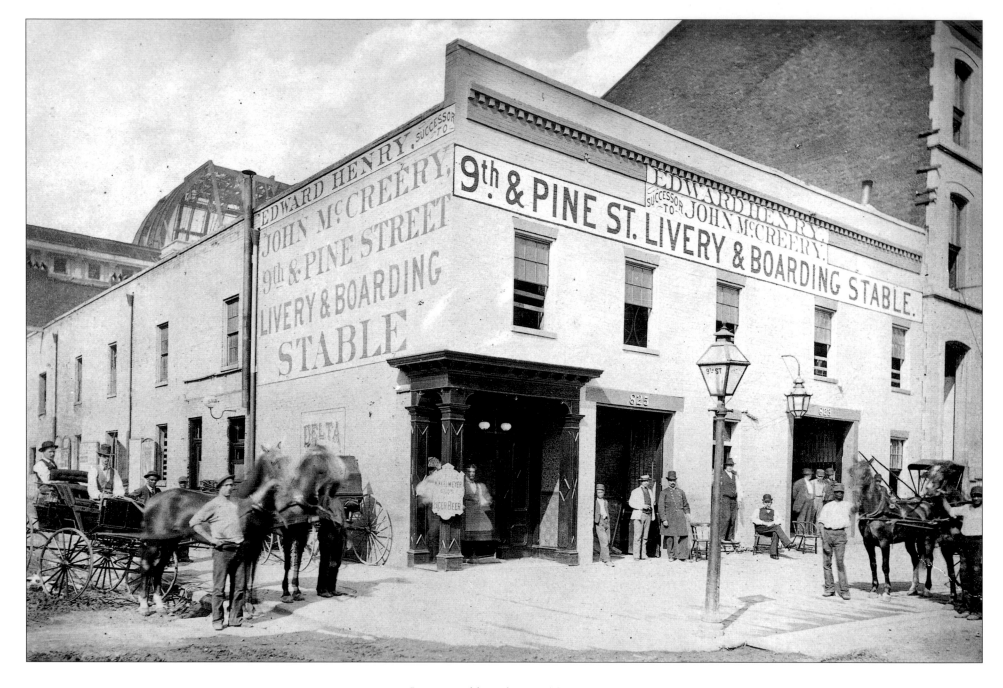

Livery and boarding stable at Ninth and Pine streets, circa 1880. The growing pains of the post-Civil War period in St. Louis made for strange neighbors. Ninth Street was once a desirable residential district (see page 38), but by the 1880s, the lack of a zoning concept combined with the all-too-human desire for convenient goods and services, found "undesirable" industry and commerce intruding onto formerly homes-only turf. Well-to-do citizens who inhabited the brick town houses on surrounding streets had to keep their equine transportation off-site.

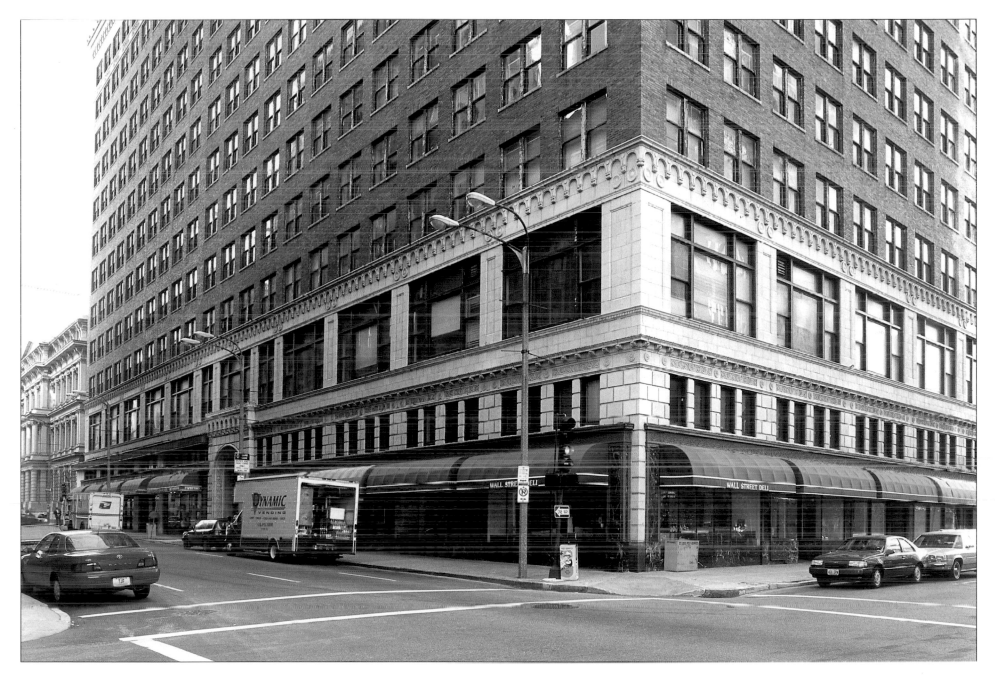

The recently completed main post office peeking over the stable in the other picture was a sure sign that the neighborhood had crossed over from predominantly residential to predominantly business. Today, almost this entire block is taken up by the Arcade Building. Built in 1907, and designed by Eames & Young, the Arcade Building was for a time the nation's tallest reinforced concrete structure. The first two floors housed interior shops gathered around an open-air atrium, making it an early precursor of the multilevel shopping mall.

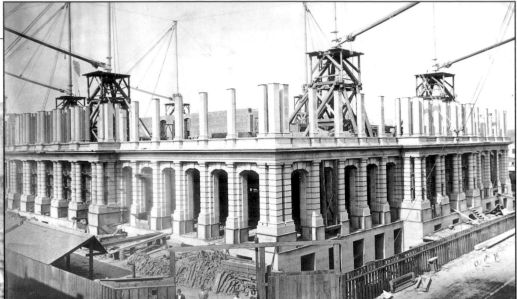

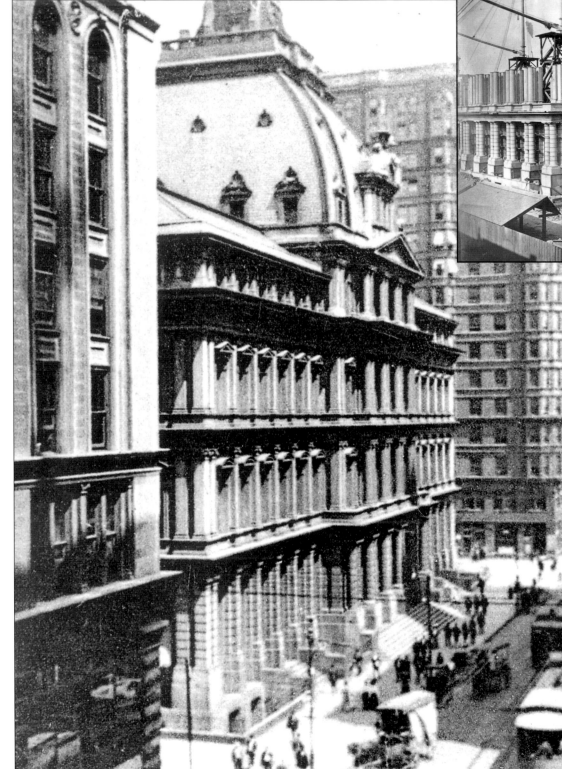

Left: View on Olive Street near Ninth, circa 1890. Designed by notable federal building architect Alfred Mullet (designer of the Executive Office Building in Washington, D.C., among others), this U.S. Customs House and Post Office was built over a decade from 1873 to 1884. In the uncertain times of post-Civil War St. Louis, the French Second Empire design bore more than cosmetic similarities to a fortress; the building featured iron-shuttered windows with rifle barrel ports and underground tunnels with a fresh water supply.

Inset: Under construction, November 7, 1875.

Right: Today, the Old Post Office is a classic example of "adaptive re-use." Although the city tried to have the building torn down, it was instead restored in the 1980s to accommodate federal offices in the top three levels, with commercial mall space on the main and two basement floors. The original twenty-five foot moat supplies natural light to these underground levels. Before the sixty-seven foot mansard cupola sits the original sculptural group *America at War and Peace* by Daniel Chester French. At right is the terra-cotta adorned Chemical Building (1896).

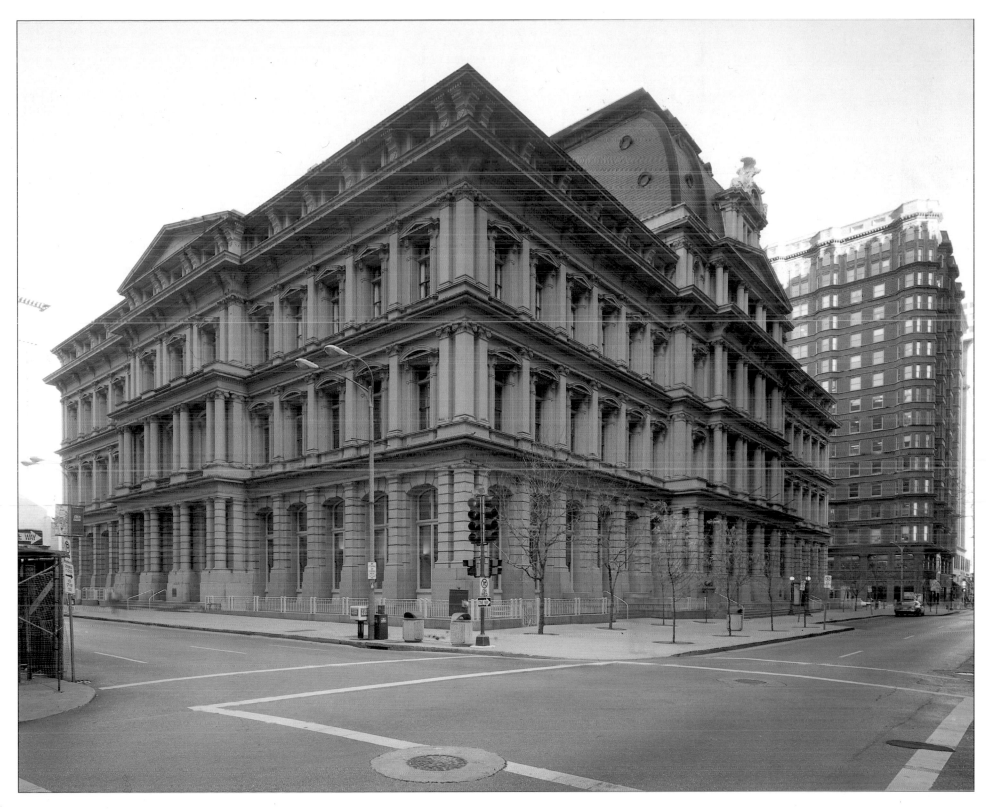

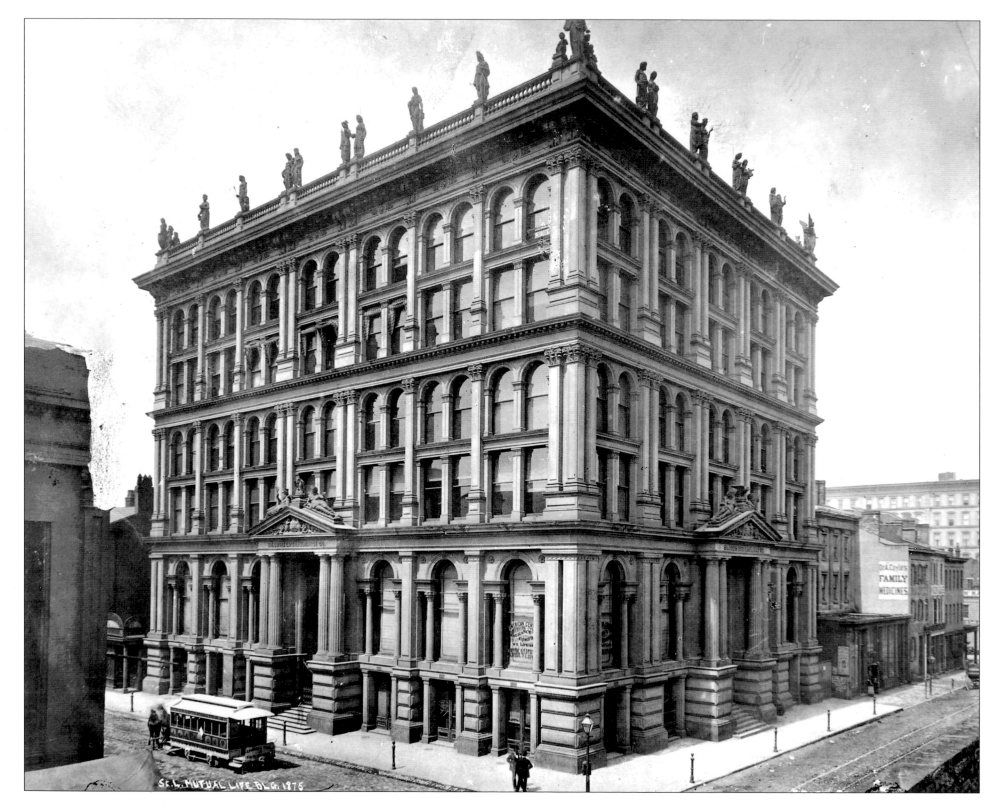

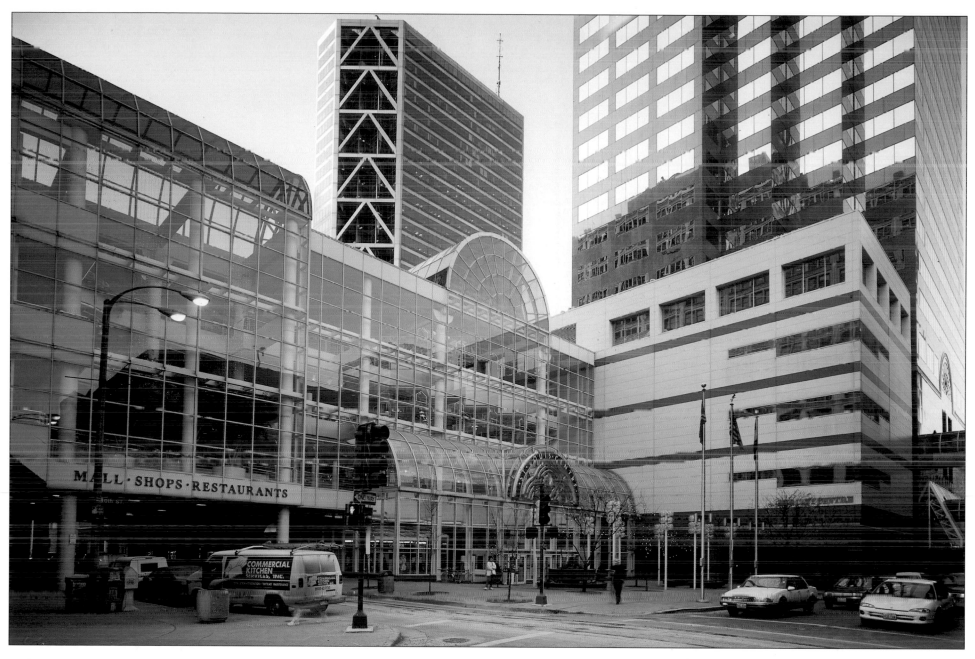

Left: Sixth and Locust streets, circa 1870s. On this corner stands the St. Louis Mutual Life Insurance Building, built in 1871 and designed by architect George Barnett. The building is graced by a series of neoclassical statues commissioned by James Eads, engineer of the Eads Bridge (pages 10–11), who was also the organization's president. In typical Gilded Age style, he had originally planned to install them on the bridge itself, but thankfully was talked out of it, preserving the bridge's spare, elegant design.

Above: Today, this corner is home to St. Louis Centre, downtown St. Louis' premier shopping venue. Constructed in 1985, the center managed to link two downtown department stores with a suburban-style, user-friendly mall. Inside, it is an open three-story atrium with vaulted glass skylight, a light and airy style that has been called "steamboat surrealism." Behind the mall rises One City Centre, an attached twenty-one story office building. At left in the background is the thirty-five story Mercantile Bank Tower (1976).

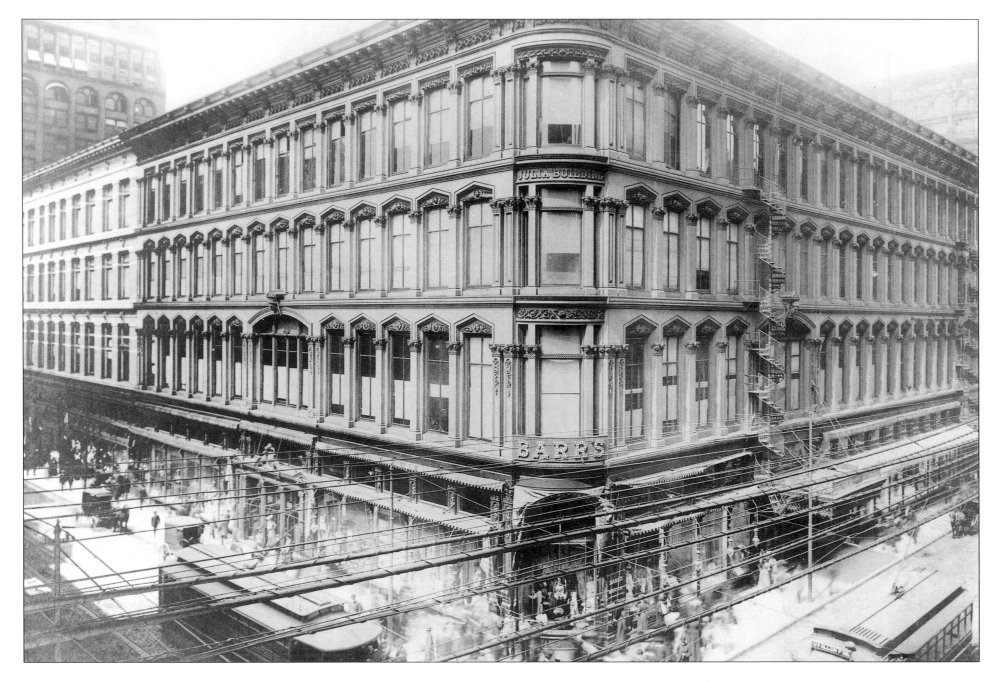

Northwest corner of Sixth and Olive streets, 1902. The William Barr Company was St. Louis' first and largest department store at the turn of the century. Founded in 1870 by retail dry goods representative William Barr, Barr's bought much of their stock directly from manufacturers, an unusual arrangement at the time, and conducted a thriving mail-order business with towns across the West. In 1900, wholesalers Hargadine and McKittrick purchased the Barr Company, and, flushed with success, would undertake construction of the city's tallest building, to be built on this same location. Electricity became available in St. Louis in 1884, making possible elevators to service tall buildings as well as the abundance of streetcars seen here.

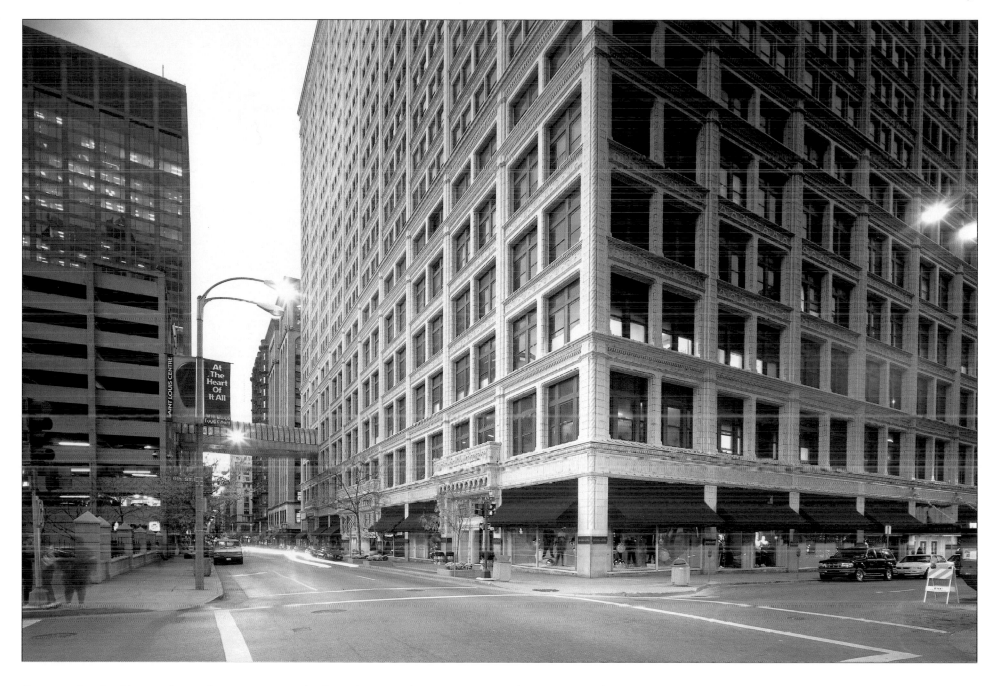

Seventy-five buildings of over five stories were built in St. Louis between 1887 and 1906, but the tallest peaked at twelve stories, the maximum allowed by city ordinance at that time, but also often the limit of smoke-obscured visibility. Then, in 1908, construction on the twenty-one story Railway Exchange Building began. Barr's was to occupy the first eight floors, the rest was to be executive suites for lease to the railroads, but cost overruns and lack of railroad cooperation put the wholesalers in a squeeze. In 1911, they sold the Barr Company to its previous rival, the May Company, owners of the Famous Company department store. Today, almost one hundred years later, Famous-Barr now occupies this entire building.

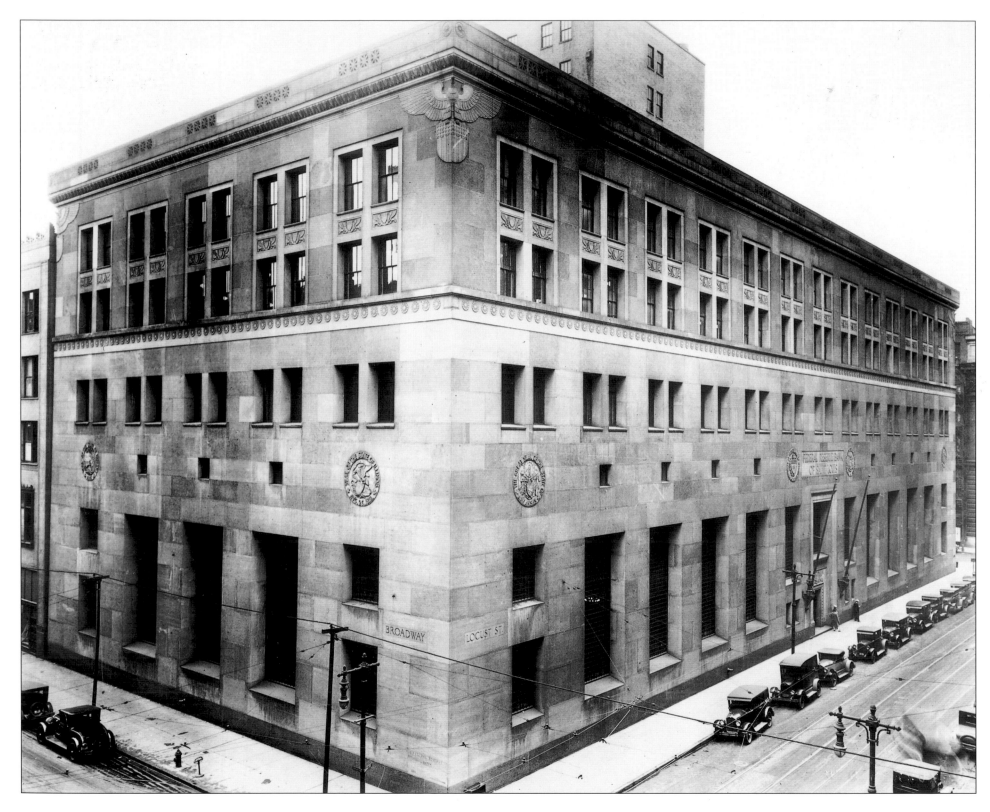

Left: Corner of Broadway and Locust, 1924. In 1913, the U.S. government established the Federal Reserve System to strengthen supervision of the nation's banks and money supply. Twelve districts were established, and St. Louis became the seat of the eighth, highlighting the city's historical role in the economy of the Mississippi Valley and the nation. At the time, the 1910 census reported that St. Louis was still the fourth largest city in the country, home to the world's largest fur market, and "first in booze, first in shoes," among other manufactured goods.

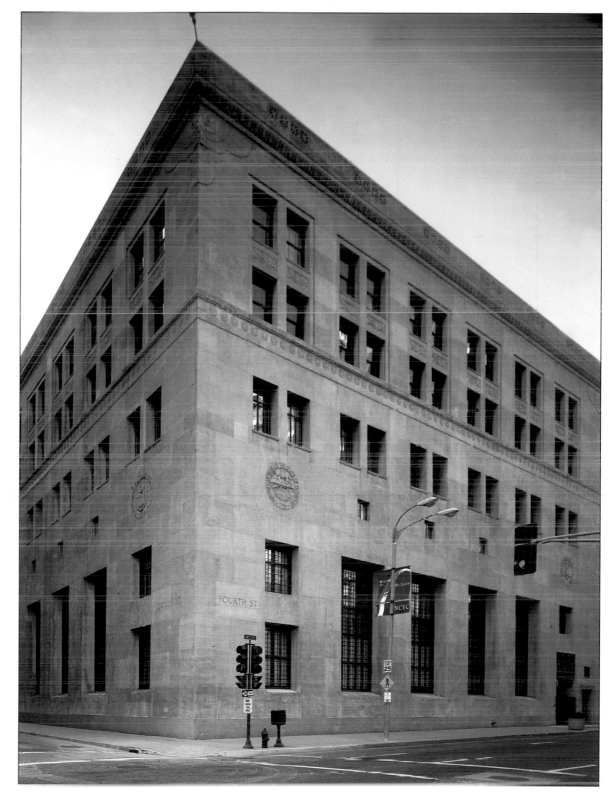

Right: Today, the unchanging, fortress-like Federal Reserve Bank (seen here from the Fourth & Locust corner) in St. Louis conveys all the stern stability intended by the system's founders. Almost ninety years later, just about the only visible changes are the contemporary streetlights and autos, and the disappearance of the streetcar tracks. Uniquely, this branch processes the postal money orders for the entire nation—about one million a day—in addition to duties shared by other Feds like shredding worn paper money (372,000 bills destroyed per day) and sorting cash (at a rate of 80,000 bills an hour).

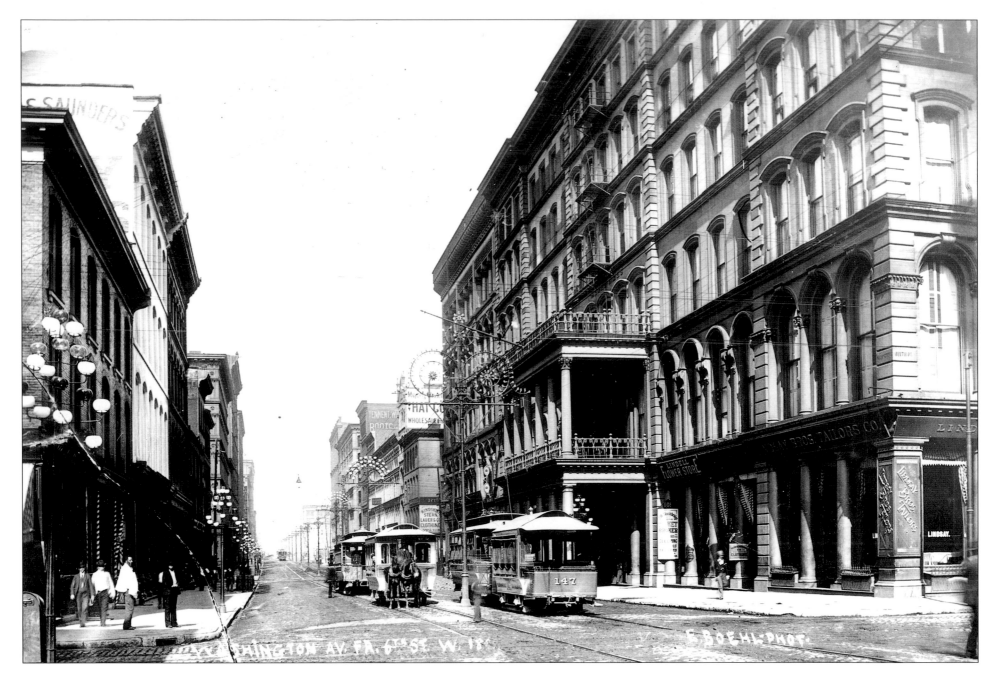

West of Sixth Street, circa 1891. These blocks were partially developed as an elite residential enclave in the heyday of Lucas Place in the 1860s, but Eads Bridge traffic of the 1870s made them eminently more valuable to business. By the 1890s, the city was electrified, and electric trolleys and streetlights were beginning to replace mule-drawn streetcars and gaslamps. The luxury Lindell Hotel, built in the 1860s, was decorated here for the Veiled Prophet Parade.

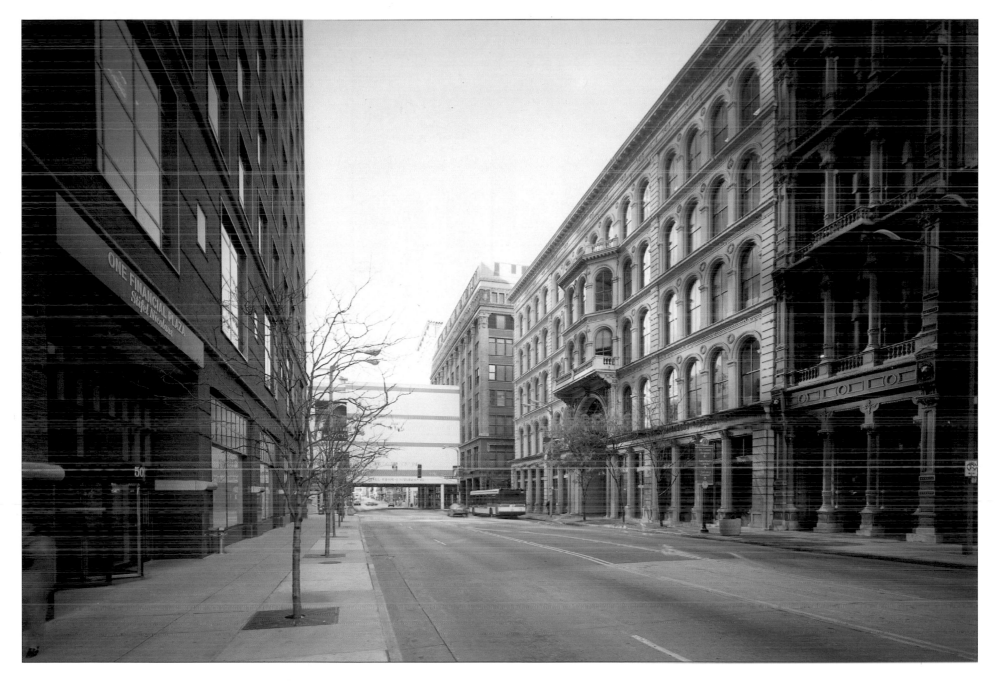

Today, the vista down Washington Avenue has been blocked by one of the
St. Louis Centre (page 53) overpasses connecting the Dillard's department store,
site of the former Lindell, to the central mall. Many of the great old buildings
from the turn of the century remain, such as the original Bradford-Martin, now
the 555 Washington Building, at right, but there are also great new additions like
One Financial Plaza and the Edison Brothers Stores Building at left.

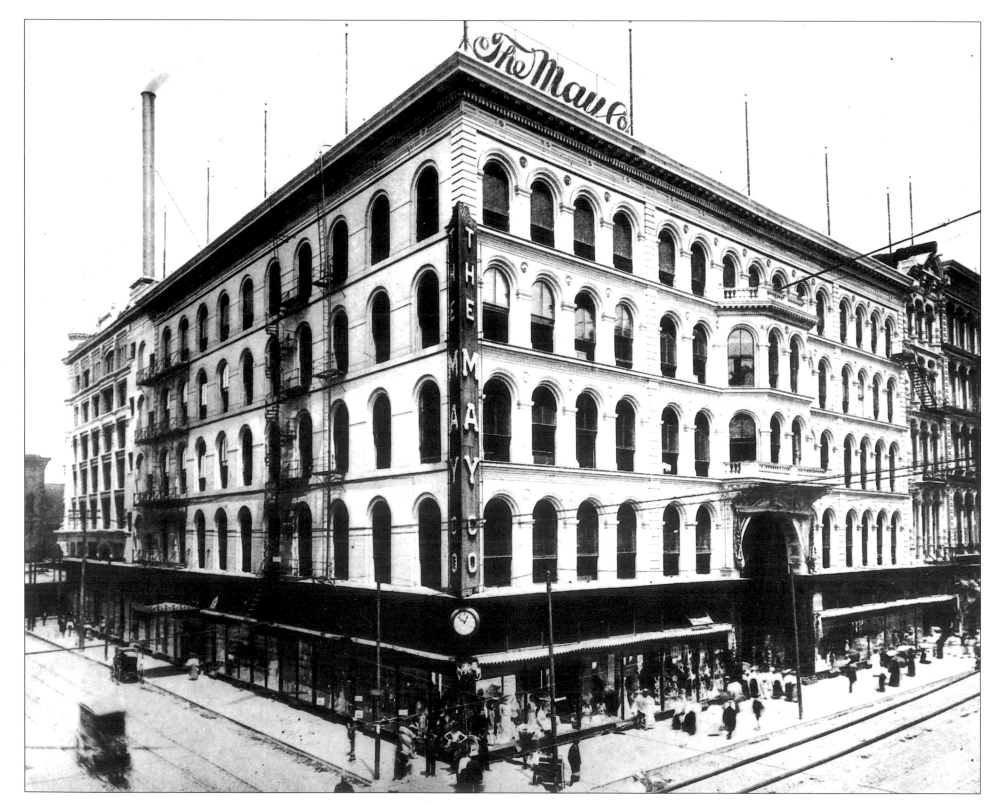

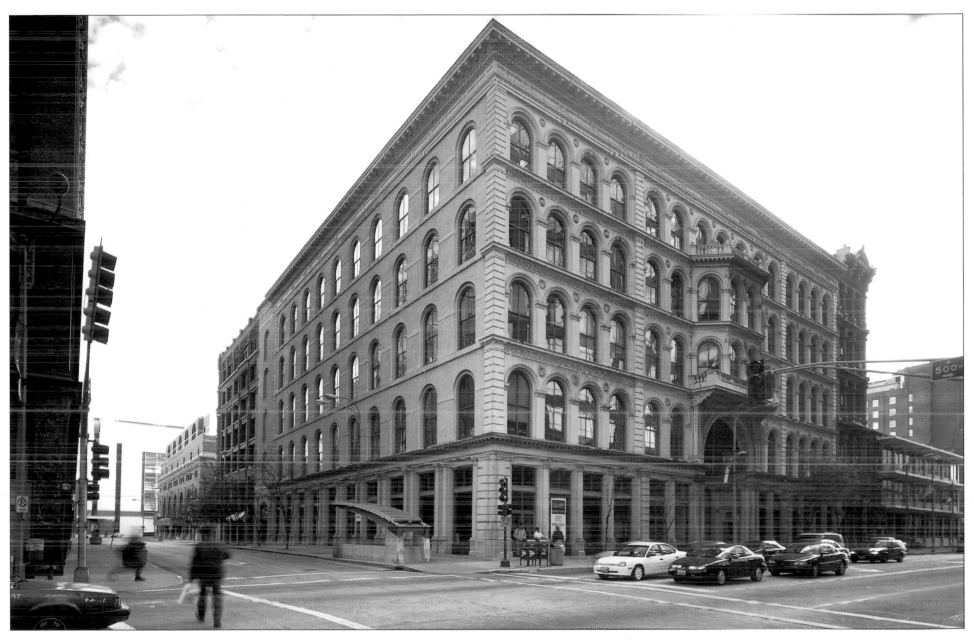

Left: Northeast corner of Washington and Sixth, circa 1906. Designed in 1898, the Bradford-Martin Building was part of a spate of new construction on Washington following the opening of the Eads Bridge. However, this construction was not exactly new; there is evidence that the nineteenth-century developer was in fact uniting preexisting buildings behind the Italianate, Beaux-Arts facade. In 1904, David May, owner of the nation's largest retailer, purchased the building. Just ten years later, the May Company would relocate.

Above: Today, the building now known as 555 Washington seems remarkably unchanged. In reality, the building was completely restored to this condition in the 1980s. In 1913, when the May Company purchased their financially strapped competition, the Barr Company, and moved into Barr's new building (page 55), the Bradford-Martin was vacated. Within a few years, the space was subdivided into a warren of garment workshops. Today, the building is owned by the U.S. Postal Service and houses office space.

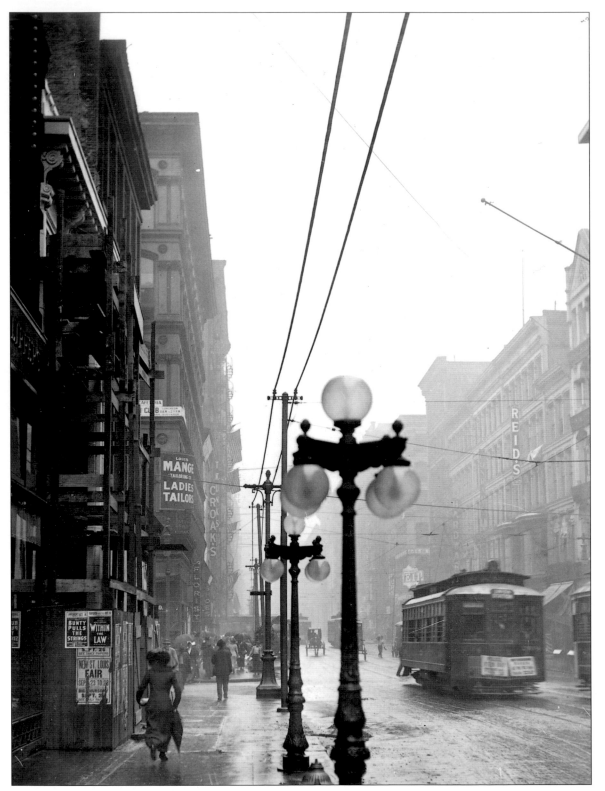

Washington west from Seventh, early 1900s. By the turn of the century, Washington Avenue had become St. Louis' wholesale and manufacturing row. In 1897, the Businessmen's League of St. Louis claimed that "compared with the world, St. Louis has the largest railroad station, hardware house, drug house, wooden warehouse, and tobacco factory. As compared with the United States, St. Louis has the largest brewery, shoe factory, saddlery market, streetcar factories, and hardwood lumber market."

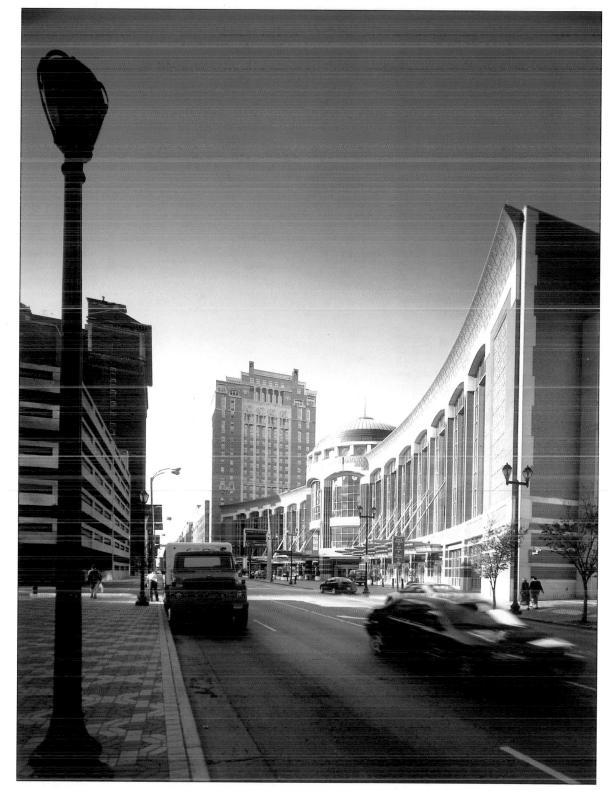

Today, this stretch of Washington between Seventh and Ninth is the artful southern face of the America's Center, the St. Louis Convention Center, which covers thirty-two acres of the north side of downtown. Behind the America's Center lies the Trans World Dome, a massive contemporary stadium covering fourteen acres and seating almost 65,000 for St. Louis Rams football games and assorted concerts and special events. Both facilities were completed in the 1990s following a resurgence in convention traffic.

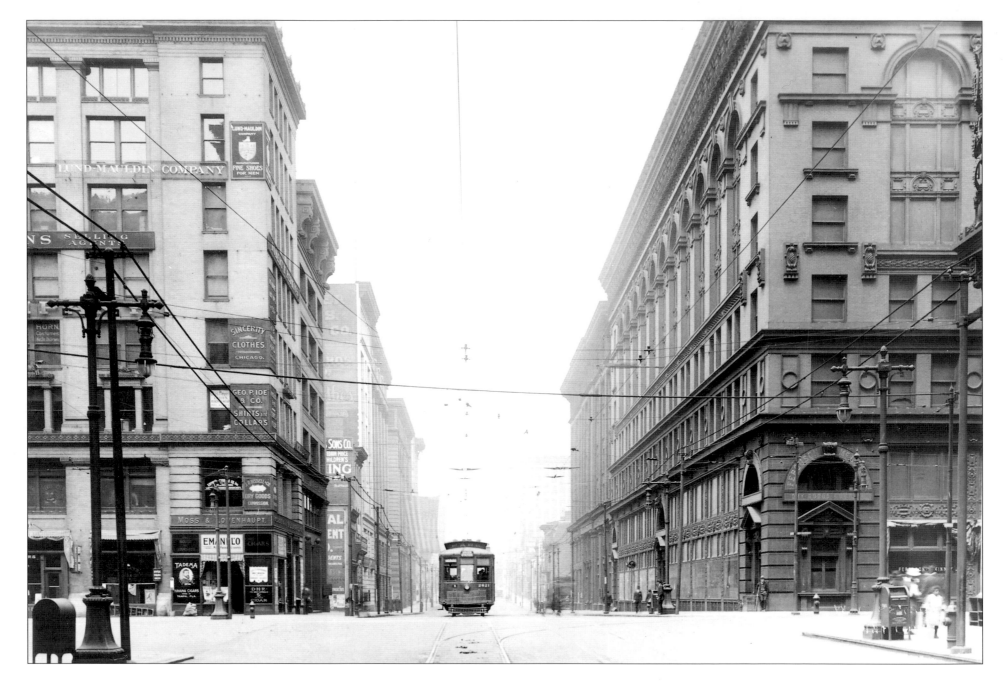

Washington Avenue from Twelfth (Tucker), circa 1914. Known at this time period as Wholesalers' Row, Washington from about Eighth westward, presented a unified face of robust, turn-of-the-century, eight-to-twelve-story buildings, filled with wholesalers and manufacturers. A popular saying held that St. Louis was "First in shoes, first in booze, and last in the American league" (this last a reference to the poorly performing St. Louis Browns). Washington featured most of the "shoes," and as the century progressed, ready-made clothing became a particular specialty of this district.

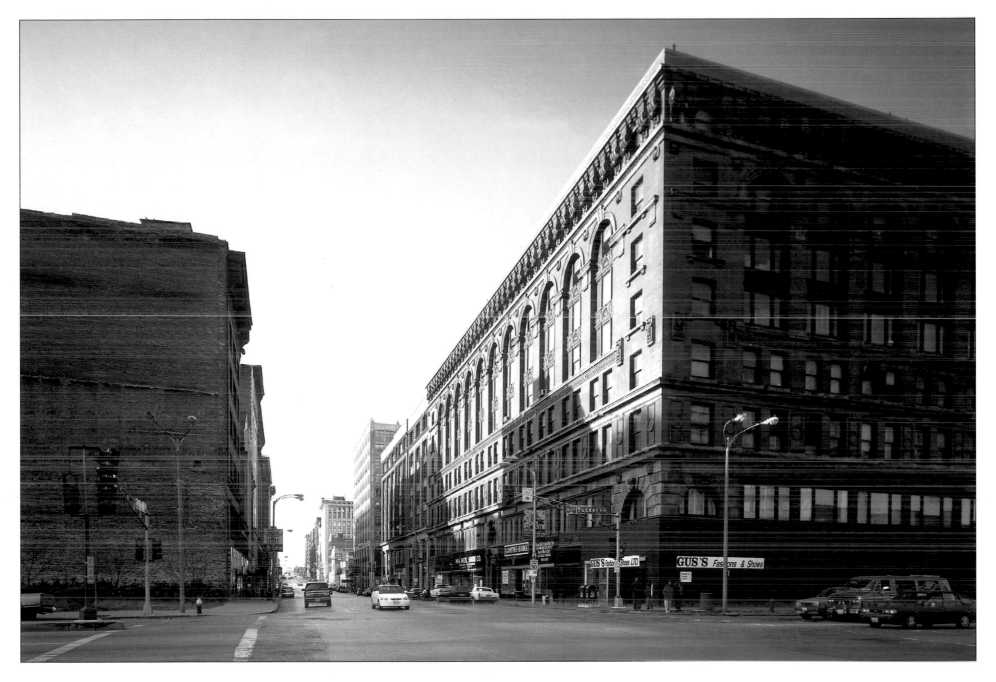

Thanks most likely to the longevity of the garment businesses, Washington Avenue is the best-preserved section of early twentieth-century St. Louis. Most of these solid old buildings have never ceased to be inhabited, or if so, for only a short span of time. Today, while some of the remnants of the old-timers remain (note the two shoe stores), this neighborhood is undergoing a fast-moving renaissance. Old garment factories are being converted into artists' lofts and offices, and the street-level storefronts are filling up with nightclubs and restaurants.

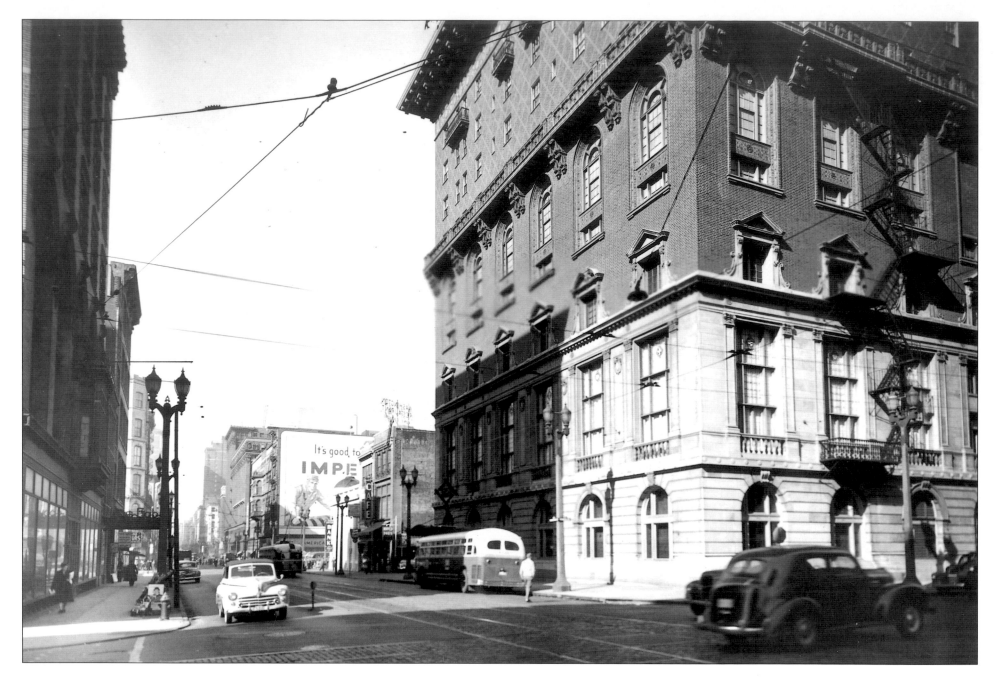

Eastern end of Washington, circa 1947. This view is interesting, falling as it does at the halfway point in the transition to the automobile age. Beneath the old-fashioned streetlights and streetcar lines, whiz by the bubbly shapes of 1940s automobiles. The cobblestones had already been paved over, except for the strips between the streetcar tracks, and there is only one streetcar visible. There is also now a bus.

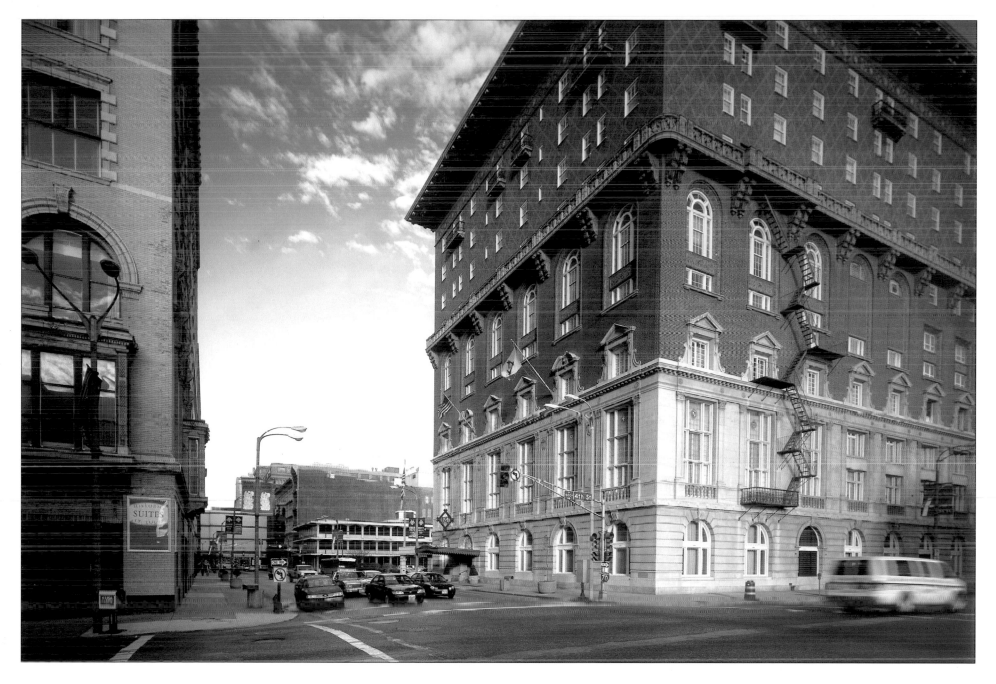

Today, the intersection of Fourth and Washington is only subtly changed.
Although the streetlights and cars are modern, and the streetcars have
entirely disappeared, the scene is clearly recognizable, thanks largely to the
Missouri Athletic Club on the corner. Built in 1914, the much-admired
MAC was designed in a type of Italian Renaissance palazzo style by architects
William Ittner and George Brueggeman.

Left: A stereoscope by Boehl & Koenig, taken circa 1868. The first Episcopal parish west of the Mississippi was founded in St. Louis in 1819, but met in five different locations until this church could be completed. New York architect Leopold Eidiltz drew up the English Gothic design, and construction began in 1859, but was delayed by the Civil War. The congregation did not celebrate their first service here until Christmas Day 1867. It was then the outskirts of the city, just across Missouri Park from exclusive Lucas Place.

Right: Named a cathedral in 1888, Christ Church today includes the 1912 addition of a High Gothic tower, complete with spires and gargoyles. The interior was renovated in 1969, the organ and choir stalls moved to the back of the nave, and the pews were replaced with interlocking chairs to create a better space for the performing arts. The intersection of Twelfth and Locust is bucolic no longer, but the Shell Building of 1926, with its almost crenelated roofline, seems an appropriate complement for this Gothic gem.

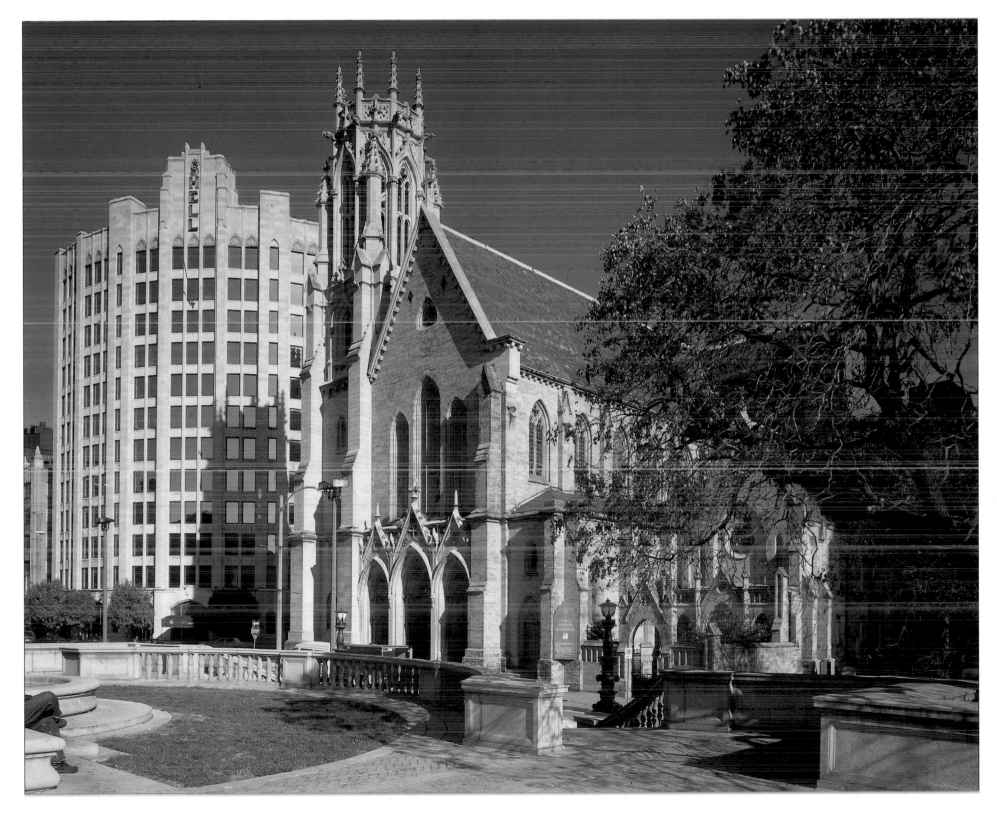

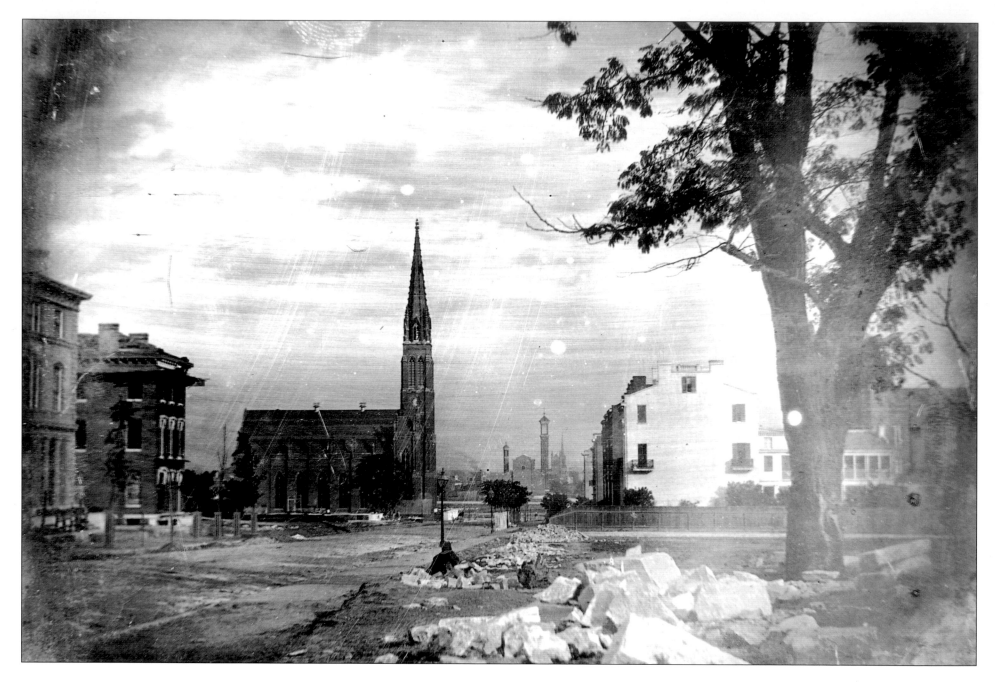

Daguerreotype, circa 1858, looking east from 17th Street. The first of St. Louis' private streets, Lucas Place was the dream of banker and land developer James H. Lucas. In 1851, Lucas and his wife donated land to the city for a park spanning present-day Locust at 14th Street. Missouri Park, as it was known, effectively buffered the new neighborhood against the commercial bustle of the city, and the Place became one of the city's wealthiest residential showplaces in just a few short years (note the piles of new construction rubble). Church at center is the First Presbyterian, one of three "institutions" allowed in the neighborhood. At right, the Campbell House.

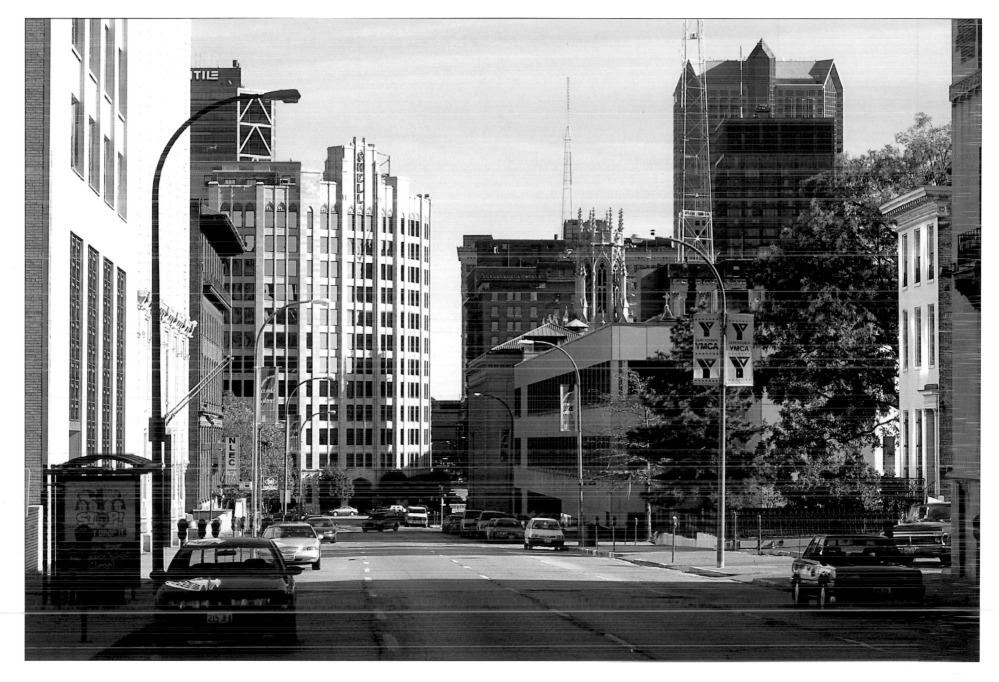

Today, Lucas Place has almost completely vanished. In 1883, James Lucas' heirs agreed with the city to drop the protection of Missouri Park. By 1893, local ordinance changed the name of Lucas Place, so that it was merely a continuation of Locust Street. Residents by this point were moving west en masse, and most of the glorious mansions quickly became derelict boarding houses. The only mansion left standing today is the Campbell House; its pale yellow face is visible at right. The rest of the street is now completely commercial. Of note: the gracefully rounded Shell Building, built in classic Art Deco style in 1926, at center.

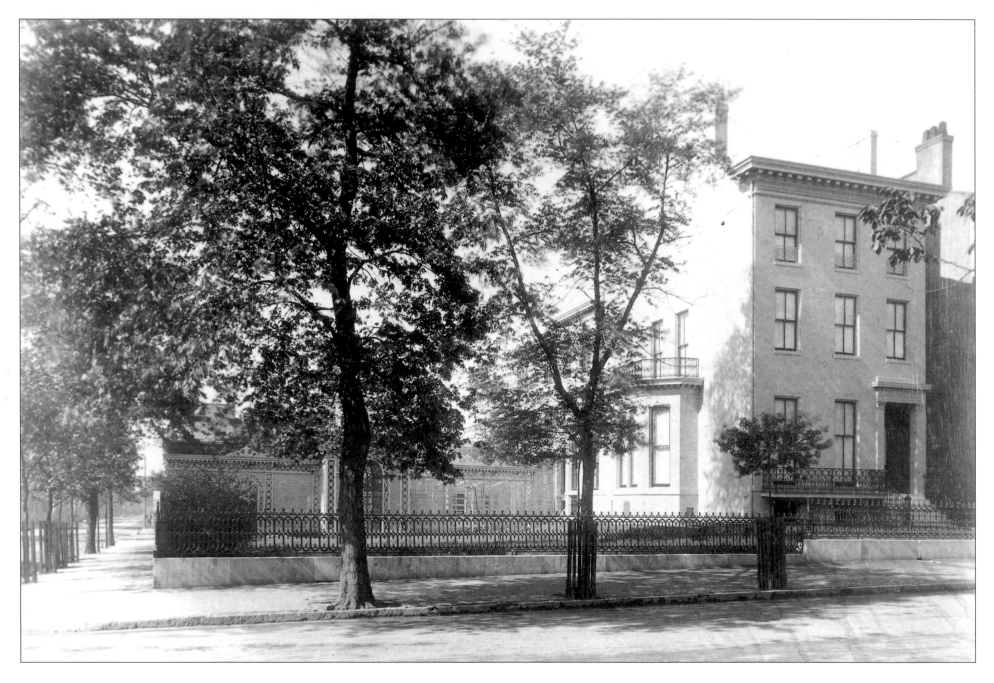

A photograph of the Campbell House, still in its heyday in the early 1880s. Built in 1851, the mansion stood on the newly formed Lucas Place, the most exclusive residential enclave at that time and the city's first private street. Irish-born Robert Campbell and his wife purchased the home in 1854. Campbell was a prosperous businessman—a partner with William Sublette in the Rocky Mountain Fur Company, as well as a merchant provisioner of wagon trains and a banker—and his wife Virginia was famous for her hospitality. Many notable people of the era visited their home, including President and Mrs. Ulysses S. Grant.

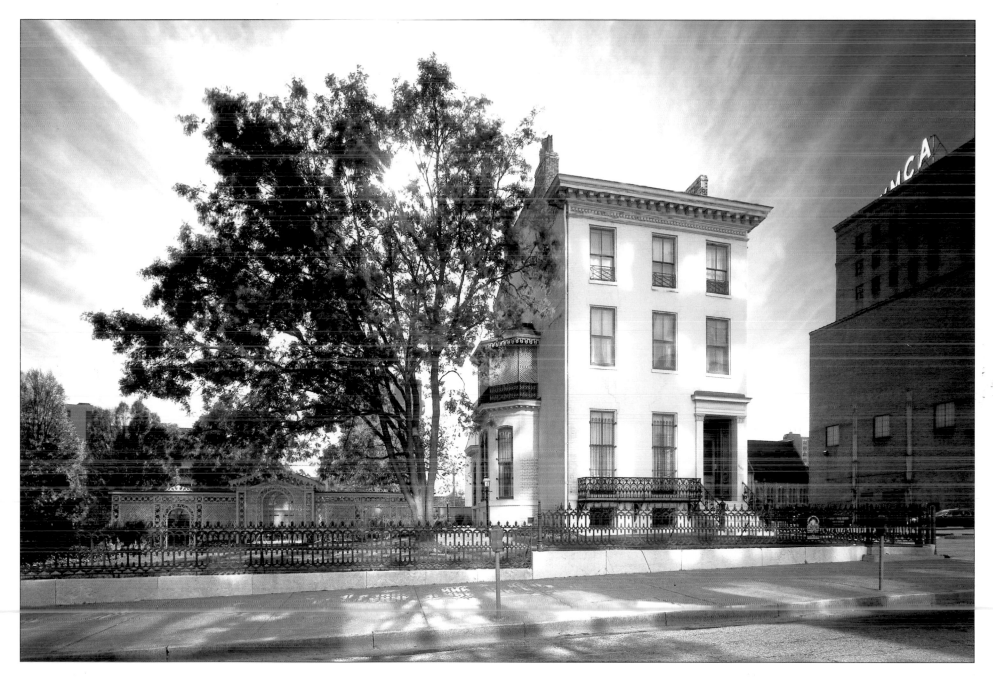

Today, on Locust Street, the Campbell House stands as the sole survivor of once-elegant Lucas Place. Now a museum, the home is a marvel of preservation, thanks in part to the tragic family history. Robert and Virginia Campbell had thirteen children, but only three lived to adulthood. When the youngest brother died at thirty, the two remaining sons became virtual recluses, living out their days well into the twentieth century in the family home as commercial buildings sprouted around them. They altered hardly a thing, and the museum now contains almost all original furnishings—from chandeliers and wallpaper to the original horse carriages.

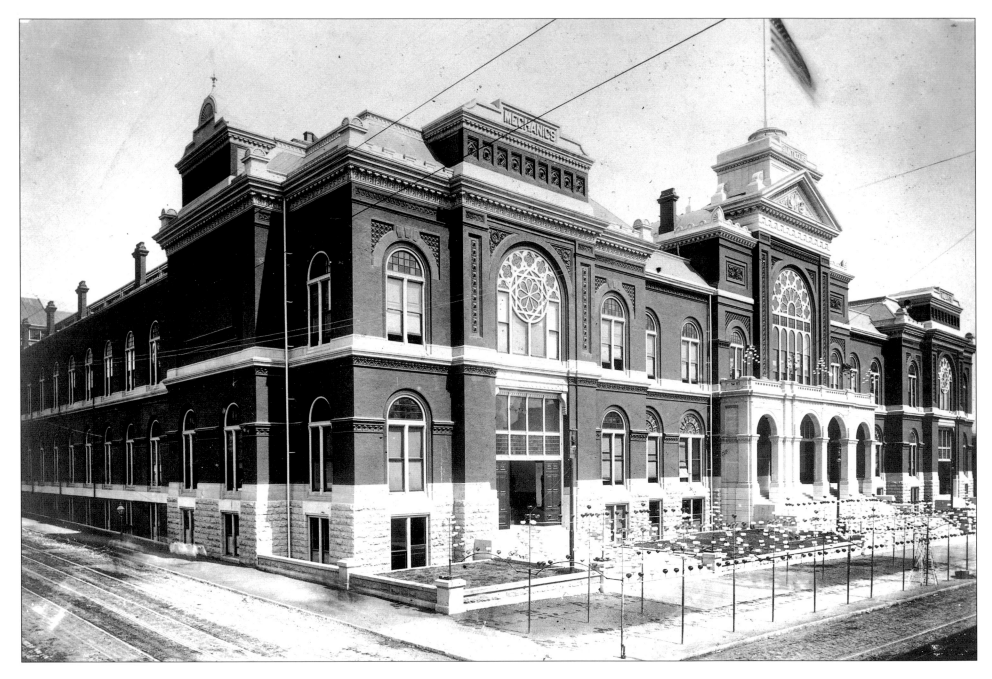

Olive and Fourteenth streets, 1890s. Missouri Park once divided exclusive Lucas Place from the city, but in the 1880s the heirs of Lucas allowed the city to use the parkland for an exhibition hall. Built in just over a year and opened in 1884, the Exposition and Music Hall served as the site of the new annual St. Louis Exposition. The music hall hosted some of the biggest bills of the 1880s, including John Philip Sousa's band and the national Saengerfest. The Exposition Hall was also the scene of the Democratic presidential convention, both in 1888 and 1904.

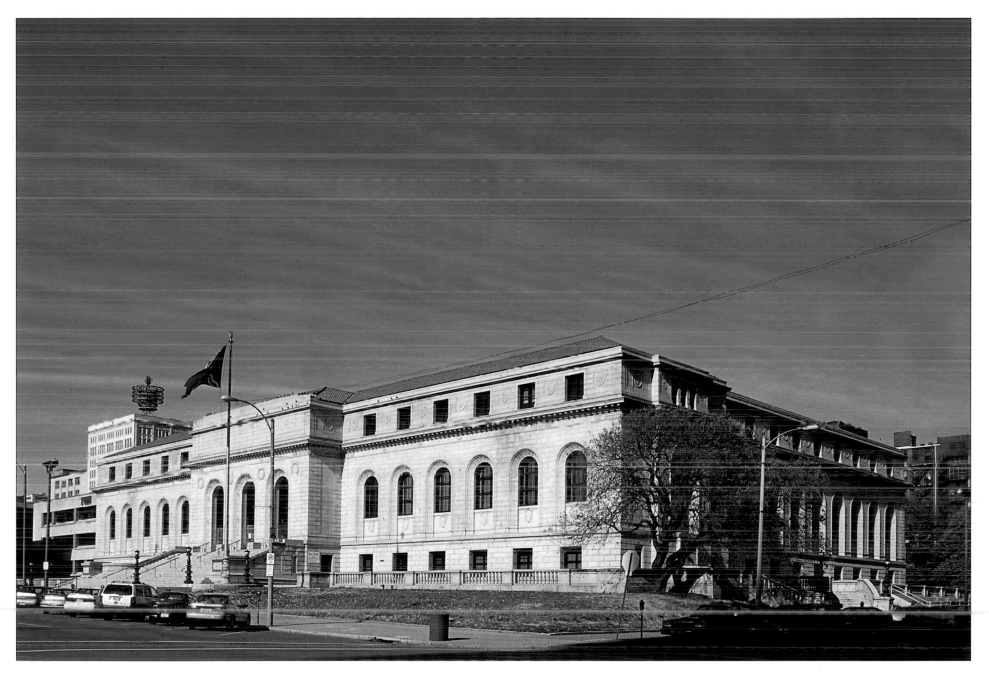

Today, in its place stands the St. Louis Public Library. By the turn of the century, the St. Louis Expositions were likely to be discontinued, despite their success. It appeared the Hall would be razed, and the site would revert to parkland. In 1902, however, Andrew Carnegie donated one million dollars for a St. Louis library system, provided the city would supply the land. The Exposition Hall site was now approved for library construction. Architect Cass Gilbert designed this lovely public building with its clean Italian Renaissance lines. It opened in 1914.

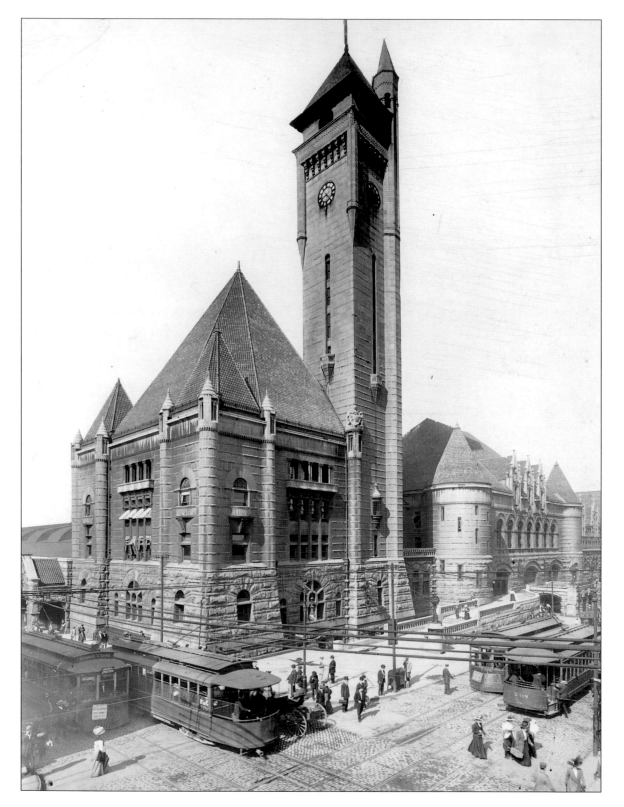

Market and Eighteenth streets, circa 1904. When completed in 1893–4, St. Louis Union Station was the nation's largest single-level passenger rail station. By the turn of the century, it was also one of the busiest. More railroads (twenty-two) converged at St. Louis than at any other point in the United States. Architect Theodore Link designed the main hall in a Richardsonian Romanesque style, with sturdy stonework and massive arches. Behind this Romantic exterior lay a thoroughly modern terminal that could accommodate 260 trains on 41 tracks and 100,000 people a day. The yard was covered by George Pegram's elegant metallic train shed, which maximized natural light.

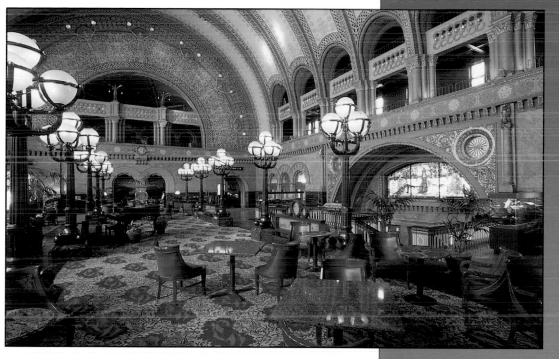

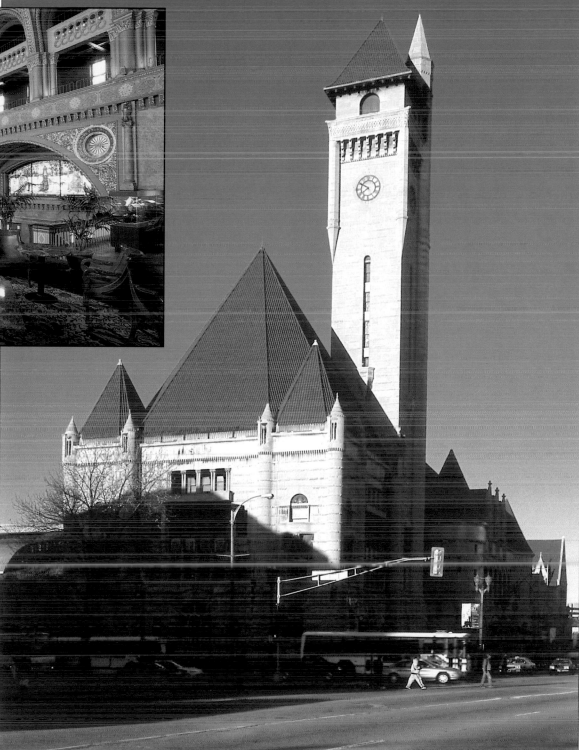

Along with the Eads Bridge, a signature landmark of St. Louis until the construction of the Arch, Union Station suffered the same fate as the railroads in the automobile age. The last train left the station in 1979, and the terminal lay dormant for seven years until the nearly $150 million dollar restoration project by Hellmuth, Obata, & Kassabaum, completed in 1985. Today, Union Station bustles once again, a tourist destination and a successful example of adaptive reuse as a "festival marketplace." The luxury station hotel was completely renovated (*inset*), and the terminal converted into shops and eateries.

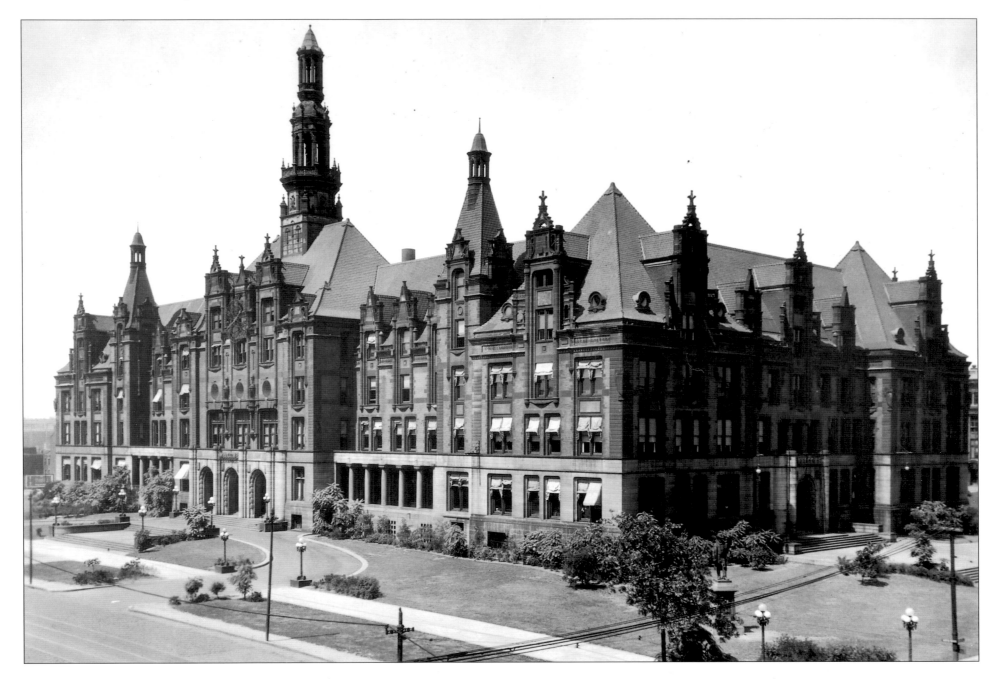

Circa, 1915. A national competition was held to design the St. Louis City Hall, and architect Harvey Ellis won with this French Renaissance creation. Modeled on the Hôtel de Ville, the Paris city hall, the building was completed in 1896 to great acclaim. The interior houses a four-story court, completed in 1904. On the corner stands a statue of long-time St. Louisan, Ulysses S. Grant. After leading the Union to Civil War victory, Grant became the eighteenth U.S. president.

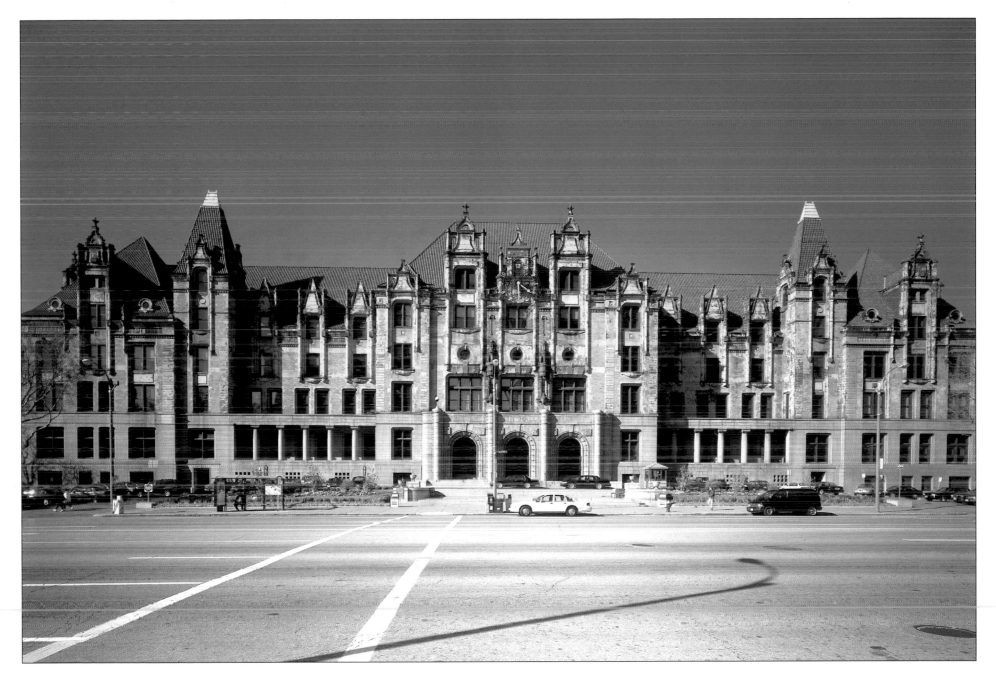

Today, this block along the corner of Tucker (Twelfth) and Market is subtly
changed from a century ago. The grassy lawn has been minimized to make way
for parking and a broader Market Street. The towers and finials on the roofline,
integral parts of Ellis' design, were removed in 1936, victims of the changing
fashion. Over a century after its completion, the building still functions as the
City Hall, housing the offices of the mayor and city council.

Northeast corner, 1926. When Laclede founded St. Louis, the limestone bluff along the river afforded one opening onto a sandy levee. That east-west gap became Market Street, a bustling commercial street throughout St. Louis' history. By the 1920s, merchants were clamoring for the widening of Market Street, and the city needed land for a courthouse. Looming over the older row of storefronts, stands the modern Bell Building at 1010 Pine. Completed in 1926, with striking set-backs and an Art Deco style described as "skyscraper-Gothic," the Bell Building was then the tallest building in the city.

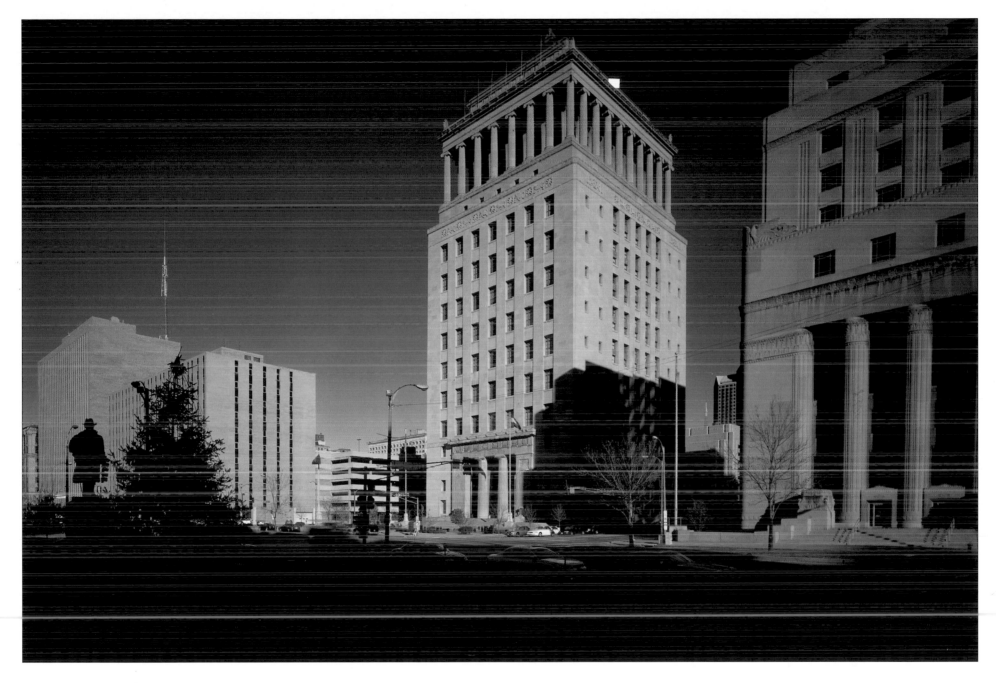

The block of mostly low-rise, nineteenth-century buildings between Chestnut and Market was torn down, Market was widened, and, blocking the view of the 1010 Pine Building, a new Civil Courts Building was erected in 1930. In style, it is the architects' (Klipstein & Rathmann) vision of what the tall tomb of King Mausolus of Caria probably looked like, complete with pyramid on top. At left is the silhouetted statue of Pierre Laclede on the City Hall grounds. The skyscraper with the green, gabled roof in the distance is St. Louis' current tallest building, the Metropolitan Square.

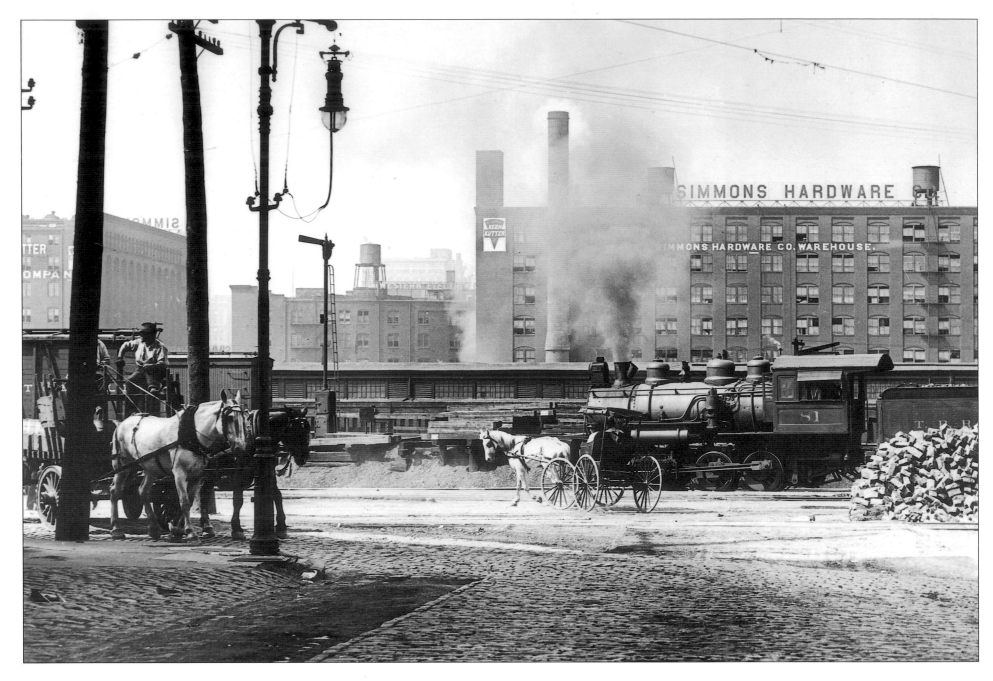

Looking north from Eighth and Poplar, circa 1905. Turn-of-the-century St. Louis was an industrial powerhouse. In this photograph, we see the horse-drawn street traffic beside the Terminal Railroad Association yards, with Cupples Station warehouses beyond. In 1892, Eames & Young designed eighteen such warehouses, comprising a freight-storage, handling, and transfer complex situated along a double-track tunnel leading from Eads Bridge to the Mill Creek Valley industrial zone. At the turn of the century, most of the city's wholesale trade (more than $200 million annually) was handled here.

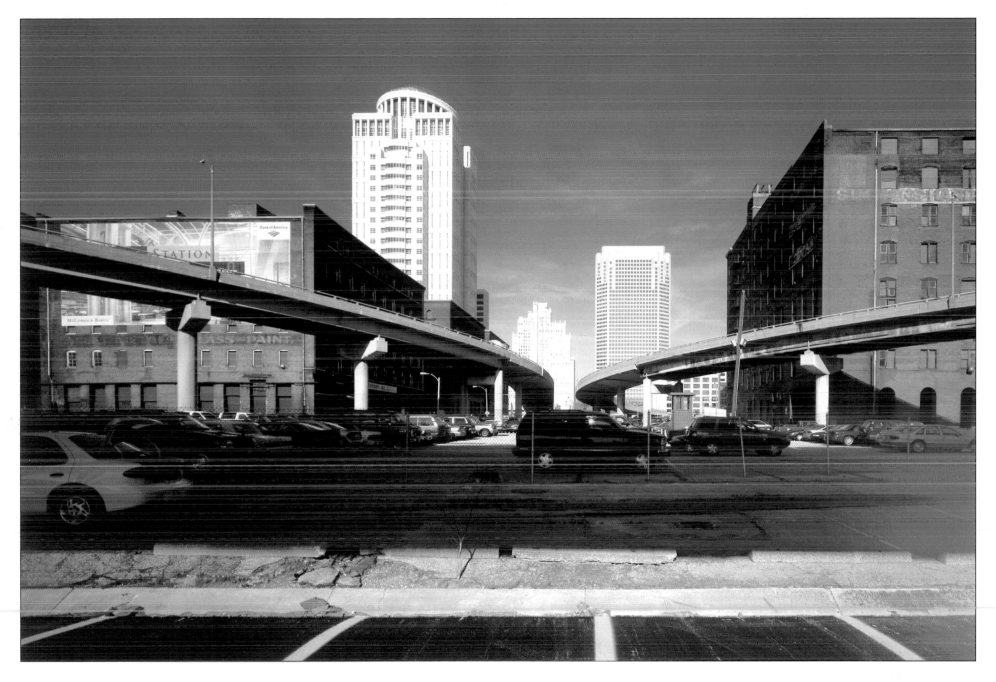

Today, cars and highways have replaced trains and rail. Cupples Station was donated to Washington University in 1900. Several of the warehouses were torn down in the 1960s to make way for Busch Stadium and its attendant parking garages, just behind the building at right. In the 1980s, several more were slated for parking garage space, but finally the historic worth of the building group was recognized, and the remaining block of warehouses at left are currently under renovation by Westin Hotel. The building at right, almost a hundred years since the photo at left was taken, bears the faint sign of Simmons Hardware.

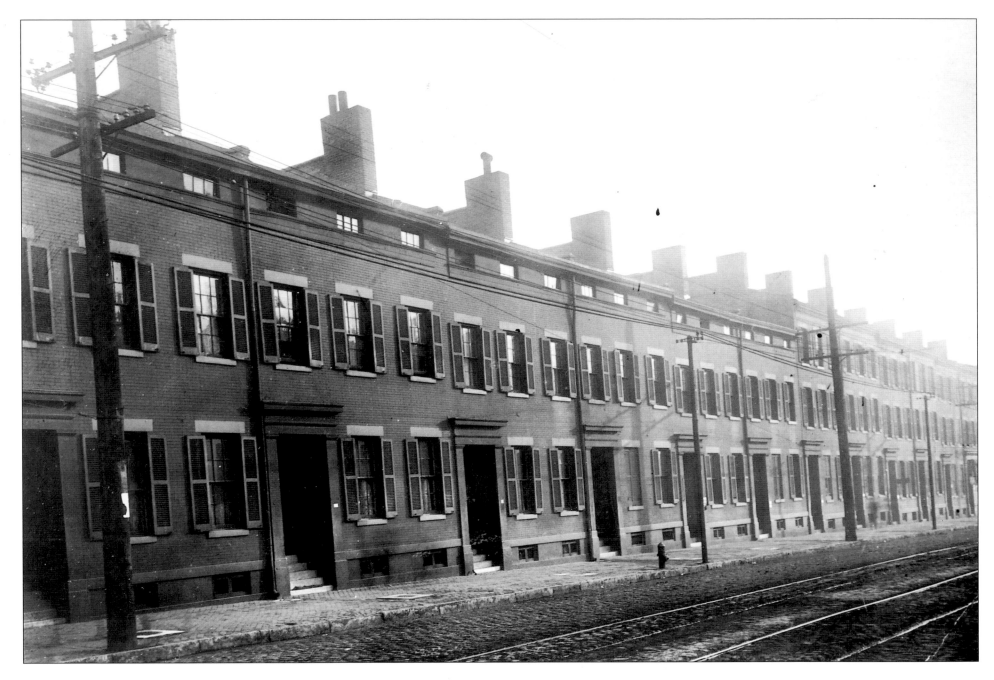

South Broadway, circa 1910. Auguste Chouteau, one of the founders of St. Louis, originally owned the land where these row houses stand. Upon his death in 1829, the land was deeded to the city of St. Louis for the support of public schools. Almost twenty years later, the city still had not grown far enough away from the riverbank to utilize the land, and it was leased to prominent merchant capitalist Edward Walsh. He built the twelve-unit row house seen here, known as Walsh's row.

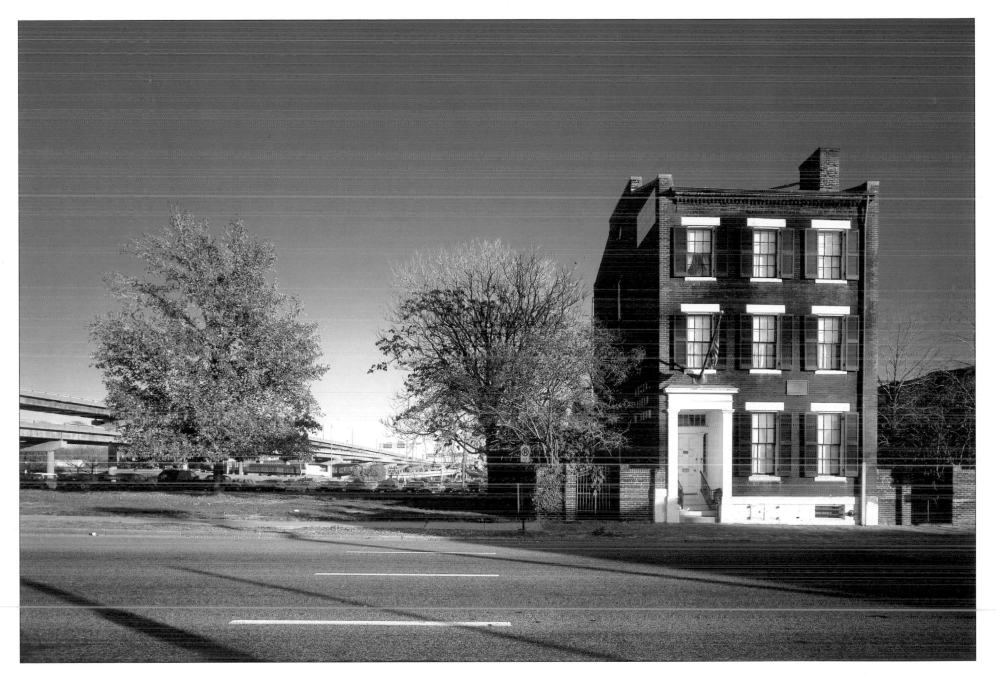

Today, only one row house remains. Second from the end of the original row, this house was the birthplace and boyhood home of Eugene Field, journalist and poet best known for his children's verses "Little Boy Blue" and "Wynken, Blynken and Nod." Mark Twain dedicated a plaque on the house in Field's honor in 1902. Also of historical note: Field's father, Roswell, a prominent local attorney, represented Dred Scott in his action for freedom. The rest of the row, long since derelict, was demolished in the 1930s.

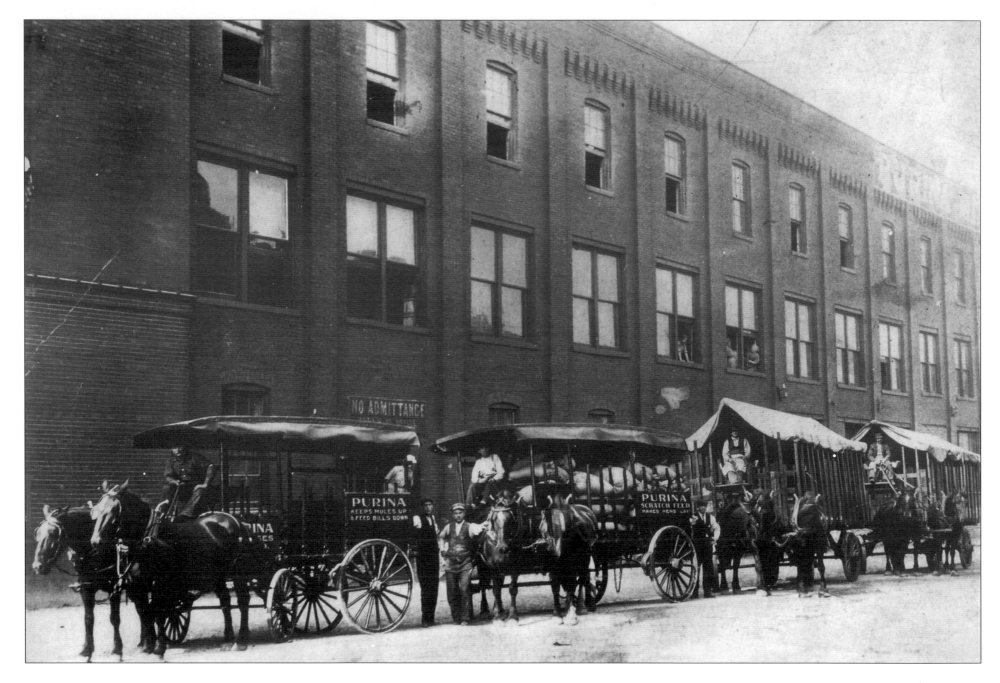

Eighth and Gratiot streets. William Danforth was a bookkepper and salesman for a small St. Louis feed store in 1893, but quickly became partner and then president of the Robinson-Danforth Company. Success with a health-food cereal (Purina Wheat) and the endorsement of a Dr. Ralston led to a name change in 1902, and the company became Ralston Purina. Their original product line was horse and mule feed. In this early 1900s photo, one wagon bears the slogan "Keeps Mules Up and Feed Bills Down"

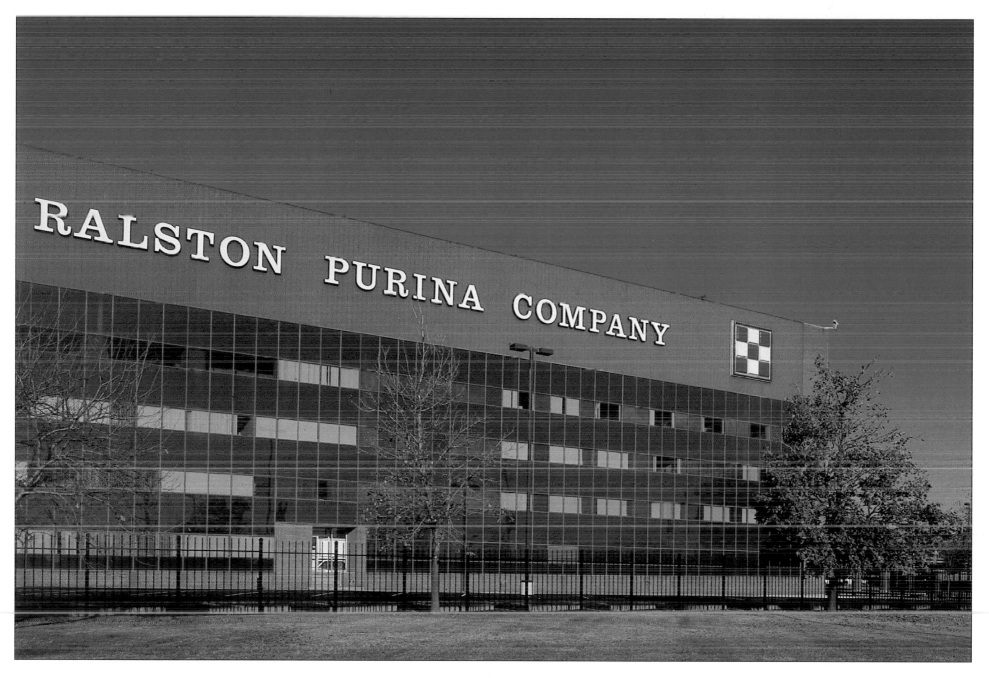

The now-famous checkerboard logo was adopted in 1902, and Ralston Purina
world headquarters, still in the same location, is now known as Checkerboard
Square. The company branched out from animal feeds and breakfast cereals
in the 1920s, essentially inventing the pet food market. Today, RP is the
largest producer of dog and cat food in the world and employs over 20,000
employees. The company has worked to help redevelop the surrounding
LaSalle Park neighborhood.

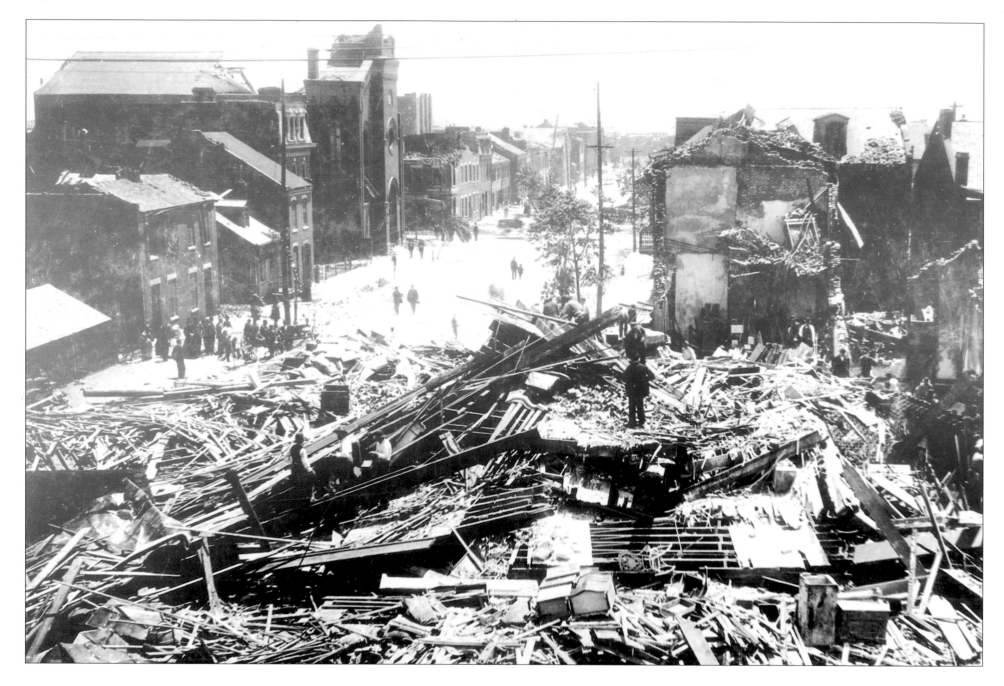

Lafayette (then known as Soulard) and Broadway, May 27, 1896. Perhaps the worst tornado in recorded St. Louis history, the cyclone of 1896 ripped through the city, touching but not greatly damaging the Eads Bridge, but flattening much of the near south side. At least 140 people were killed (some estimates range above 300), over 1,000 severely injured, many of them struggling immigrants living in homes between Lafayette Square and the river. More than eight thousand buildings were destroyed, and contemporary damage estimates surpassed ten million dollars.

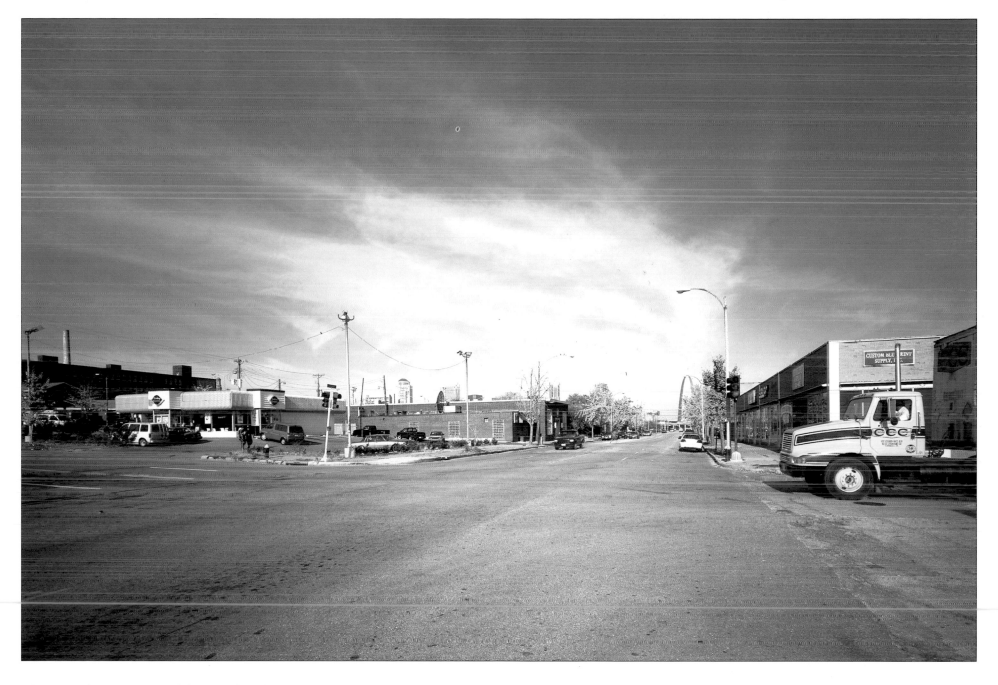

The tornado was a natural disaster, but the city's handling of the aftermath was a manmade disaster. The victims, many of them German immigrants, appealed to the city for disaster relief and loans, but were met with admonitions to be brave and self-reliant. Despite the city's lack of relief planning, the close-knit community pulled together and did manage to rebuild much of the neighborhood. However, certain areas never fully revived and eventually lapsed into the sort of nondescript semi-industrial type seen here.

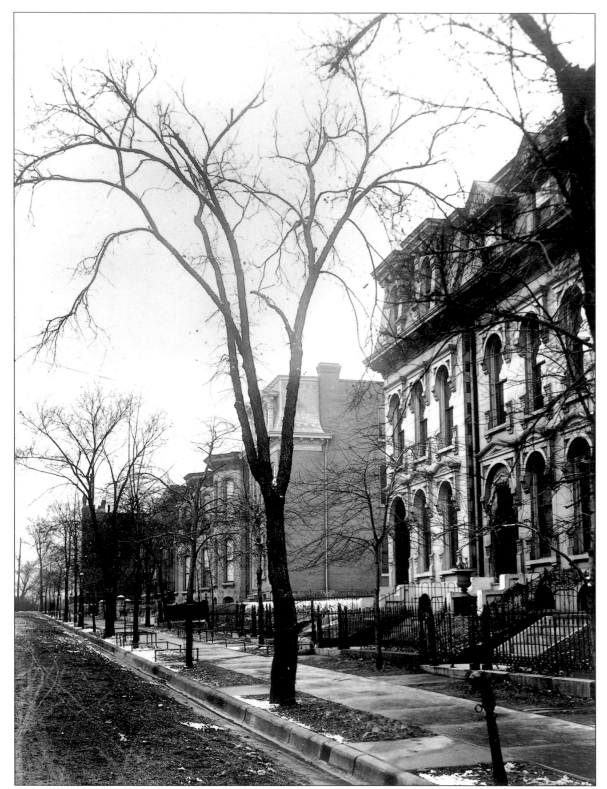

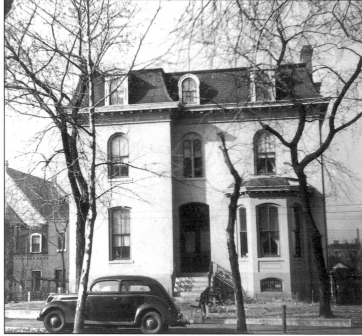

North side of Kennett Place, early 1890s. One of the many elegant private streets in the genteel Lafayette Square neighborhood. Lafayette Park, the city's first, was created in 1836 on the high point of the old French common land. The area remained relatively undeveloped until the 1850s when the surrounding streets became a fashionable "suburban" enclave for the city's wealthiest families, and a flurry of construction began. Benton Place, the city's second private place, completed in 1867, was lined with mansard-roofed mansions (*inset above*).

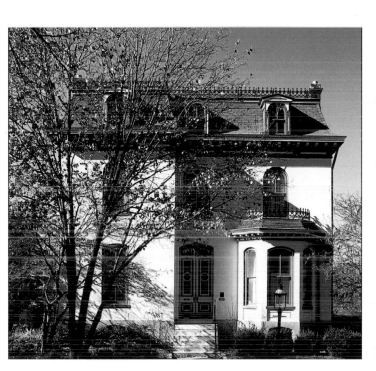

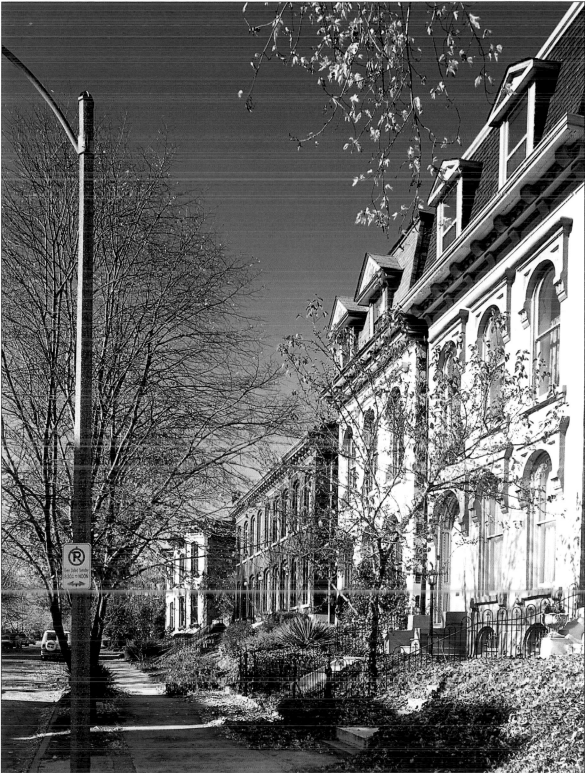

Both the park and the Lafayette Square neighborhood were badly damaged by the tornado of 1896. Thanks to the personal wealth of the inhabitants, many of these beautiful homes were quickly rebuilt, and others were replaced with huge Romanesque mansions. However, the sprawl of the city was encroaching on this exclusive area, and residents began moving west. After a long decline, Lafayette Square was rediscovered in the 1960s, and today is once again a vibrant and now historic neighborhood.

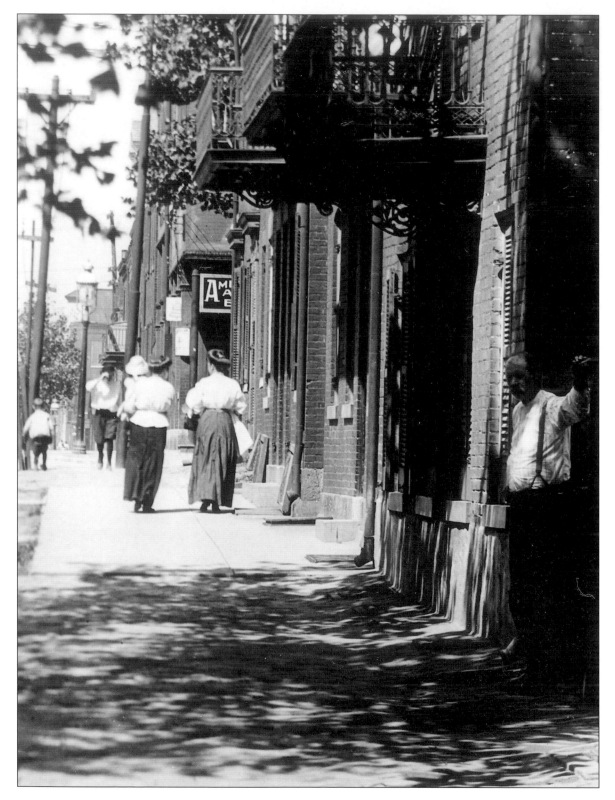

Eighth Street, near Soulard Market, 1910s. Originally settled by the French, the Soulard neighborhood, with its plentiful work opportunities in factories and breweries, became the point of entry for many recent immigrants. Around the central farmers' market, there grew up communities of Croatians, Czechs, Hungarians, Italians, and most of all, the "Southside Dutch" (Germans). In these insular "support communities," people spoke their own languages, published community newspapers, and built ethnic churches. When the 1896 tornado partially destroyed the area, these close-knit ethnic communities rebuilt Soulard.

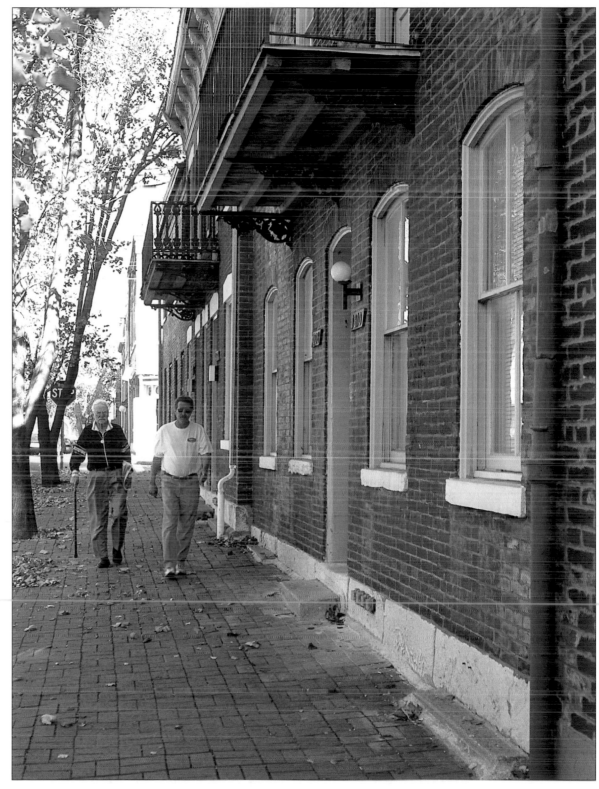

Today on the National Register of Historic Places, Soulard is an eclectic hodgepodge of 19th century styles loosely described as "vernacular." Eighth Street displays Soulard's characteristic red-brick row houses. Buildings date mostly to the first half of the 19th century, and there are examples of a type of flat thought to be unique to St. Louis, in which the second floor is accessed via a street-level tunnel through the first floor leading to the back-porch stairs. The intricate wrought-iron balconies are a reminder of St. Louis' Creole ancestry. The Soulard area remains a true walking neighborhood with the market, cafes, and shops nestled among the homes.

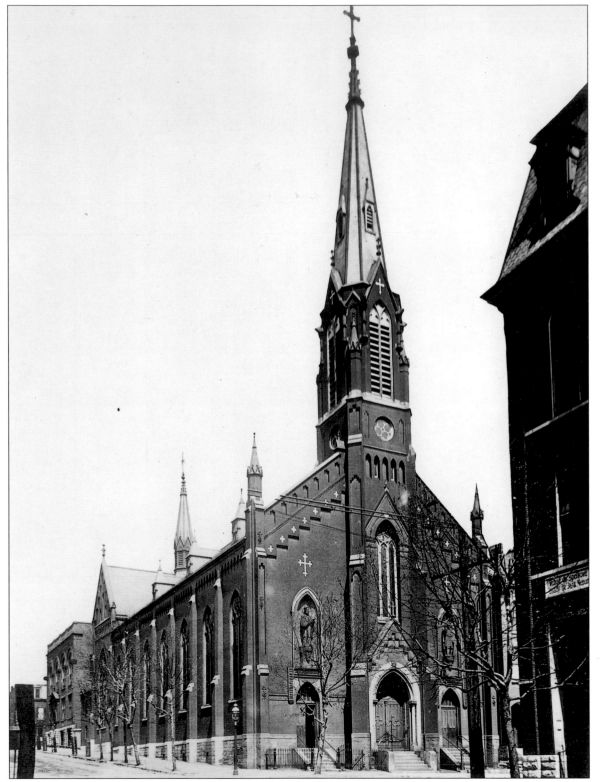

Soulard and Eleventh, circa 1890s. The first Czech Catholic church in America, established 1854 (this building was completed in 1870). South St. Louis in the 1850s was a patchwork of recent immigrants—Czech, Croatian, Hungarian, German, Italian, Irish, Lebanese—all drawn by the work opportunities afforded by the city's plentiful breweries, flour mills, iron foundries, tobacco and cotton factories, and brick manufacturing. They had one thing in common—most of them were Catholic. St. John Nepomuk served the surrounding Czech area known as Bohemian Hill.

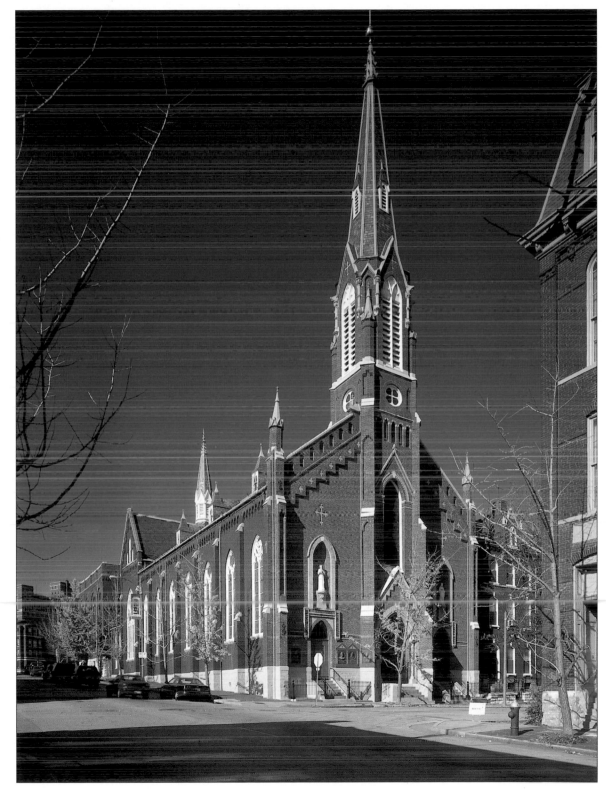

Today, St. John Nepomuk is on the National Register of Historic Places. Though nearly destroyed in the tornado of 1896, the parish rebounded and rebuilt. At one time, it supported two schools and a print shop where the local Czech-language newspaper was printed. The rise of street-cars, and then automobiles, sounded the death knell for most of St. Louis' ethnic neighborhoods, but the churches remain: St. Joseph's Croatian, St. Mary of the Victories (Hungarian), St. Agatha (one of several German), St. Ambrose (Italian), St. Vincent (one of several Irish), and St. Raymond (Lebanese).

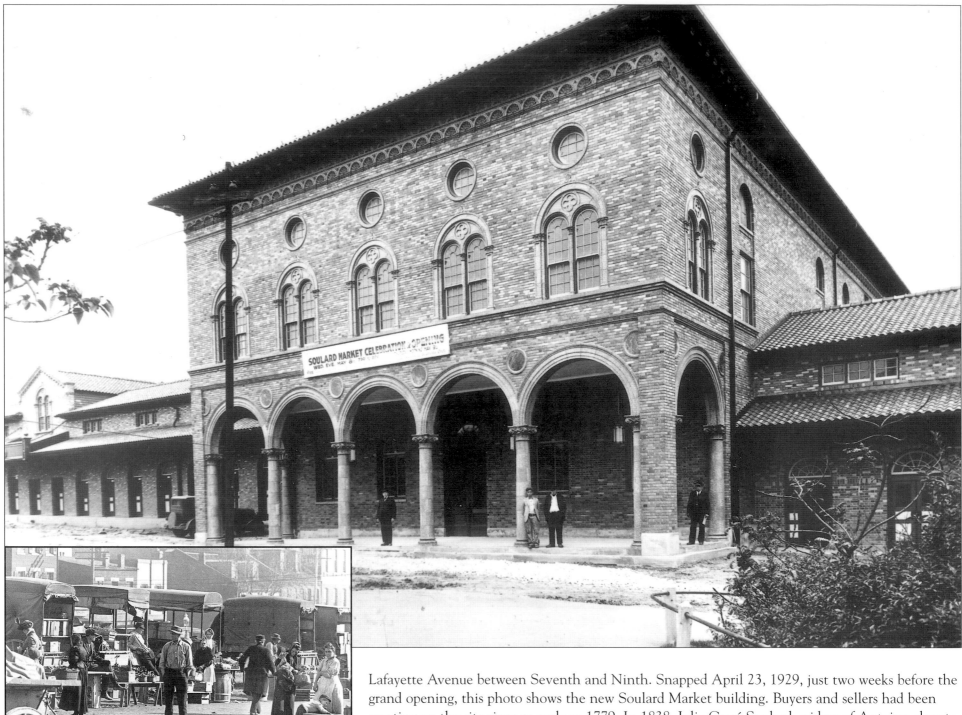

Lafayette Avenue between Seventh and Ninth. Snapped April 23, 1929, just two weeks before the grand opening, this photo shows the new Soulard Market building. Buyers and sellers had been meeting on the site since as early as 1779. In 1838, Julia Cerré Soulard, widow of Antoine, donated the two blocks to the city of St. Louis, stipulating that the land continue to be used as a public marketplace, and shortly thereafter the first permanent building was erected. *Inset:* Farmers using their wagons as stalls in the 1910s. The earliest building was destroyed in the tornado of 1896.

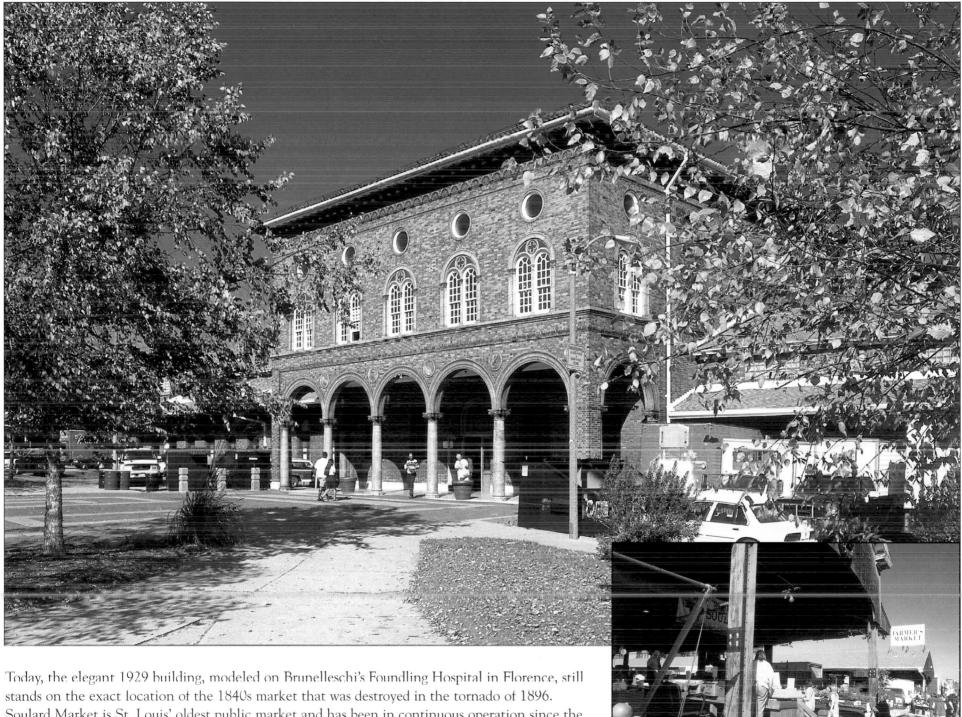

Today, the elegant 1929 building, modeled on Brunelleschi's Foundling Hospital in Florence, still stands on the exact location of the 1840s market that was destroyed in the tornado of 1896. Soulard Market is St. Louis' oldest public market and has been in continuous operation since the 1770s. The 275-stall structure has grown somewhat since 1929, but several of the same family produce businesses are still represented today, seventy years later. *Inset:* crowds still flock to the fresh flowers, fruit, and vegetables, dairy, meat, fish, and abundance of other household items.

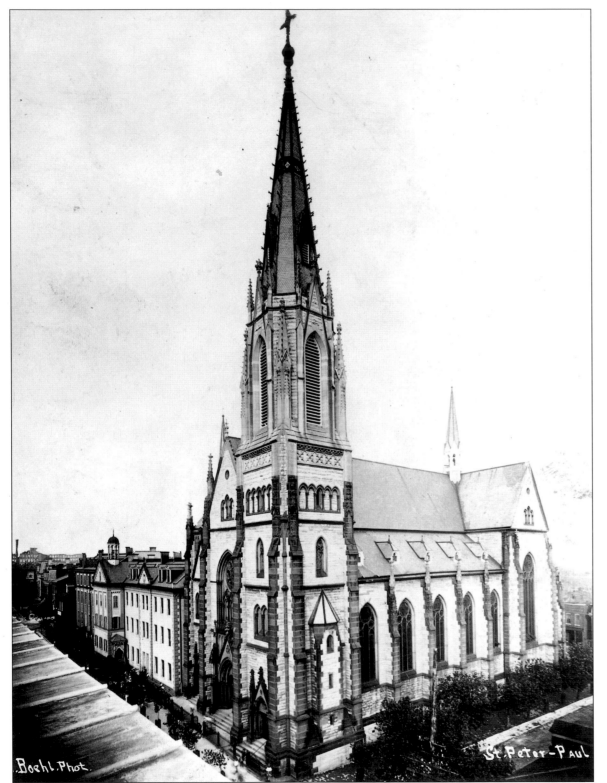

Seventh and Allen Streets, circa 1890. Founded in 1849 for a predominantly German congregation, SS. Peter and Paul was first housed in a temporary one-story structure, then a new brick building, and finally, in 1875 on the same site, this German Gothic Revival style edifice. Built of limestone from Grafton, Illinois, and designed by Franz Georg Hempler, SS. Peter and Paul could accommodate 1,700 people in its heyday, but was frequently so full that overflow crowds spilled into the church basement chapel.

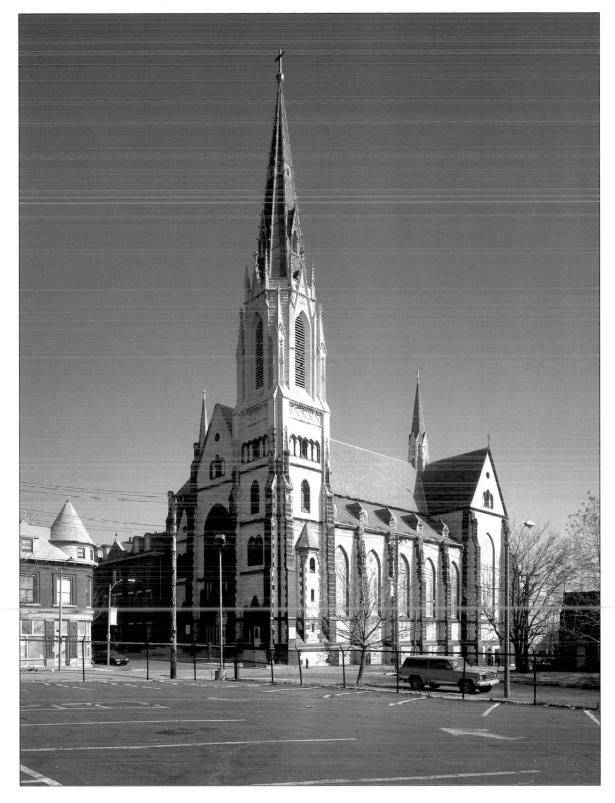

Today, SS. Peter and Paul's 214-foot spire still towers over the well-preserved Soulard district. The interior reveals beautiful stained-glass windows, imported from Innsbruck, and oil-painted stations of the cross from Beuron, Germany. During renovations in 1984, the seating was made more intimate and now holds around 400. This historic church now draws from a much larger area than just its immediate neighborhood: three-quarters of parishioners live outside the parish boundaries.

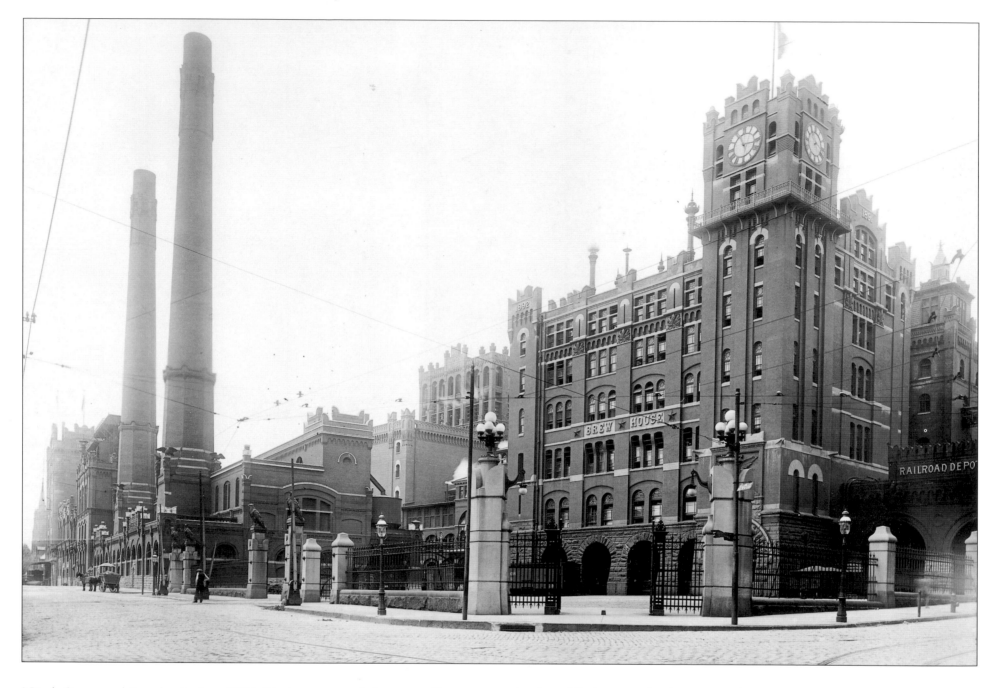

Ninth Street and Pestalozzi, circa 1920. Having surpassed the one million barrel mark in 1901, Anheuser-Busch was well on the way to becoming the largest brewery in the world. Eberhard Anheuser founded the company in 1860, when he bought the extant Bavarian Beer Co. He was joined in business by his astute son-in-law, Adolphus Busch, in 1864. It was Busch who developed Budweiser, the first national brand, in 1876. Three years later, the company was renamed Anheuser-Busch Brewing Association. The brewery complex was essentially self-contained, with such facilities as blacksmith, wagonmaking, boxmaking, cooperage, even cork manufacture. Later, glassworks and refrigerated rail cars were added.

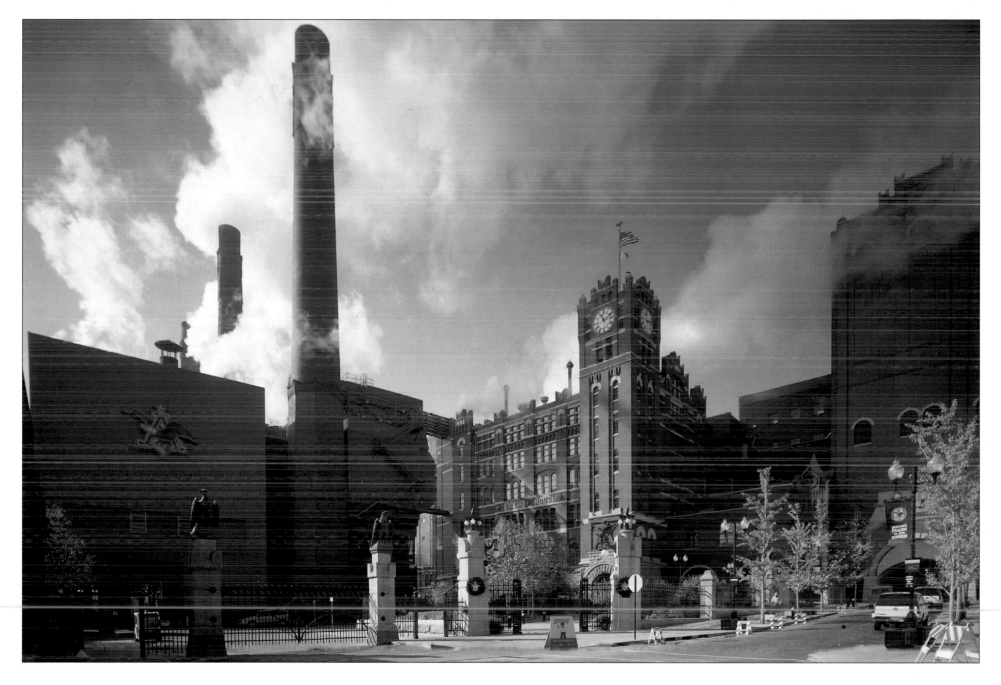

The one-hundred acre Anheuser-Busch brewing complex holds three National Historic Landmarks: the Clydesdale Stables, the Lyon School, and the Brew House seen here. Built in 1891–2, the Brew House, with its distinctive clock tower, is built in a Victorian Gothic style, but presides over a wide range of architecture on the campus. In 1901, the St. Louis brewery set a record with 1.25 million barrels; today this brewery alone produces 13.6 million barrels, and worldwide production for 1999 was 92 million. A-B owns breweries nationwide and a variety of subsidiaries from refrigerated rail cars and metal containers to Sea World and Busch Gardens theme parks.

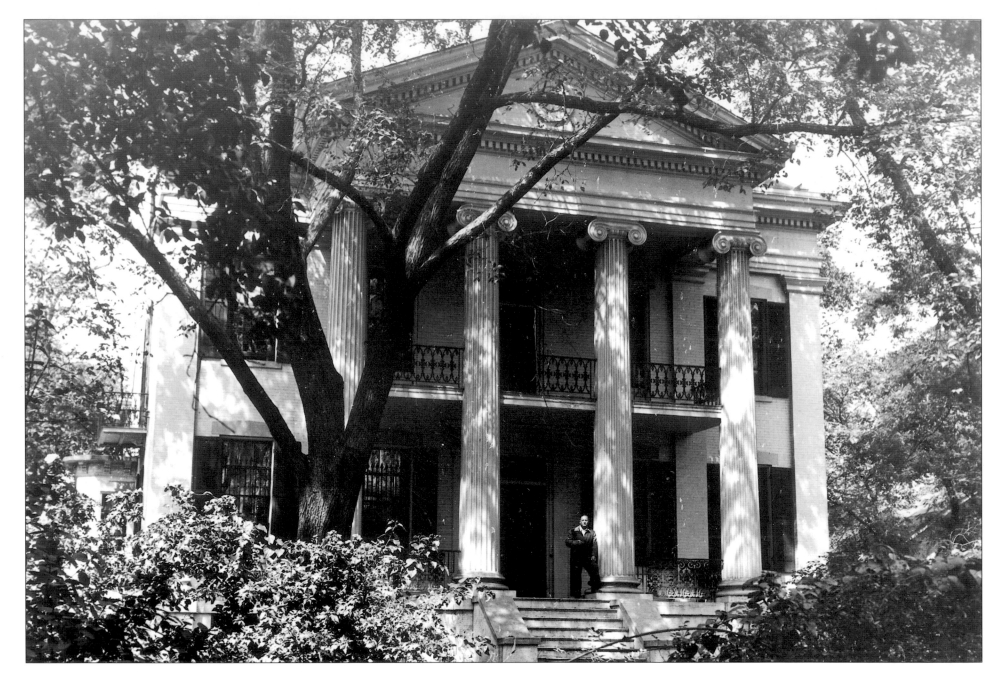

In some disrepair, circa 1946. In 1848, well-to-do widow Odile Delor Lux purchased this lot from the city; it was formerly part of the Commons. Her second husband Henri Chatillon, guide and hunter with Francis Parkman on the Oregon Trail, built the original structure soon after. When wealthy French physician Nicolas DeMenil purchased the house in 1856, it was still considered a farmhouse, and DeMenil and his wife (St. Louis aristocrat Emilie Chouteau) used it as their summer retreat. In 1861, they commissioned English architect Henry Pitcher to transform the building into a Greek Revival mansion, a style already then considered old fashioned, but one which Emilie associated with Southern charm.

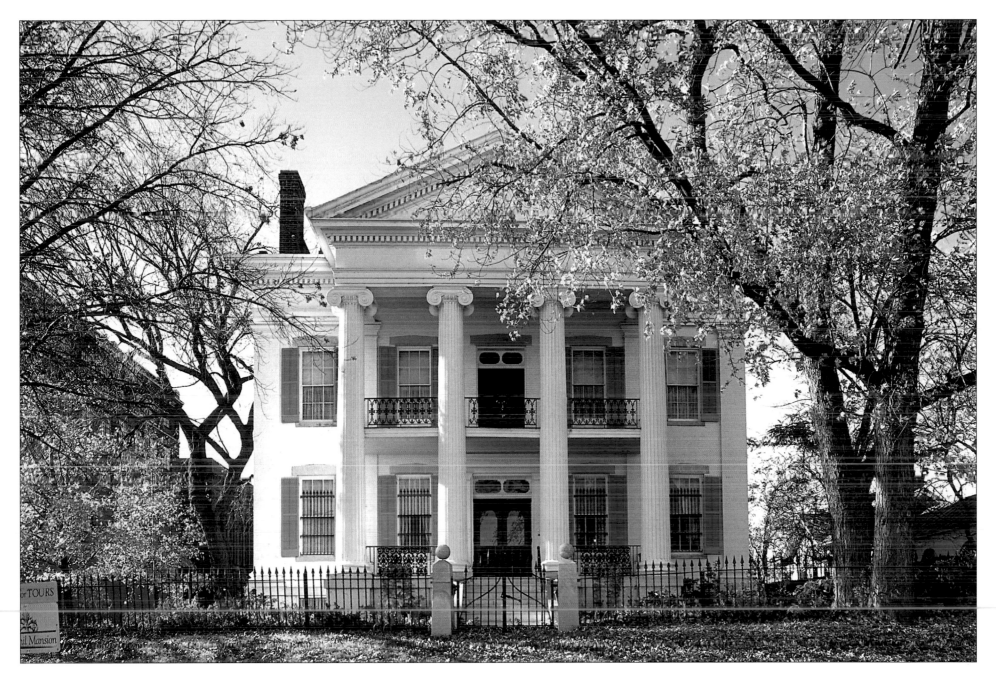

After a long slide into disrepair, and a stint as a tourist attraction based on the caves that lie beneath the area, the mansion was slated for demolition in the 1960s to make room for interstate 55. Preservationists fought to save it as one of the few remaining examples of Greek Revival architecture in St. Louis. In 1964, the Landmarks Association was able to purchase and restore the house, and it is now run as a museum by the Chatillon-DeMenil House Foundation. The elegant iron railings are original, and surprisingly so are the first-floor window bars. Known Southern sympathizers during the Civil War, the DeMenils had them installed to protect the house from pro-Union vandals.

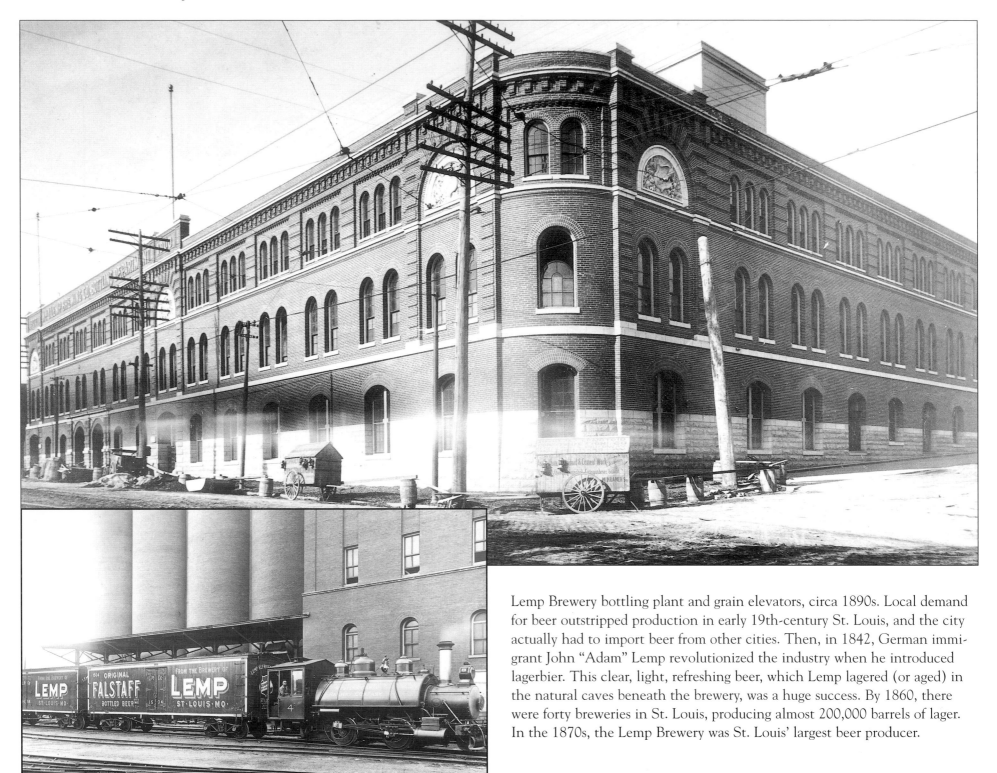

Lemp Brewery bottling plant and grain elevators, circa 1890s. Local demand for beer outstripped production in early 19th-century St. Louis, and the city actually had to import beer from other cities. Then, in 1842, German immigrant John "Adam" Lemp revolutionized the industry when he introduced lagerbier. This clear, light, refreshing beer, which Lemp lagered (or aged) in the natural caves beneath the brewery, was a huge success. By 1860, there were forty breweries in St. Louis, producing almost 200,000 barrels of lager. In the 1870s, the Lemp Brewery was St. Louis' largest beer producer.

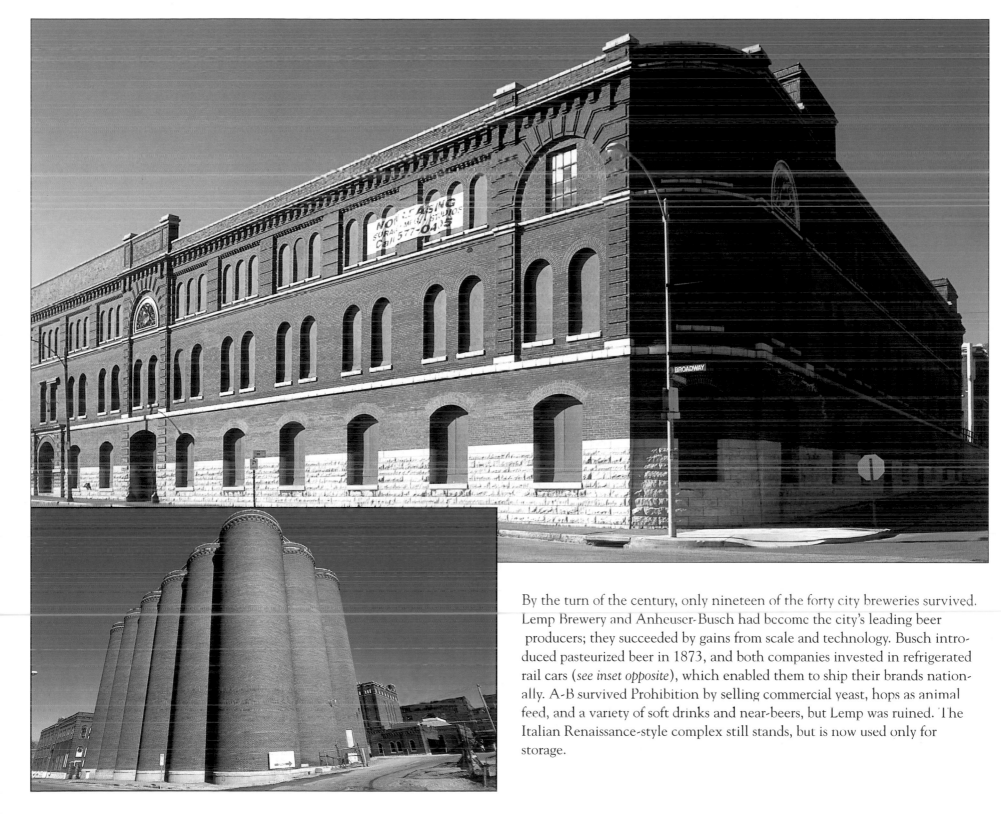

By the turn of the century, only nineteen of the forty city breweries survived. Lemp Brewery and Anheuser-Busch had become the city's leading beer producers; they succeeded by gains from scale and technology. Busch introduced pasteurized beer in 1873, and both companies invested in refrigerated rail cars (*see inset opposite*), which enabled them to ship their brands nationally. A-B survived Prohibition by selling commercial yeast, hops as animal feed, and a variety of soft drinks and near-beers, but Lemp was ruined. The Italian Renaissance-style complex still stands, but is now used only for storage.

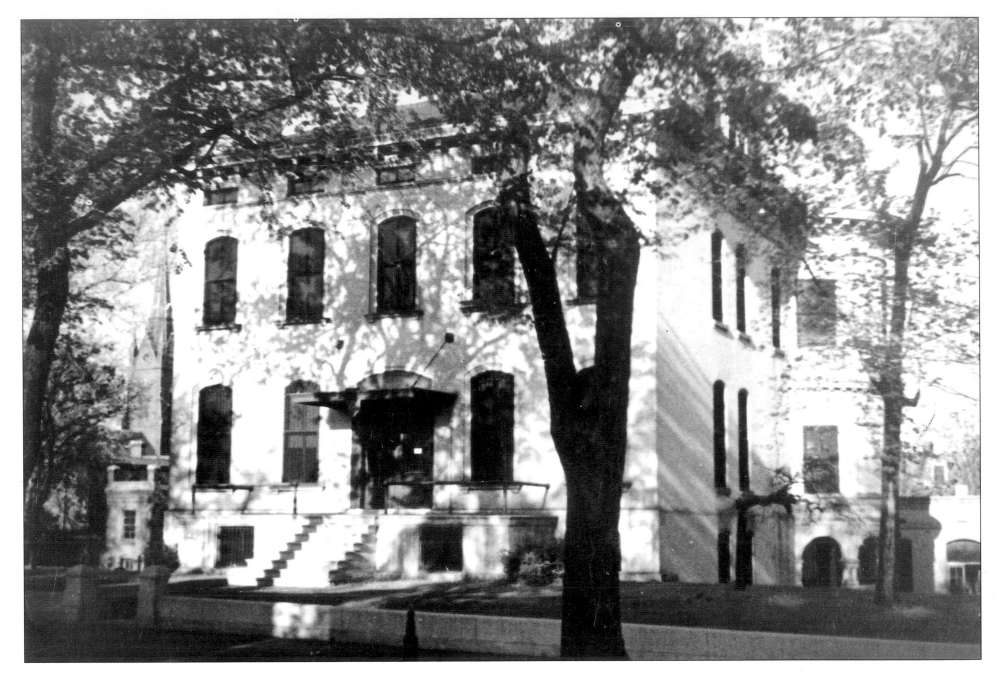

South 13th Street (now DeMenil Place), early 1900s. Built in 1868 by Jacob Feickert, the mansion was purchased by William Lemp, son of Adam, and his wife Julia in 1876 at the peak of the Lemp Brewery's success, and they turned the thirty-three room house into a Victorian showplace. They had five children, but the family was riddled with tragedy. Around the time of this photo, Frederick, the heir apparent to the brewery presidency, died under mysterious circumstances, and the tragedies didn't stop there.

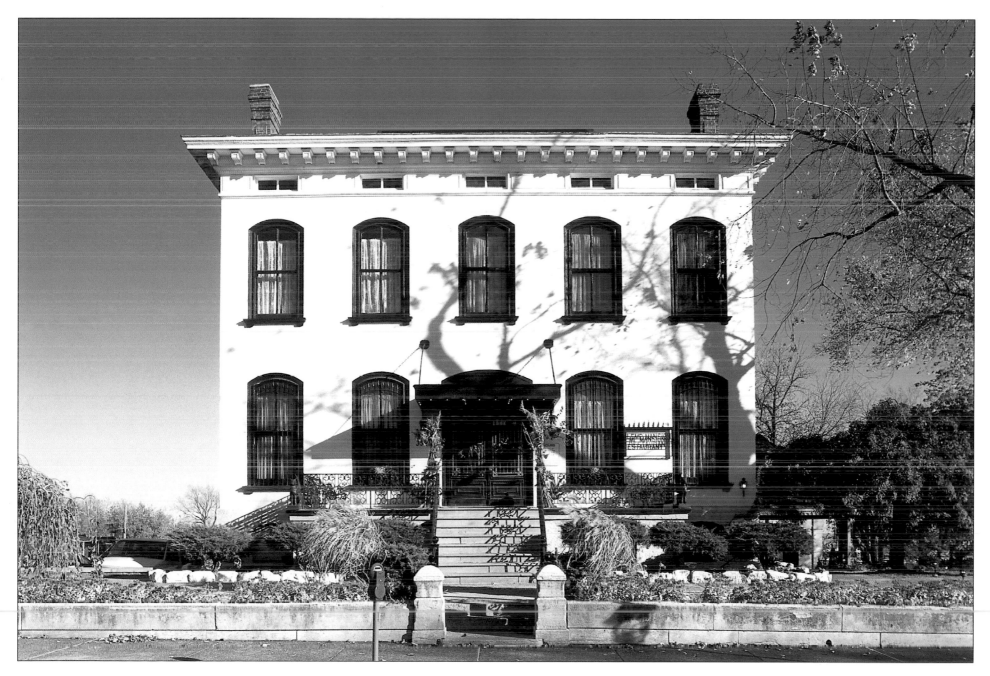

Three years after Frederick's death, William, still grieving the loss of his son, shot himself here. After unhappiness in love, daughter Elsa also ended her life. Prohibition ruined the brewery, and after the property was sold for eight cents on the dollar in 1922, William Jr. committed suicide in the same room his father had. After years of use a boarding house, today the Lemp Mansion was purchased and restored privately. It is now open to the public as a restaurant and inn and is widely believed to be haunted.

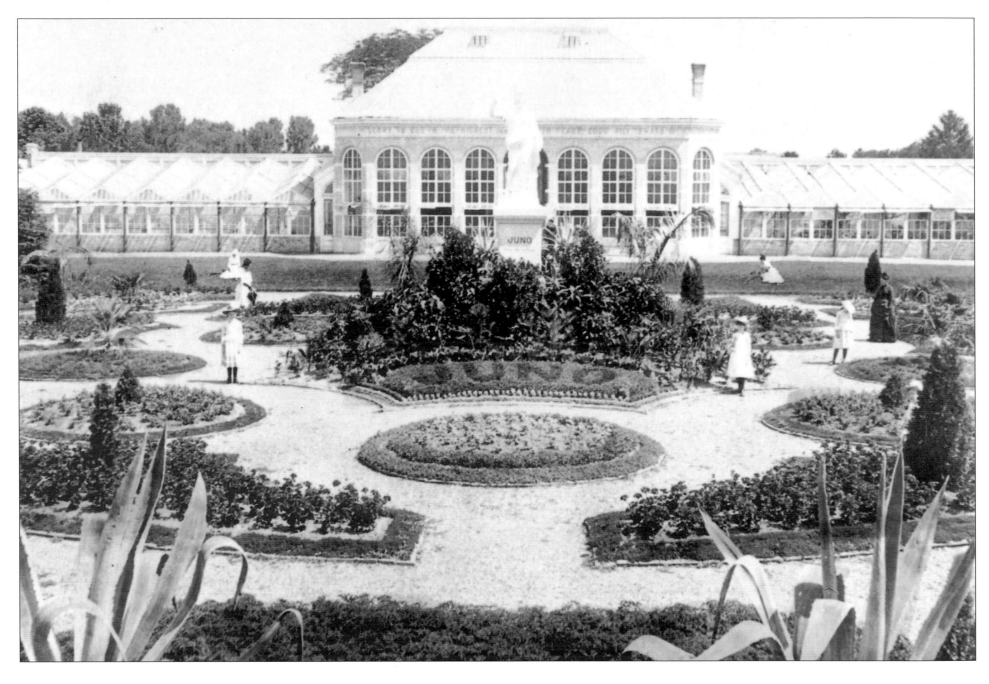

Near the garden's main gate on Flora, 1890s. A native of Sheffield, England, Henry Shaw was just nineteen when he came to St. Louis in 1819 and made a fortune in hardware. As a child he had admired Kew Gardens, and he planned for years to found a public garden for St. Louis. He commissioned George Engelmann, physician and famed botanist, to build the collection.

In 1859, Shaw donated to the city his scrupulously groomed, 79-acre country estate. He would later donate an additional 277 acres (Tower Grove Park) and lease the land surrounding it. Upon his death in 1889, Shaw left his fortune and the lease revenues for the support of the garden.

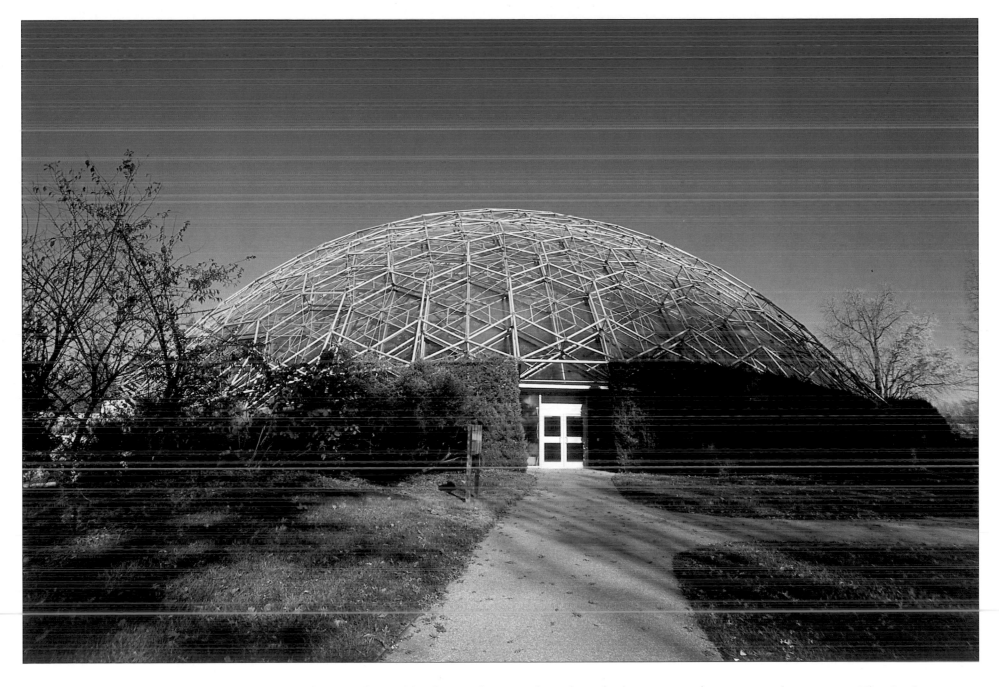

The garden quickly became a major attraction, drawing almost fifty thousand visitors in 1868. In 1904, the great Frederick Law Olmsted, designer of New York's Central Park, was commissioned to design a master plan for future development. The garden evolved with the city, and today only one nineteenth-century greenhouse remains. Seen here is the Climatron, a geodesic dome built in 1960 to house tropical vegetation. The Garden continues to be an active research institution with a world-renowned herbarium of over 4.5 million specimens and an excellent horticultural library. Other highlights include formal rose gardens and a renowned Japanese garden.

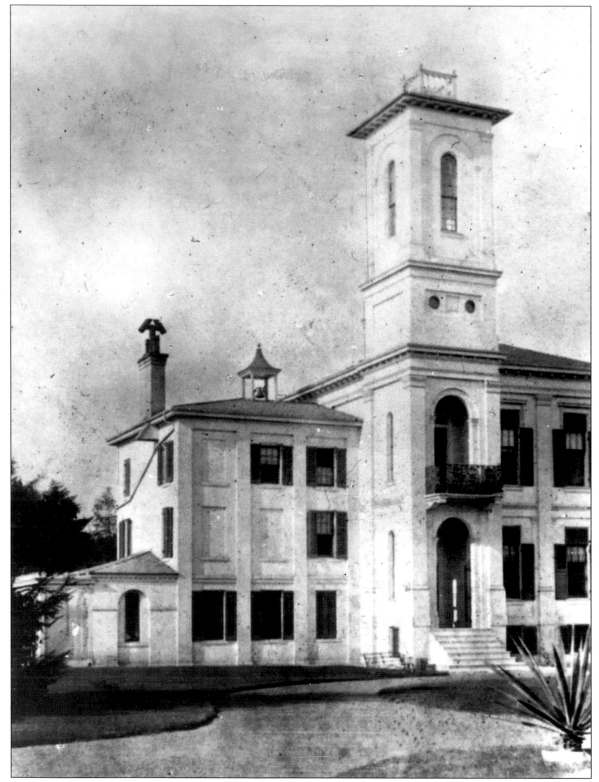

Circa 1865. Like most of his wealthy peers, hardware magnate Henry Shaw maintained both a country villa and a town house. In 1849, he hired architect George Barnett to design a home on property that was, at that time, fields of tall prairie grass and wildflowers far from the city. The Italian Renaissance (Lake Como) style was very fashionable in the period, and the name derived from the tower on the house and a nearby lone grove of sassafras trees.

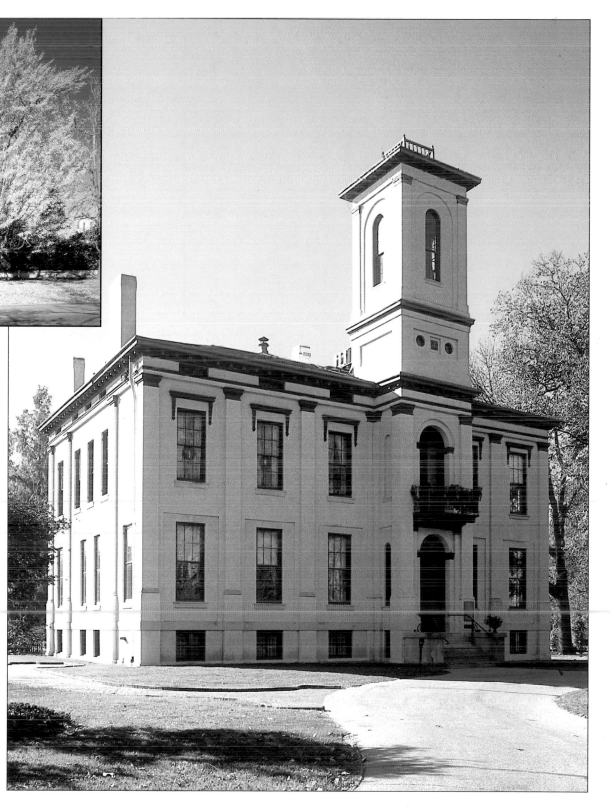

Shaw retired to Tower Grove House, and lived there in the midst of his newly created public garden until his death in 1889. The interior of the house has been restored as a Victorian showpiece and is today open to the public. After Shaw's death, his town house (*above*), located at Seventh and Locust streets downtown, was dissembled and moved to the public garden as well. Today, this attractive Renaissance palazzo-style house provides administrative offices for the Garden.

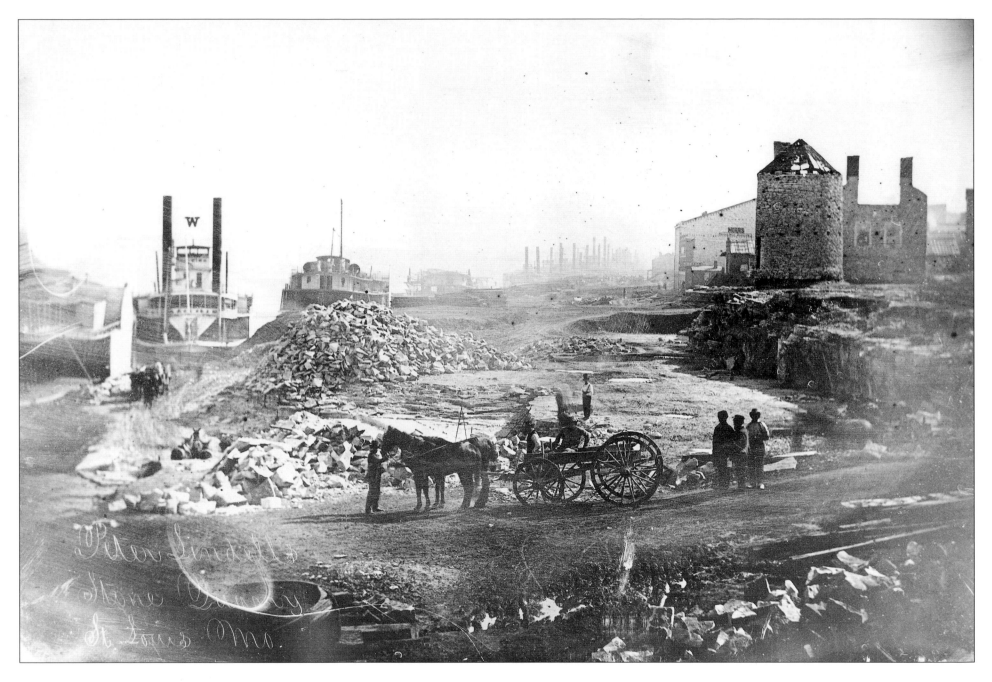

Looking south from Mullanphy Street, 1850. This daguerreotype by Thomas Easterley shows Peter Lindell's stone quarry at the junction of the river and Bates Street. The bluff that originally bordered the river here had been all but leveled by the quarrying of stone. At right, the decrepit round structure was the old windmill of original French settler Antoine Roy. In 1811, the northern boundary of the city was defined by Roy's mill.

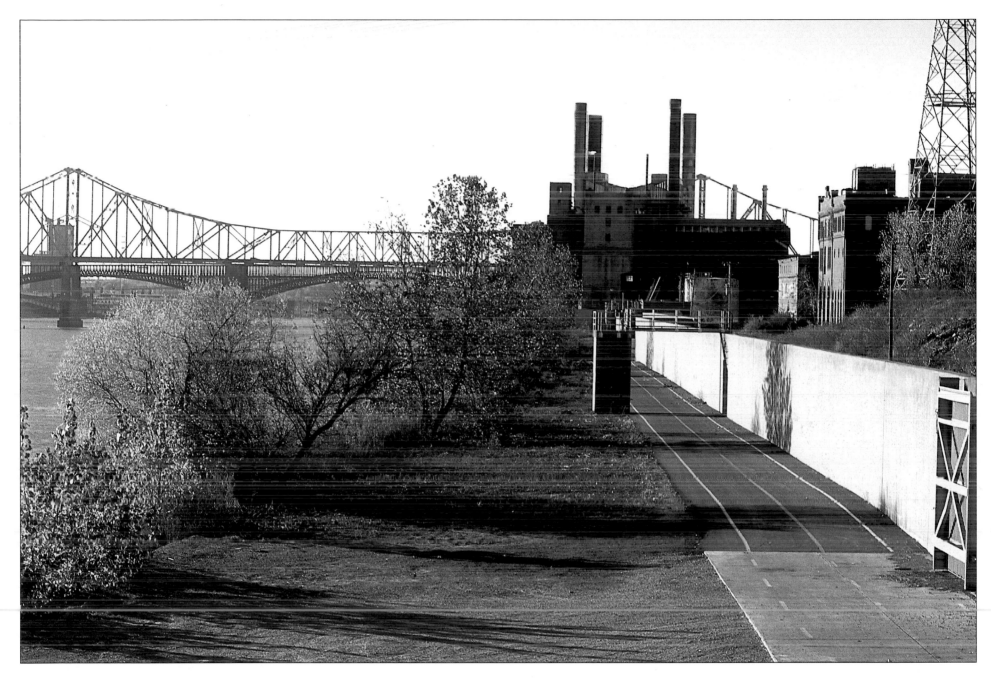

The same scene today is changed, but just as industrial. Factory smokestacks
crowd the riverfront here. Milling of grain into flour was a St. Louis specialty
until the later half of the nineteenth century. As the city grew and Roy's mill
fell into ruin, the tower became known as Spanish tower. It was thought to
have been part of Spanish eighteenth-century fortifications from the forty-
year period when Spain held the Louisiana Territory.

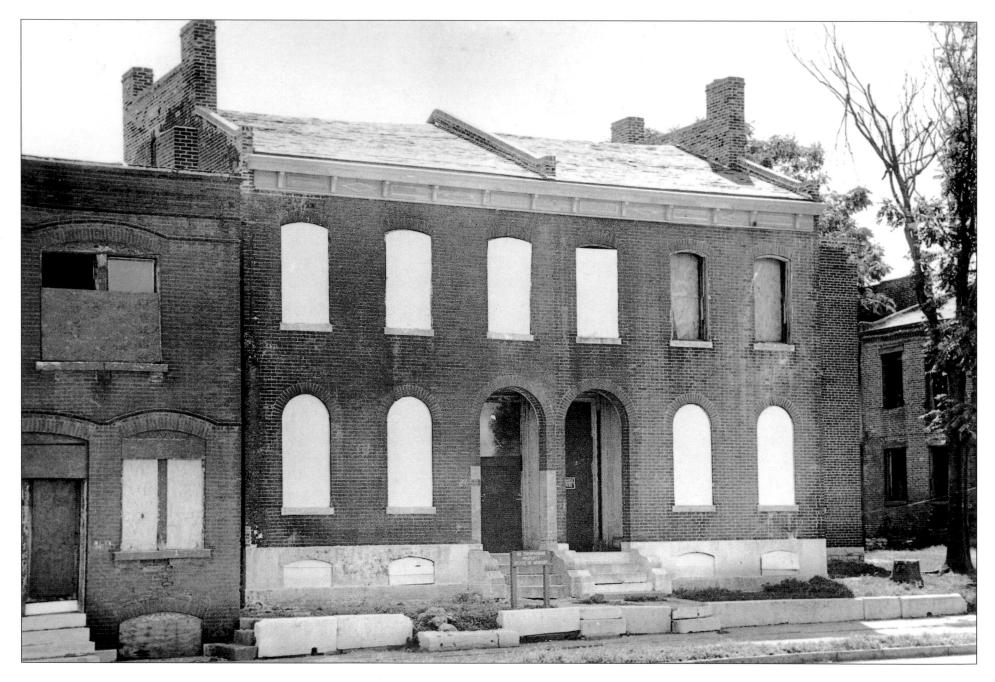

Delmar Boulevard shortly before renovation by the State of Missouri in the 1980s. At the turn of the century, Morgan Street, as Delmar was then called, was a busy, densely populated blue-collar district of African-Americans and German immigrants. The nearby "Chestnut Valley" was the location of notorious dive bars and honky-tonks in which Joplin performed. He and his wife Belle moved from Sedalia, Missouri, into this modest walk-up flat in 1902 and lived in St. Louis for nine years before moving to New York.

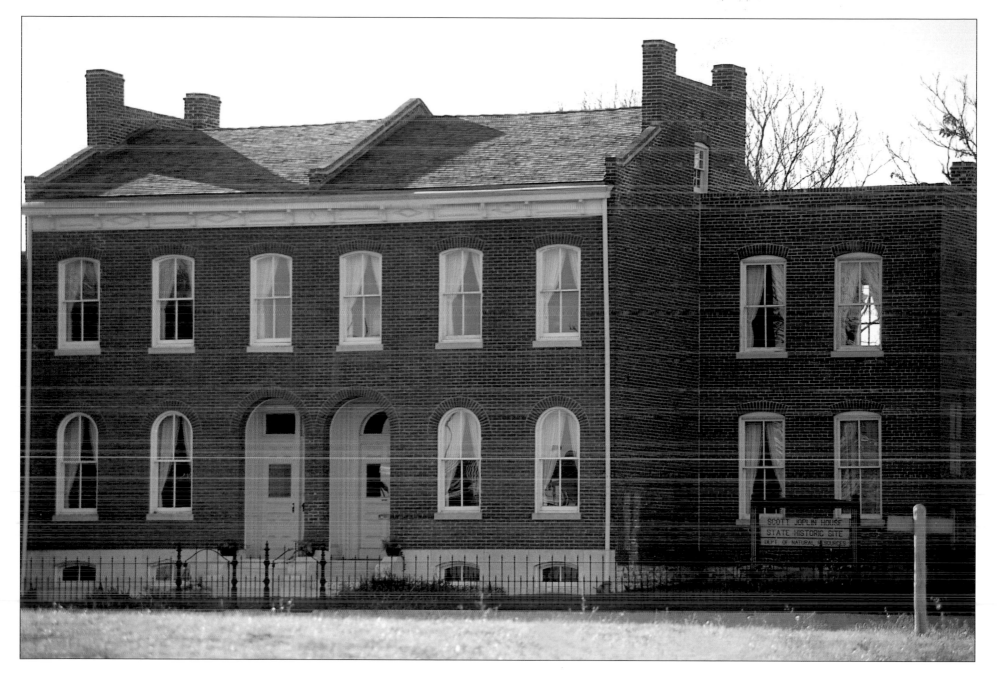

Fallen into gross disrepair by the latter half of the twentieth century, this block of buildings
was slated for demolition. Thankfully, its historical context was discovered, and it was
declared a National Historic Landmark and State Historic site. Joplin here composed one of
his most famous works, "The Entertainer," among others. Today, the house is a museum
dedicated to the "King of Ragtime." Renovations are also underway on the building next-
door, which will re-create Tom Turpin's famous Rosebud saloon, where Joplin often played.

SUMNER HIGH SCHOOL

Below: "Sumner High School—occupied September 1910," photo from the 56th Annual Report of the Board of Education, 1909–1910. Sumner High opened in a downtown location in 1875; it was the first African-American high school west of the Mississippi. By the turn of the century, community leaders petitioned the board of education to move the school away from the poolrooms and saloons of downtown to its present location. William Ittner, who designed more than fifty St. Louis schools, designed the red-brick Georgian Revival building. The school is named for Senator Charles Sumner, who in 1861 was one of the first prominent politicians to call for full emancipation.

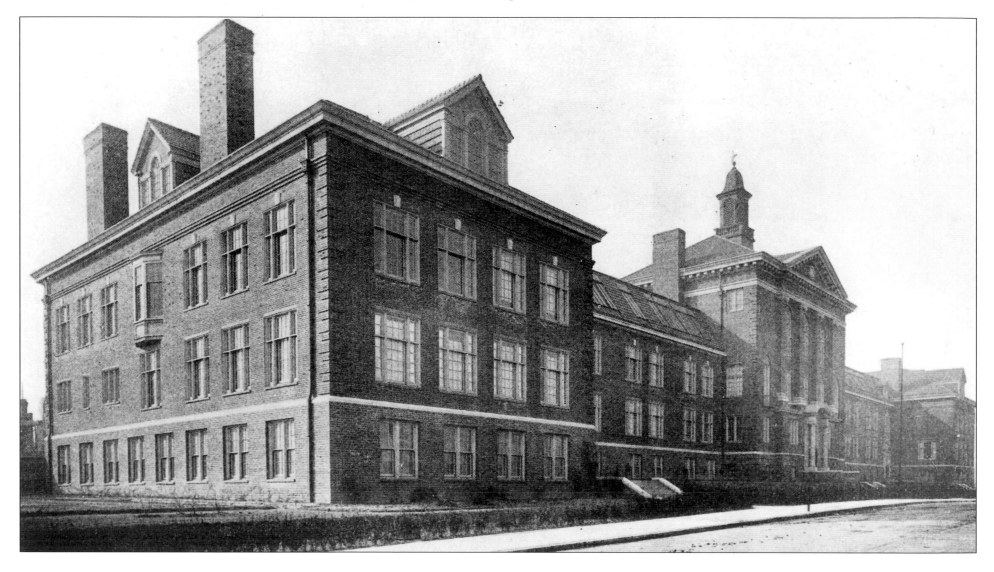

Right: Since 1910, Sumner High has served as a cornerstone of its historic neighborhood, the Ville. The Ville was home to an early branch of the African Methodist Episcopal church, and later the nation's foremost teaching hospital for African-American doctors, in addition to a variety of professional training colleges. Sumner High became a magnet for the brightest, most talented African-American students. Prominent graduates include Tina Turner, Bobby McFerrin, Arthur Ashe, actor-singer Robert Guillaume, activist Dick Gregory, opera singer Grace Bumbry, musician David Hines, educator Julia Davis, and the list goes on.

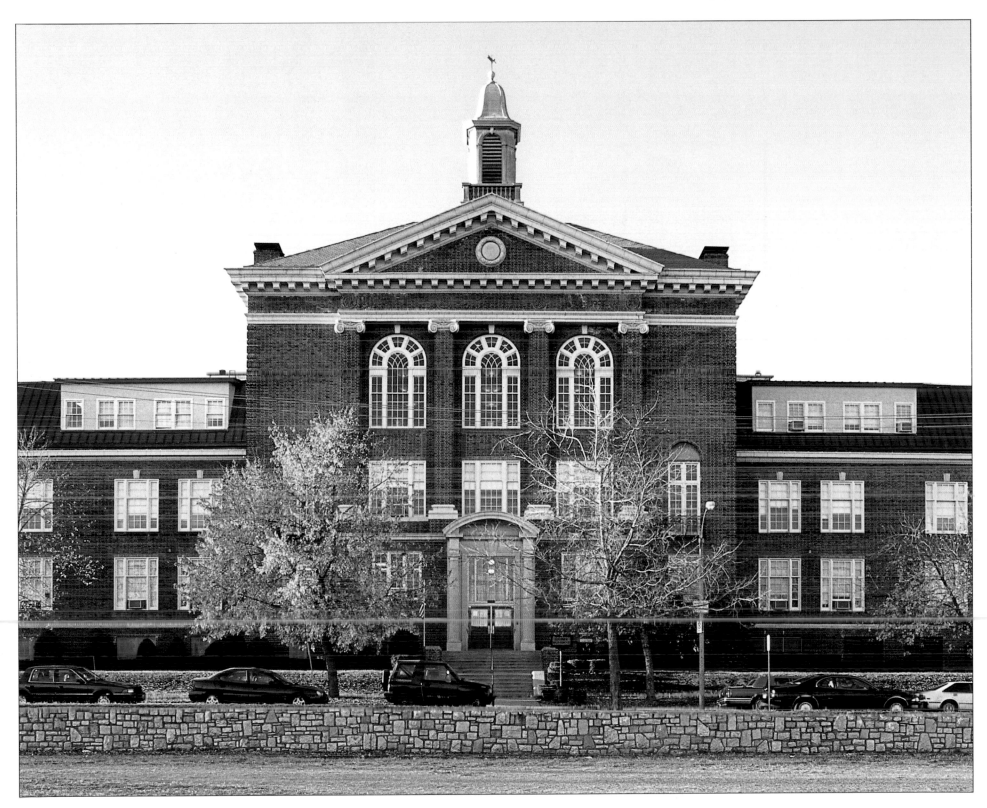

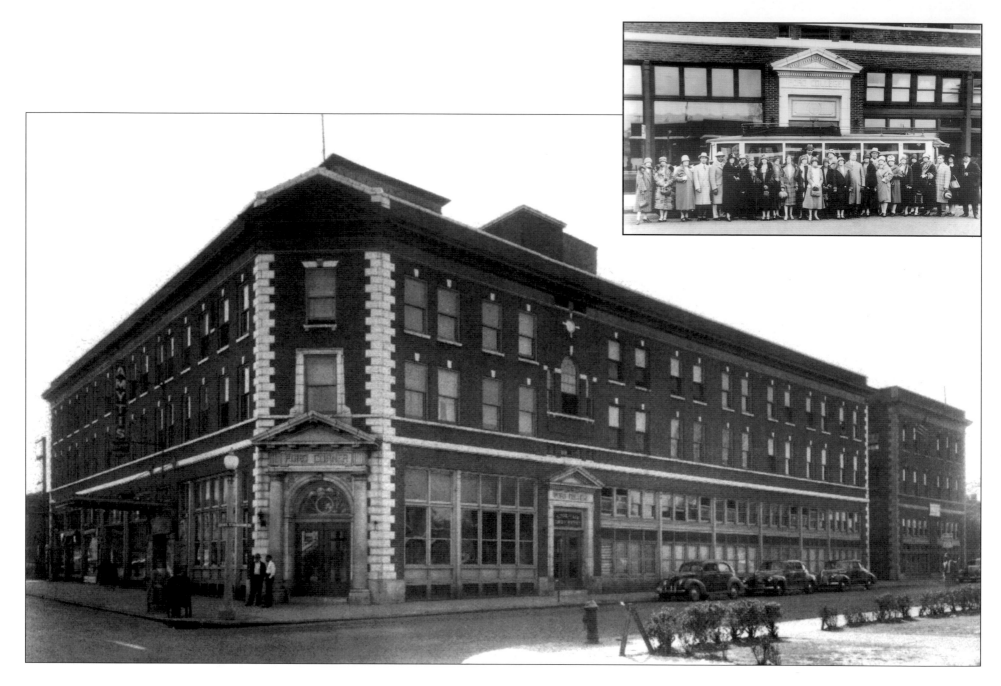

St. Ferdinand and Billups avenues, 1930s. In 1902, Annie Malone moved her business from Peoria to St. Louis. She had developed (and trademarked) a brand of scalp treatment for growing and straightening hair called Poro. In 1917, she built Poro College, where beauticians and salespeople from around the country were trained in Poro products, providing nearly 200 jobs for Ville residents. The college also functioned as a community center. After the 1927 tornado, Poro College housed the homeless and served as a Red Cross relief center. *Inset:* a group of students with Annie Malone in 1927.

Annie Turnbo Pope Malone became one of the Missouri's first self-made millionaires and the nation's first African-American female millionaire. In 1930, she moved the business to a larger market (Chicago), and the building housed first a hotel, and then in 1939, Lincoln University Law School, the state's first African-American university law program. St. James African Methodist Episcopal Church purchased the Poro College building and demolished it in 1965 to build the James House, a senior-citizen apartment complex.

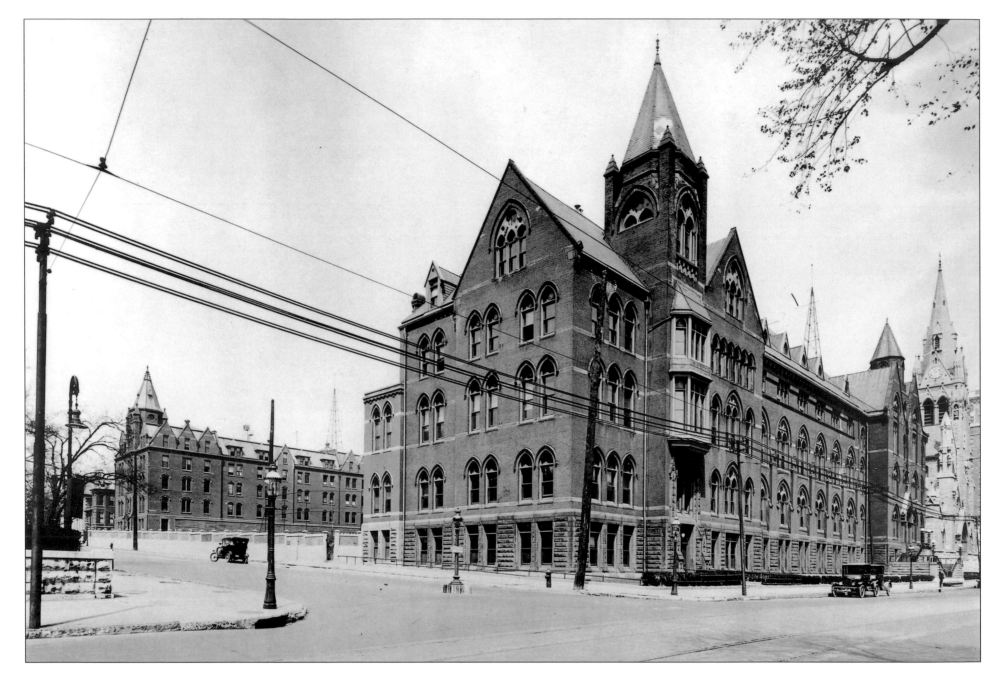

Grand and Lindell, 1925. Designed by Thomas Waryng Walsh, the English Gothic style hall on the corner contained the entire university when it opened in 1888. French Bishop Louis DuBourg founded the school in 1818 as an academy downtown, near Ninth and Lucas. In the 1820s, he invited the Jesuits to take over, and in 1832, St. Louis University became the second Jesuit institution in America (after Georgetown) and the first university west of the Mississippi. St. Francis Xavier Church, constructed in 1898, stands behind the hall.

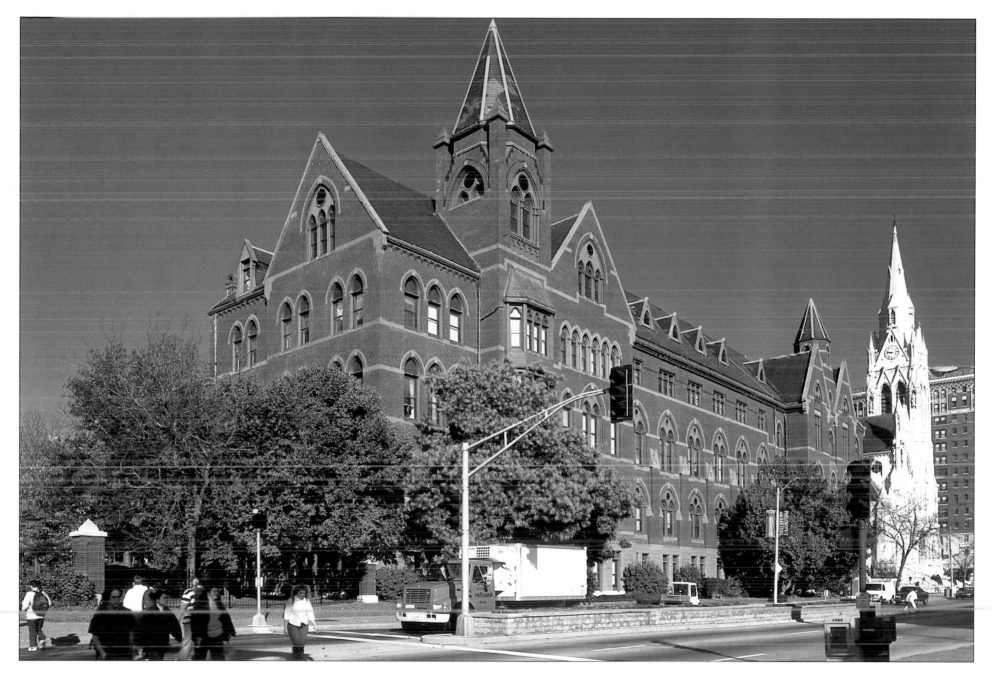

Today, the building is known as DuBourg Hall, and the university has grown dramatically. In 1962, SLU purchased 22 acres of the cleared Mill Creek Valley area for expansion. Several classroom buildings, lecture halls, and an athletic field were constructed on the site. Today, SLU is a leading Catholic institution with over 11,000 students. An anchorpoint in the Midtown community, the university is actively involved in urban redevelopment. Greater St. Louis is also home to Washington University and a campus of the University of Missouri.

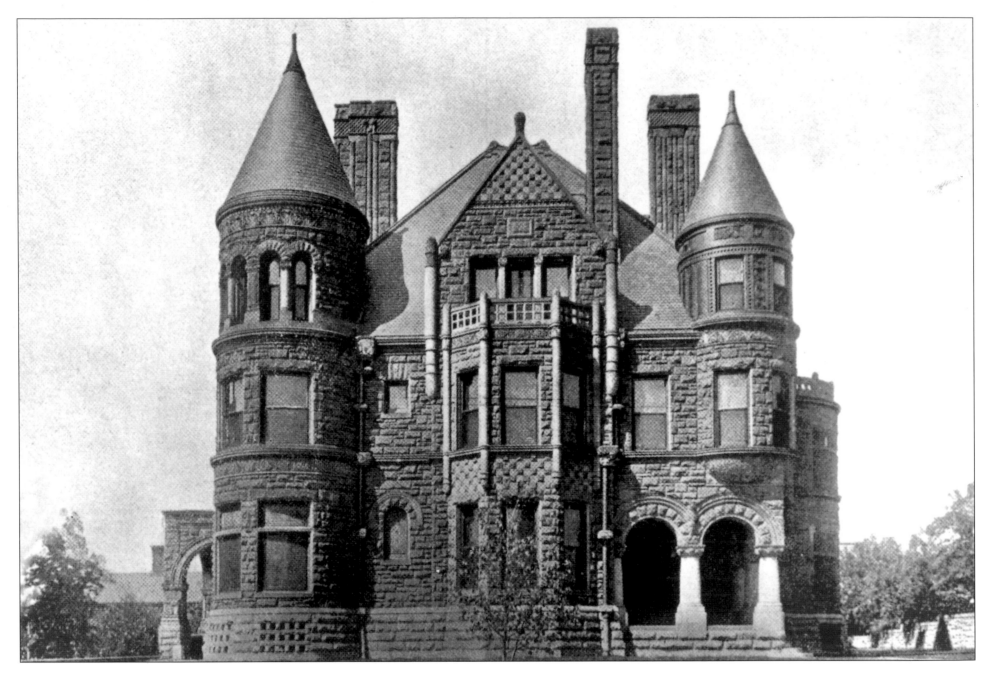

West Pine, 1928 photo from *Missouri's Contribution to American Architecture*. In 1888, woodenware importer Samuel Cupples commissioned Thomas Annan to design this mansion in the Romanesque Revival style that came to be known as Richardsonian Romanesque (after the Boston architect). The home included forty-two rooms, with twenty-two fireplaces, and a richness of interior woodwork never before seen in St. Louis, at a total cost of $500,000 (the equivalent of $15 million in today's currency). In its day, it was one of a row of great opulent Gilded Age mansions built by wealthy St. Louis industrial magnates.

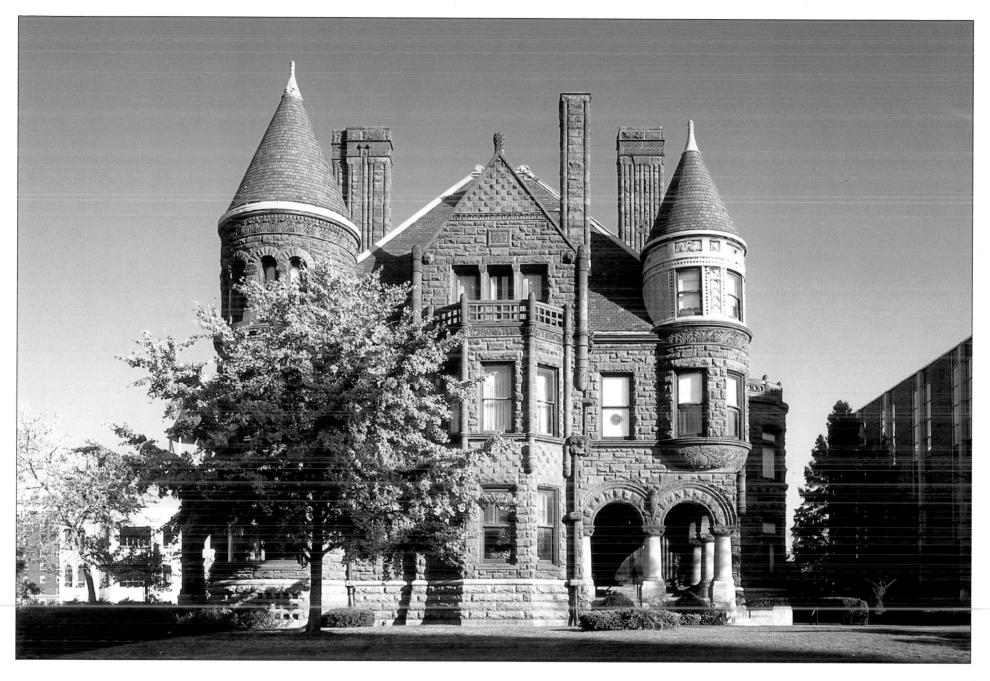

Once appropriately settled on a row of luxurious mansions, the Samuel Cupples House now sits alone on a block vacated to suit the St. Louis University quadrangle. One of the only Richardsonian Romanesque buildings in St. Louis, the house is even more unusual for its construction in "purple" Colorado sandstone, complete with towers and gargoyles. In addition to the rich woodwork, the interior also boasts several clear leaded-glass installations by Tiffany. Acquired by the University in 1942, the elegantly preserved home serves as an art center and museum. The SLU library is partially visible at right.

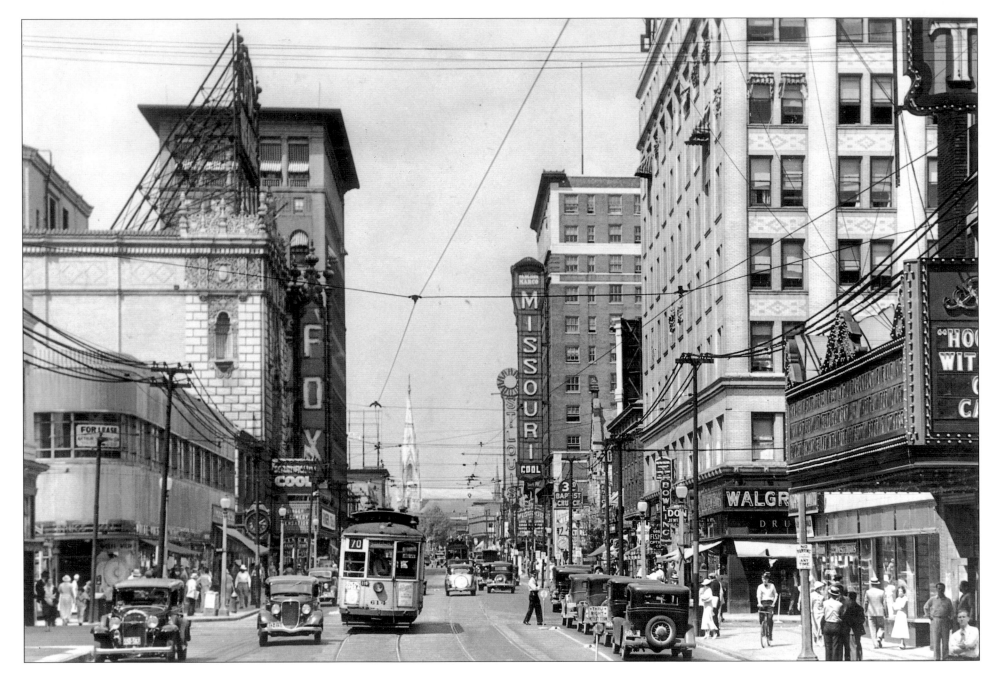

Grand and Olive, circa 1929. From St. Louis University north up Grand Avenue, an area known as Midtown, there was a thriving entertainment district with theaters, movie palaces, restaurants, bowling alleys, bars, and nightclubs to rival downtown. In 1867, the Grand Avenue Railway Company ran a line on Grand from north 20th Street south to Meramec, and after the line was electrified in the 1890s, the itersection of Grand and Olive was deemed "fifteen minutes from anywhere." The Schubert (*near right*), originally called the Princess, opened in 1912 as the first vaudeville house. The steeple of St. Alphonsus Liguori is visible in the background.

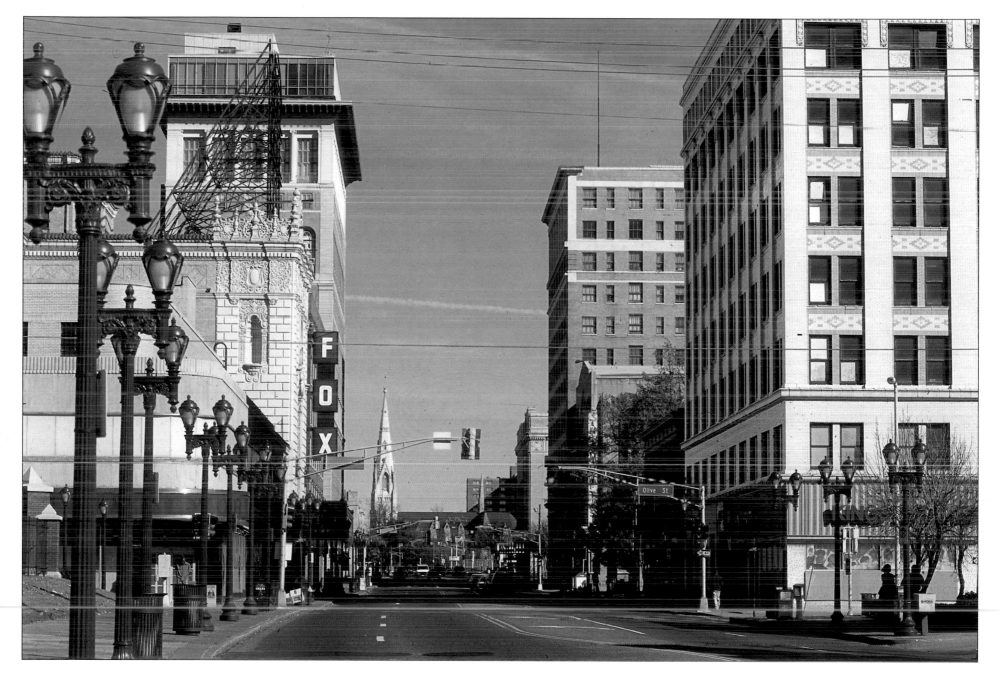

Ironically, the very success of Midtown proved its near undoing. With the advent of the car, businesses could afford to move "off-line" away from the hustle and high rents of the streetcar tracks. When the Mill Valley area south of the theater district was razed in the early 1960s, even streetcar service ceased, and the area began to decline. Today, Midtown is undergoing a renaissance thanks to the efforts of the Grand Center nonprofit organization and a few long-timers. The fall of 1992 saw the opening of St. Louis' first new theater in twenty years, the Grandel Square Theatre, located in the former First Congregational church.

The Fox Theatre opened on the eve of the Depression in 1929. With 5,042 seats, it was then the second largest theater in the country and truly lavish—it sported its own symphony orchestra, a barbershop for the ushers, and a second organ to serenade people lined up in the lobby. The building was designed by Howard Crane, but the wife of a Fox movie mogul is often credited with the eclectic interior, sometimes referred to as "Siamese-Byzantine." The design features elephants, lions, and scimitar-wielding rajahs, among other fanciful creations.

Privately purchased in 1981, the Fox Theatre has been renovated to its former glory, only now with state-of-the-art sound, lighting, and stage equipment. Today, the Fox presents major touring theatrical productions and concerts. The St. Louis Symphony Orchestra, the second oldest in the nation, led the way for redevelopment of the neighborhood in 1967 with the purchase of the St. Louis Theatre up the street. They transformed it from a vaudeville/motion picture house into Powell Symphony Hall, where they perform to this day.

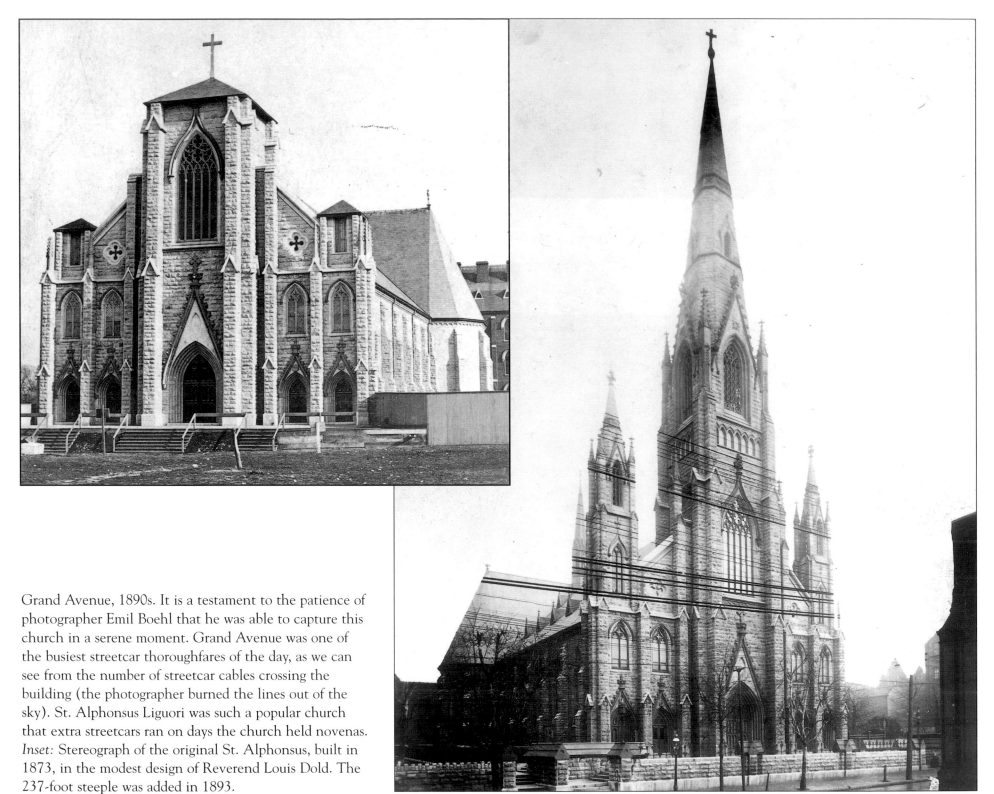

Grand Avenue, 1890s. It is a testament to the patience of photographer Emil Boehl that he was able to capture this church in a serene moment. Grand Avenue was one of the busiest streetcar thoroughfares of the day, as we can see from the number of streetcar cables crossing the building (the photographer burned the lines out of the sky). St. Alphonsus Liguori was such a popular church that extra streetcars ran on days the church held novenas. *Inset:* Stereograph of the original St. Alphonsus, built in 1873, in the modest design of Reverend Louis Dold. The 237-foot steeple was added in 1893.

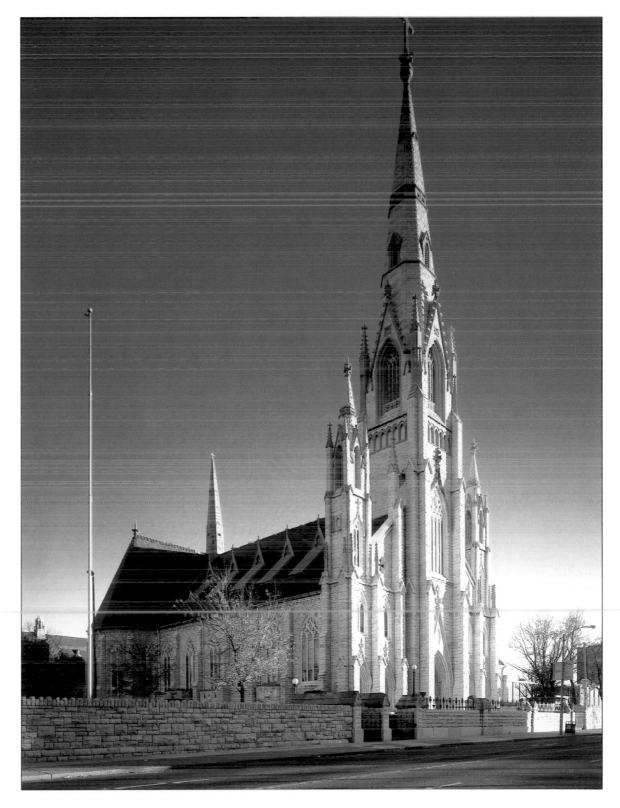

Today, the Rock, as it is popularly known for the prominence of its limestone walls and steeple, is once again a vibrant church community. Established as a parish for Irish immigrants, today St. Alphonsus' congregation is predominantly African American, and the church is known for its outstanding gospel choir and the use of African-American traditions in its music and liturgy. The church is a Mother of Perpetual Help Shrine with popular annual novena. Of artistic note are the stained-glass windows from Munich, which were exhibited at the 1904 World's Fair.

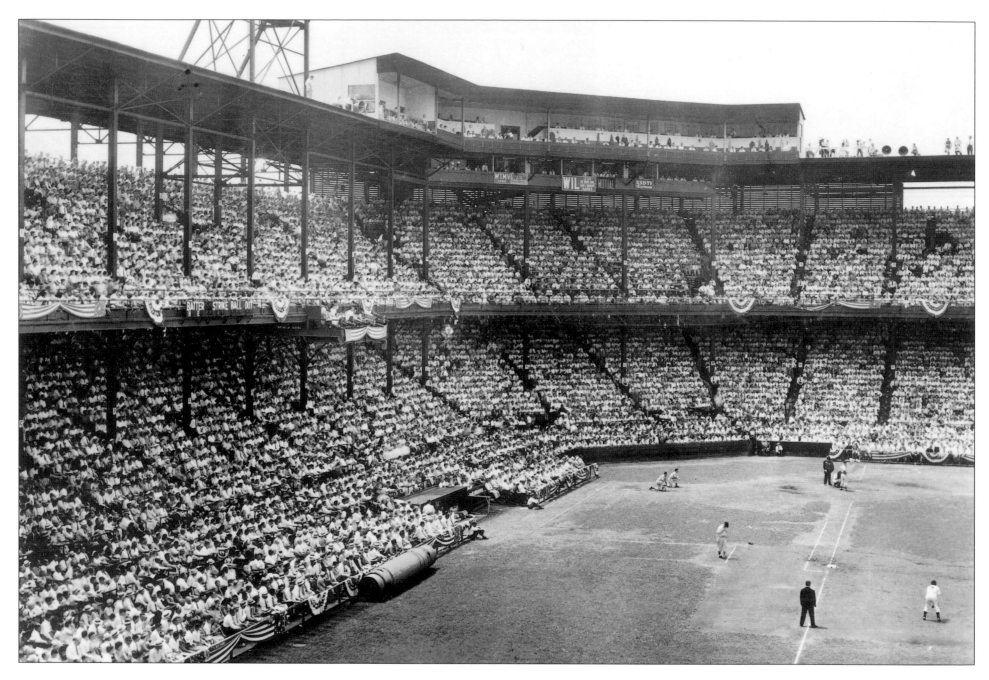

Grand and Dodier, 1948 All-Star Game. Established in 1866 in Midtown, the Grand Avenue Grounds were a private enterprise designed to entertain customers of local saloons with baseball games. It was renamed Sportsman's Park in 1876, when it became home to the St. Louis Browns. The Cardinals joined the Browns in 1920, and in 1934 the "Gashouse Gang" won the National League pennant. Ten years later, the unusual "Streetcar Series"

would pit the Cards against the Browns, and the Cards emerged triumphant. The '40s, '50s, '60s saw the likes of Cardinals' Stan Musial and Enos Slaughter, and seven World Series wins. The last game was played here on May 8th, 1966. When the last out was called, a helicopter swooped onto the field, home plate was dug up and whisked away to be installed in the new stadium.

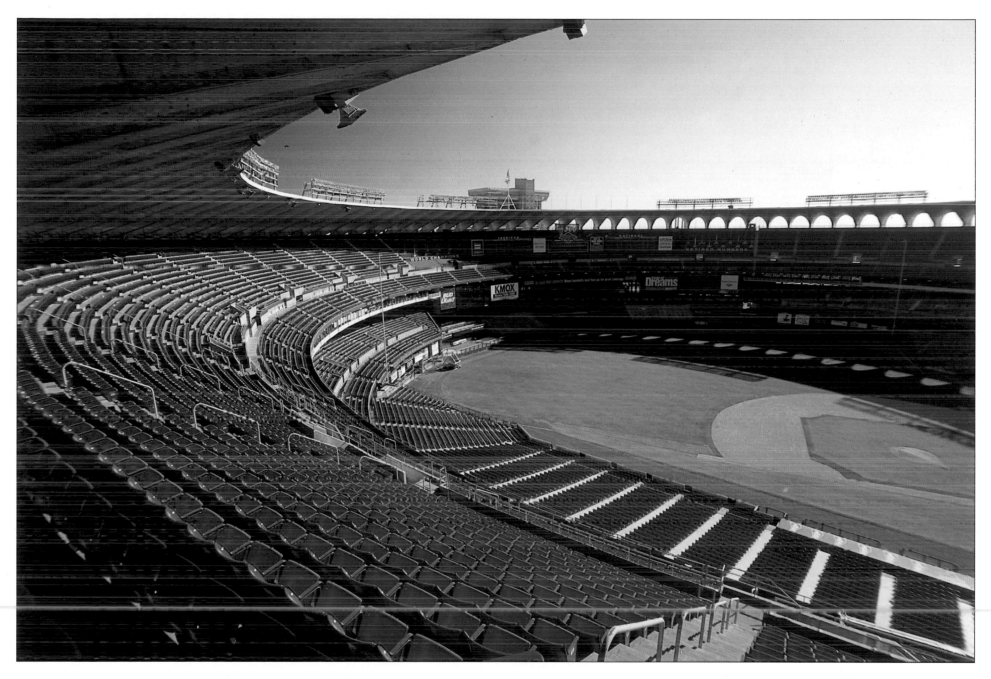

Broadway and Seventh, Walnut and Spruce, the "new stadium" where the Sportsman's Park home plate was installed. August Busch Jr. bought the Cards and Sportsman's Park in 1953. Shortly thereafter private fund-raising began for a new downtown stadium. Busch donated the Sportsman's Park location to the Herbert Hoover Boys' Club, and the Cards moved to their new downtown home, Busch Stadium, in 1966. The almost-circular arena seats over 50,000 fans with no obstructed views. Designer Edward Durell Stone echoed the nearly completed Arch's catenary curve in the stadium's famous roofline. The playing field and lowest seats are actully below ground level, giving the building a low-slung profile and also helping to cool the stadium during hot St. Louis summers.

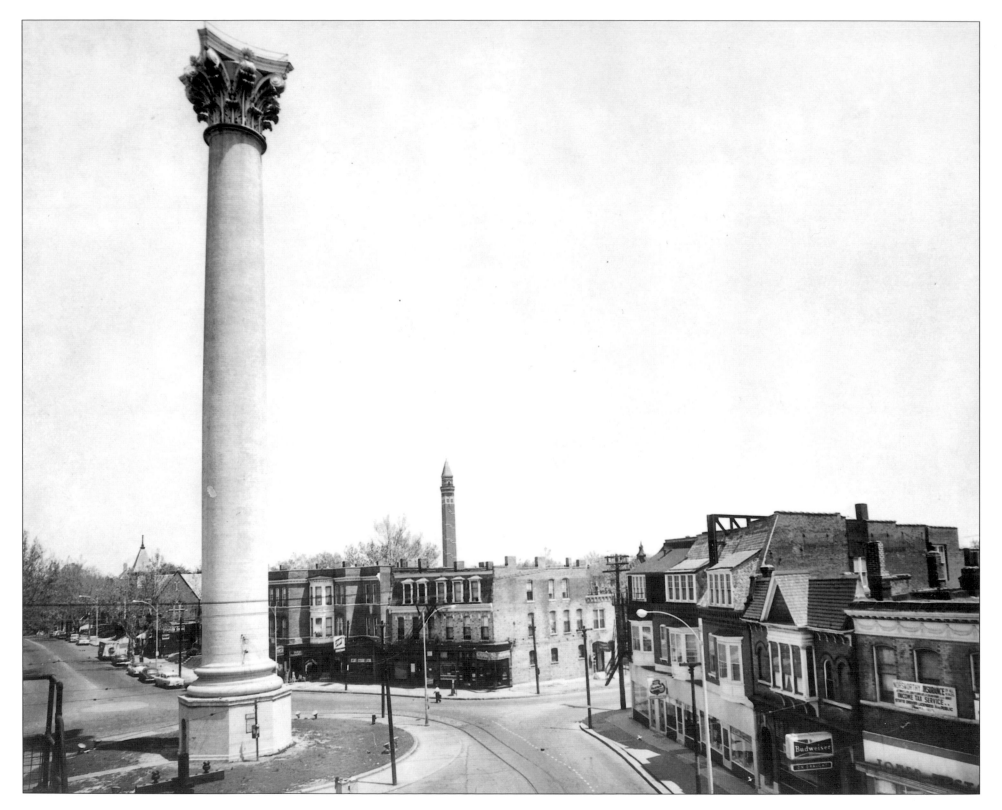

Left: North Grand, 1950s. The Grand Avenue water tower, with its Corinthian capital, was designed in 1871 to help regulate the mains from the city's first waterworks on Bissell's Point. Perspective is deceiving because the red-brick tower, added fifteen years later on Bissell Street, was actually the tallest in the city at almost 200 feet. The surrounding area, originally known as Bremen (later Hyde Park), was a close-knit German community in the nineteenth century.

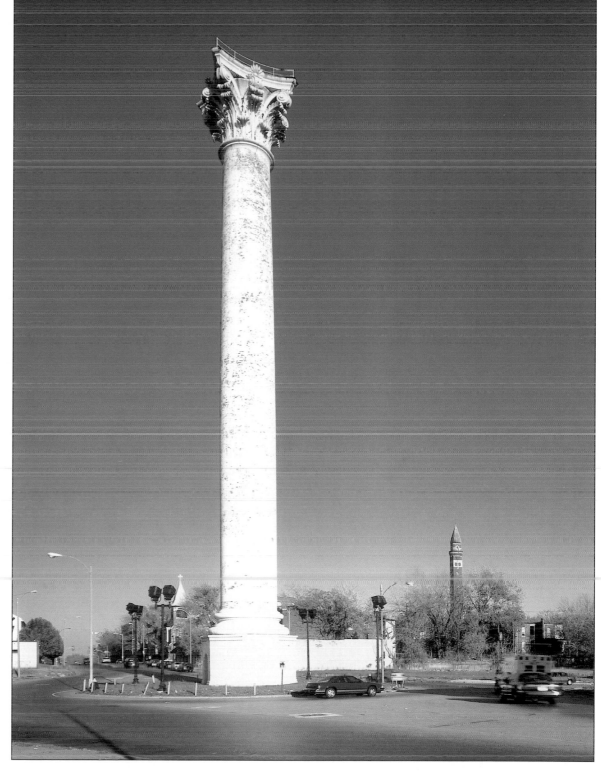

Right: Today, the Hyde Park neighborhood faces the challenges of many urban areas. Though both towers were put out of service around 1912, they remain, as one architect put it, monumental punctuation in the middle of the street. Both landmarks are listed on the National Register of Historic Places. Of only seven historic water towers left in the United States, three are in St. Louis. The third is the Compton Hill water tower, which is still in service.

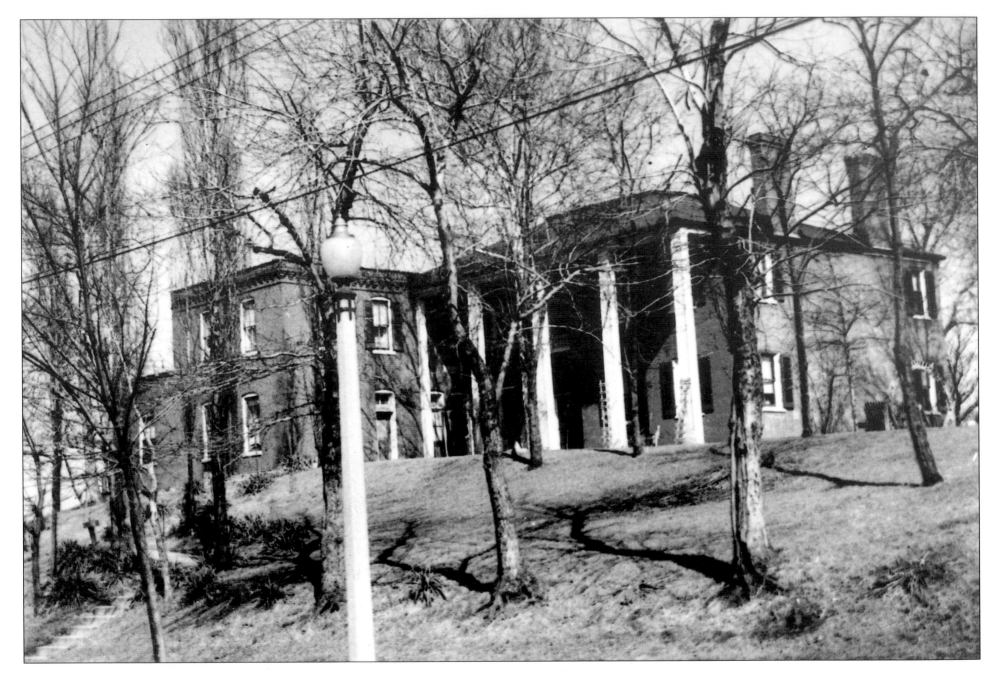

Randall Place, 1946. This brick home was built in the mid-1820s by Captain Lewis Bissell, making it the oldest home extant in St. Louis. Under commission from President Thomas Jefferson, Bissell was sent from his native Connecticut to the rolling hills of the Louisiana Territory, recently purchased from France. After serving with distinction in the War of 1812, he acquired this propery overlooking a bend in the river, which came to be known by the riverboat pilots as Bissell's Point.

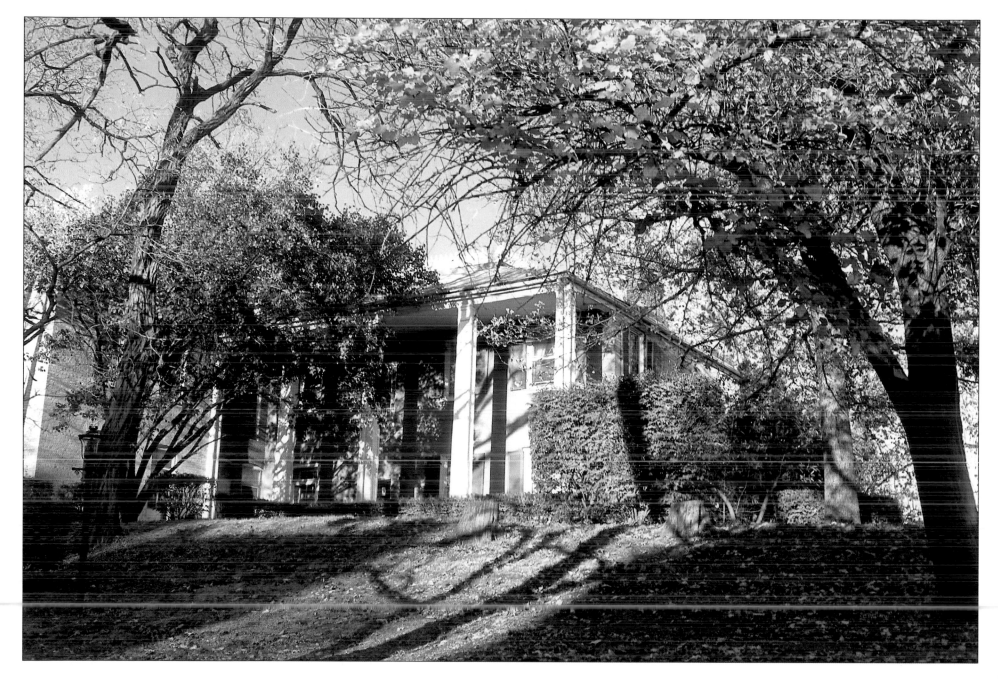

The mansion was threatened with demolition in the 1950s by the construction of interstate 70. Fortunately, a group of concerned St. Louisans was able to negotiate with the highway commission to have the road rerouted and a retaining wall built. That group became the Landmarks Association of St. Louis, which continues to fight for preservation of historic St. Louis buildings and neighborhoods. The Bissell Mansion is now privately owned and run as a dinner theater.

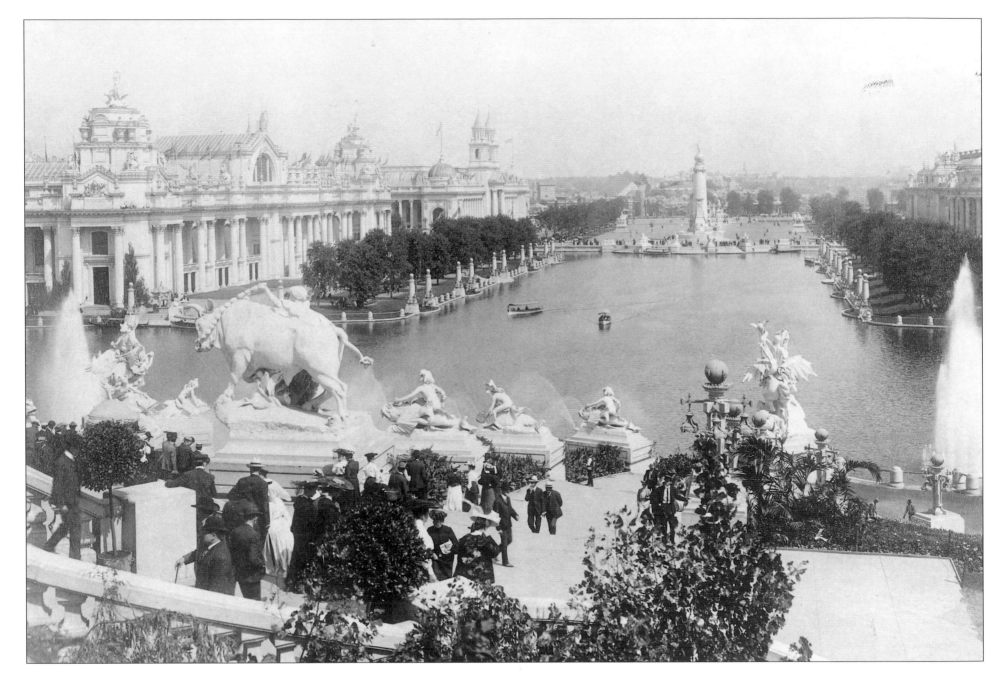

Grand Basin looking north, Peace Monument in the distance, 1904.
The 1904 Louisiana Purchase Exposition was the biggest World's Fair ever
staged, before or since. St. Louis' Forest Park, one of the nation's largest at
1,293 acres, was deemed a suitable location. After much public debate, fair
organizers were allowed to clear only the western end of old trees and
construct there a Beaux Arts fantasy of vast exhibit "palaces" and statuary set
among the manmade cascades, canals, and fountains. Visitors could tour the
entire grounds by gondola, and naval battles at three-quarter scale were
staged on the lagoon.

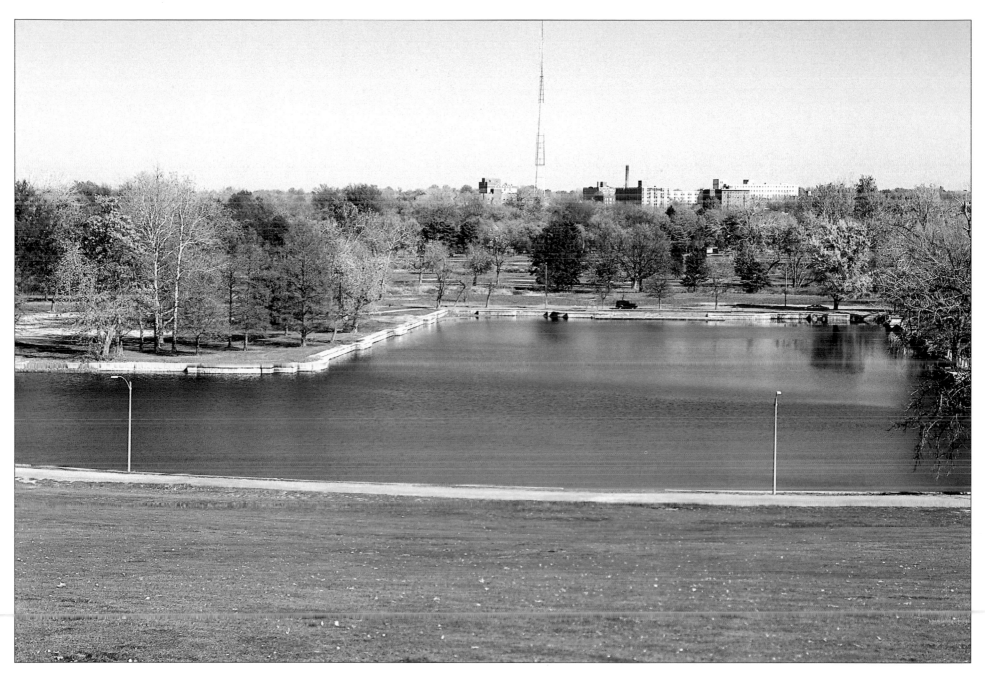

With the sole exception of the Palace of Fine Arts, all Expo buildings were intended to vanish after the fair and were constructed in "staff," a hard reinforced plaster. The malleability of the medium led to great flights of fancy in design, fondly remembered by fair-goers, but existing now only in photos. Fair organizers promised to restore the park to its prefair forests; they planted thousands of trees. Forest Park today does feature fine tracts of woods, but Art Hill, as its now known, is bare but beloved for its superb winter sledding (once the lagoon freezes, of course).

Construction of the Palace of Fine Arts, 1903, in preparation for the 1904 Louisiana Purchase Exposition. St. Louis, then the fourth largest city in the nation, hosted the 1904 World's Fair celebrating the 100th anniversary of Jefferson's purchase of the Louisiana Territory. Of the twelve grand exhibition halls, only one was built to be permanent—the Palace of Fine Arts. Designed by New York architect Cass Gilbert, this palace was masonry with a limestone-clad Roman Revival exterior.

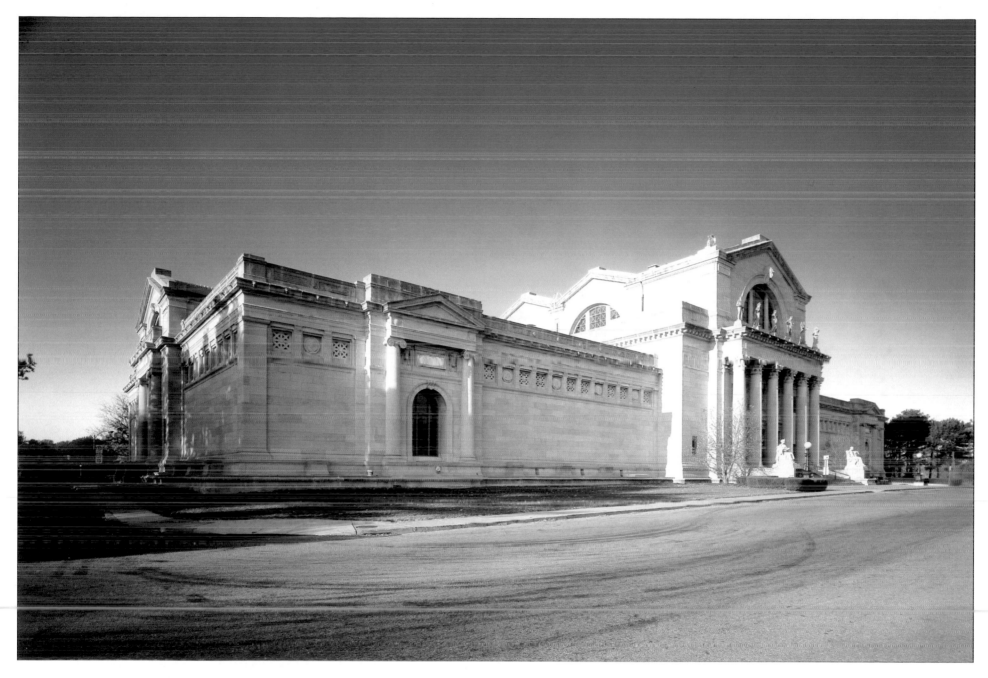

After the fair, the Palace of Fine Arts housed Washington University's Museum of
Fine Arts for a time. The attraction proved so popular that the city created a perma-
nent art museum. Today, the St. Louis Art Museum holds over 30,000 works of art by
masters like Rembrandt, Monet, van Gogh, and Picasso. Admission to the St. Louis
Art Museum, as for the St. Louis Zoo, is free; thanks to the public-minded spirit that
prevailed after the Fair, they are both funded with tax dollars.

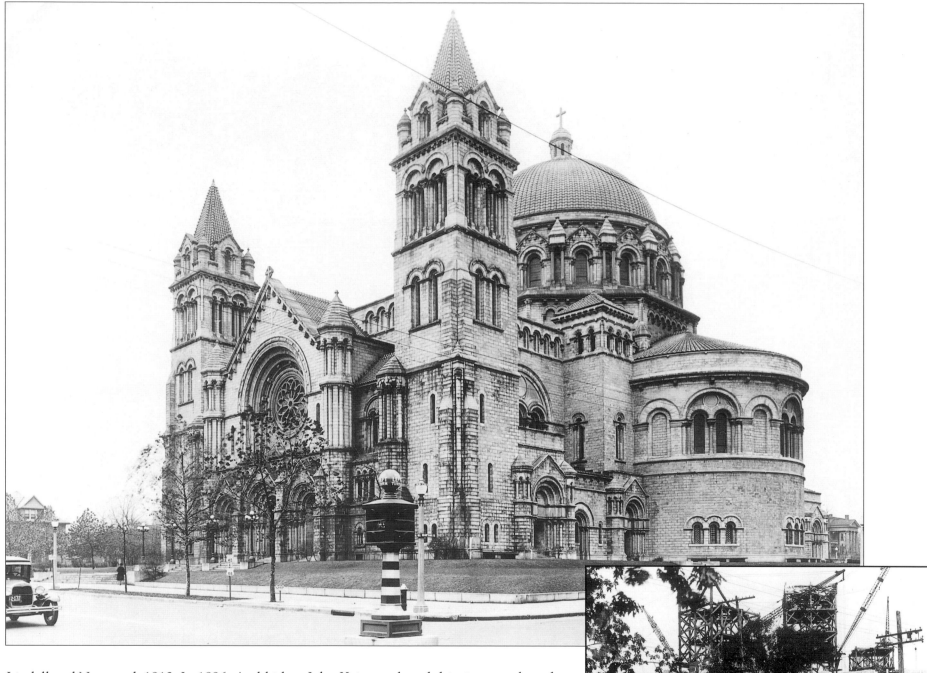

Lindell and Newstead, 1912. In 1896, Archbishop John Kain purchased this site to replace the Old Cathedral at the riverfront. The population was moving west with the streetcars, and the church was catching up. Begun in 1907, construction on the New Cathedral was finally completed in 1914. The style, probably influenced by that of Westminster Roman Catholic Cathedral completed in London in 1903, is Byzantine-Romanesque with a 227-foot dome. It was designed by architects Barnett, Haines, & Barnett. *Inset:* construction, circa 1910.

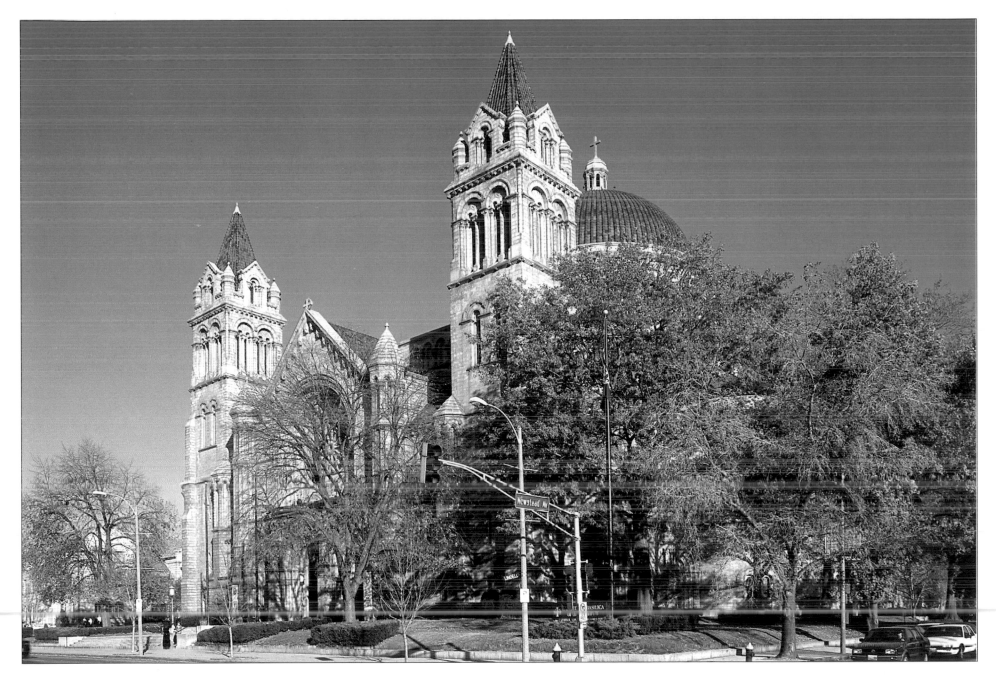

Along with the West End's private places and the Euclid Avenue shopping district, the New Cathedral, as it's known to distinguish it from the Old Cathedral downtown, is a major attraction for St. Louisans and visitors alike. In keeping with its upscale neighborhood, little expense was spared in the New Cathedral's decoration, and the interior boasts 83,000 square feet of mosaics, purportedly the largest collection in the world. They were installed by Tiffany, Gorham, and the Ravenna Mosaic Company over seventy years.

West entrance, circa 1905, Richardson Romanesque gates designed by Theodore Link. Established by the wealthy elite as urban islands and protected from noise, pollution, and riffraff by restrictive covenants, private "places" were a St. Louis phenomenon. The rules dictated minimum building expenses, property upkeep, even cleaning schedules (e.g., front steps are to be scrubbed twice weekly). The problem was, the city kept growing west, and zoning was a thing of the future. No amount of neighborhood covenants could prevent industry from setting up shop upwind. Residents of earlier private places moved west into Portland Place to escape just such problems, and they were determined to avoid those mistakes.

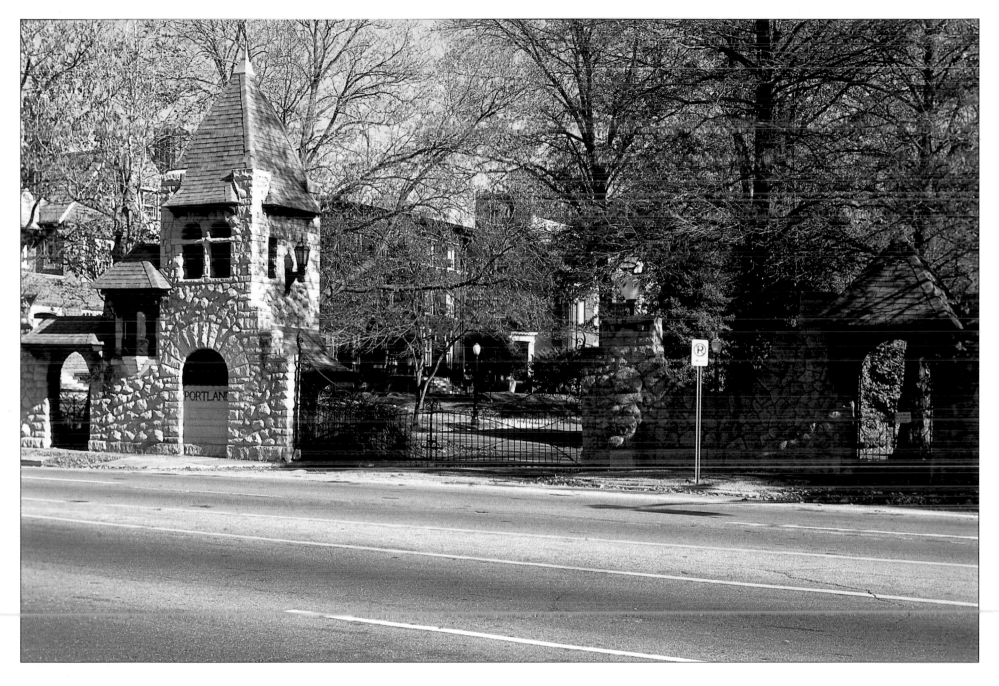

Designed by Julius Pitzman, the planner of most of the other private "places," Portland Place (along with her sister Westmoreland Place) was established in 1888. Subject to the usual strictures and fees, residents also embarked on a plan to control the surrounding environment. For those issues they could not dispatch through their social influence, they used their wealth, buying up adjacent railroad yards and installing luxury hotels in their place. The designers had learned as well, instead of the vulnerable single streets, they now grouped private places together and bordered them with preexisting public parks. Today, both Portland and Westmoreland places are superbly maintained, and entire books have been devoted to their architecture.

INDEX